THE METROPOLITAN MUSEUM OF ART

Greece and Rome

THE METROPOLITAN

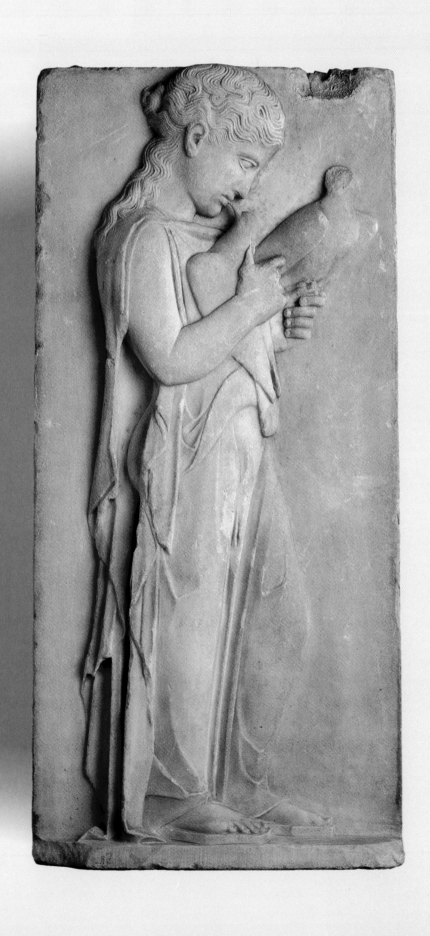

MUSEUM OF ART

Greece and Rome

INTRODUCTION

BY

Joan R. Mertens

CURATOR
DEPARTMENT OF GREEK AND ROMAN ART

THE METROPOLITAN MUSEUM OF ART, NEW YORK

PUBLISHED BY

THE METROPOLITAN MUSEUM OF ART
New York

PUBLISHER
Bradford D. Kelleher

EDITOR IN CHIEF
John P. O'Neill

EXECUTIVE EDITOR
Mark D. Greenberg

EDITORIAL STAFF
Sarah C. McPhee

Josephine Novak

Lucy A. O'Brien

Robert McD. Parker

Michael A. Wolohojian

DESIGNER
Mary Ann Joulwan

———

Commentaries on Plates 1–63 written by Joan R. Mertens, curator, Department of Greek and Roman Art; those for Plates 63–123 written by Maxwell L. Anderson, assistant curator, Department of Greek and Roman Art.

Photography commissioned from Schecter Lee, assisted by Lesley Heathcote: Pages 2, 13, 87 and Plates 2, 3, 8–12, 14–19, 21, 22, 24, 25, 30, 32–34, 36–38, 43–46, 48–50, 55, 56, 58, 62–66, 68–74, 78–81, 84–88, 90–95, 97–117, 119–123. All other photographs, including details of Plate 122, by The Photograph Studio, The Metropolitan Museum of Art.

Maps and time chart designed by Irmgard Lochner.

TITLE PAGE

Girl with Doves
Grave relief
Greek, ca. 450–440 B.C.
Marble; H. 31½ in. (80 cm.)
Fletcher Fund, 1927 (27.45)

THIS PAGE

Pilaster with a Foliate Acanthus Rinceau
(assembled view)
1st C.A.D.
Marble; 11 ft. 6 in. x 2 ft. 4⅜ in.
(3.5 m. x 72 cm.)
Rogers Fund, 1910 (10.210.28)
Page 126: text

Library of Congress Cataloging-in-Publication Data

The Metropolitan Museum of Art (New York, N.Y.)
 Greece and Rome.

 1. Classical art — Catalogs. 2. Art — New York (N.Y.) —
Catalogs. 3. Metropolitan Museum of Art (New York, N.Y.)
— Catalogs. I. Title.
N5603.N4M485 1987 709'.38'07401471 86-16430
ISBN 0-87099-446-8 (pbk.) — ISBN 0-300-08785-3 (Yale
University Press)

Printed and bound by Dai Nippon Printing Co., Ltd., Tokyo.
Composition by U.S. Lithograph, typographers, New York.

This series was conceived and originated jointly by The Metropolitan Museum of Art and Fukutake Publishing Co., Ltd. DNP (America) assisted in coordinating this project.

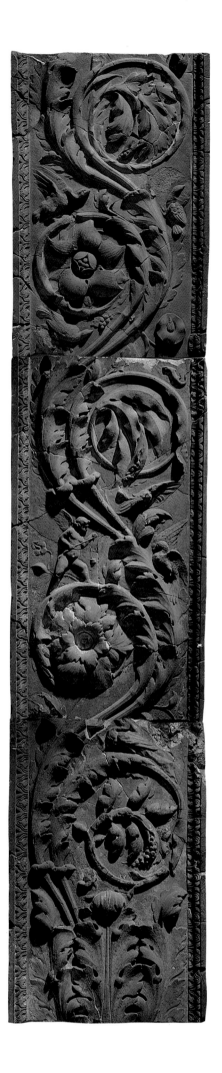

This volume, devoted to the arts of ancient Greece and Rome, is the second publication in a series of twelve volumes that, collectively, represent the scope of the Metropolitan Museum's holdings while selectively presenting the very finest objects from each of its curatorial departments.

This ambitious publication program was conceived as a way of presenting the collections of The Metropolitan Museum of Art to the widest possible audience. More detailed than a museum guide, and broader in scope than the Museum's scholarly publications, this series presents paintings, drawings, prints, and photographs; sculpture, furniture, and decorative arts; costumes, arms, and armor—all integrated in such a way as to offer a unified and coherent view of the periods and cultures represented by the Museum's collections. The objects that have been selected for inclusion in the series constitute a small portion of the Metropolitan's holdings, but they represent admirably the range and excellence of the various curatorial departments. The texts relate each of the objects to its cultural milieu and period and incorporate the fruits of recent scholarship. The accompanying photographs, in many instances specially commissioned for this series, offer a splendid and detailed tour of the Museum.

We are particularly grateful to the late Mr. Tetsuhiko Fukutake, who, while president of Fukutake Publishing Company, Ltd., Japan, encouraged and supported this project. His dedication to the publication of this series contributed immeasurably to its success.

Since it was established over a century ago, the Metropolitan Museum has been acquiring classical art, and its collections are among the most comprehensive and representative to be found in North America. These collections have grown both through the gifts of many generous donors and through judicious purchases made possible by several important bequests and acquisitions funds. Most notable among the gifts and bequests to the Department of Greek and Roman Art are those of Henry G. Marquand and J. Pierpont Morgan. Purchases have been facilitated by funds donated to the Museum by, among others, Christos G. Bastis, Isaac D. Fletcher, Frederick C. Hewitt, Joseph Pulitzer, Jacob S. Rogers, Norbert Schimmel, as well as the anonymous donor of the Classical Fund.

In order to prepare this volume, the editors have relied upon the help and advice of the staff of the Department of Greek and Roman Art, and we are grateful to Dr. Dietrich von Bothmer, chairman of the Department, and to Maxwell L. Anderson and Joan R. Mertens, curators in the Department, for having selected the objects, prepared the commentaries that accompany the reproductions, supervised the photography, and reviewed the design and the text.

Philippe de Montebello
Director

GREECE AND ROME

The origins of classical art may be followed back to a time —roughly 5000 B.C.—long before the people who are known as Greeks settled the lands to which they gave their name. The material remains of the very early cultures that have been found in the regions of Thessaly, central Greece, the Peloponnesos, Crete, and the Cycladic Islands are sparse, but they include figural representations that can justifiably be called art and be seen as antecedents of Greek art. From the very beginning, clay and marble were preferred materials for artistic creativity, human figures were the preferred subjects, and a pronounced sense of measure governed the forms that were produced. The first great flowering of marble sculpture took place during the third millennium B.C. in the Cycladic Islands. Marble was plentiful on these barren outcroppings of sheer rock, and indeed, the variety from Paros continued to be quarried and used through the Roman period. The Cycladic figures introduce us to another feature that remains fundamental to classical art: a limited repertoire of forms that retain their vitality as long as artists endow them with the freshness and power of their own interpretations.

The preserved Cycladic material consists primarily of statuettes of female figures represented with legs together and bent slightly at the knees, arms folded over the chest, and head erect; the position of the feet suggests that some were intended to stand, others to lie. Throughout the roughly one thousand years during which they were made, the basic type was treated with considerable diversity, influenced by such factors as local development and predilection, the influence of significant artists and workshops, as well as the element about which we know least: the function they served. While figures of men and animals were made as well, and while there are marble vases of many shapes, the preponderance of women suggests some connotation of fertility and, perhaps, some religious association. Within the grand panorama of classical art, the Cycladic contribution is small, yet it is exceedingly significant because it is the first statement of the fundamental theme, man.

A consideration of the earliest cultures in Greece from an artistic standpoint leads to a somewhat different and narrower field of vision than would a balanced, archaeological inquiry into the rich record of the region as a whole that is now coming to light. For the third millennium, our attention turned to the Cyclades. For much of the second millennium, it is concentrated on the island of Crete where, between about 2000 and 1400 B.C., the civilization called Minoan —after the legendary king Minos—developed and flourished. Because the art of Crete is inadequately represented in the collections of the Metropolitan Museum, it should detain us only briefly. Minoan culture was centered in great palaces like those of Knossos, Phaistos, Mallia, and Zakro that brought spatial planning and architecture to the fore, and that also prompted a great demand for luxurious accoutrements in addition to basic necessities like storage jars, axe heads, loom weights or braziers. The palace workshops, therefore, produced ceramic vases of exquisite delicacy decorated in bright colors with motifs often drawn from nature. Other vessels were created in materials as varied as bronze, ivory, rock crystal, and faience. Gem engravers produced seals on which subjects of great complexity were perfectly accommodated onto the smallest surfaces. The large expanses of palace and house interiors, by contrast, were covered with wall paintings that celebrated the beauty of nature as well as various aspects of palace life: the men and women who were part of it, or such events as the ceremonial bull-jumping. Minoan art—on whatever scale, in whatever material, with whatever subject—is colorful, vigorous, and sensitive to nature: man, octopus, swallow, or flowering lily.

As these great palaces were flourishing on Crete, centers of power and wealth grew on the Greek mainland as well; they culminated in the communities—part stronghold, part town—that archaeological investigation has revealed at such sites as Mycenae, Pylos, and Athens, and that Homer brings to life in the *Iliad* and the *Odyssey*. The Mycenaean civilization, named after its preeminent center, reached a height during the fourteenth and thirteenth centuries B.C. One of its most salient features is the expansionism that it pursued in trade and war, which were probably often combined. The incursions of Greeks from the mainland, and the tidal wave generated by the eruption of Thera, brought an end to the palace culture of Crete. The latter, however, significantly influenced Mycenaean artists, both through the remains which were still visible on Crete and through Minoan craftsmen who probably immigrated to the mainland.

The distinctly martial aspect of the Mycenaeans, so for-

eign to the Minoans, appears in the extent to which skilled craftsmanship was applied to objects of war—splendidly inlaid daggers, a suit of armor—or representations of warriors on rare examples of stone relief sculpture, on objects of ivory, and on vases. Assisted no doubt by these martial skills, merchants traded their wares over an area that encompassed much of the Mediterranean, particularly in the East, as attested by the imported Mycenaean pottery and local derivatives that have been found in quantity from Anatolia to Egypt. The inventories and other documents preserved on clay tablets in the palaces of Knossos and Pylos, as well as tomb paintings and texts of the Egyptians, contribute significantly to our knowledge of how the Mycenaeans looked, how they lived, and where they went. Their works of art are so permeated with Minoan borrowings that much scholarly discussion is devoted to the respective Cretan and Greek ingredient in any given object. As against the spontaneity and grace of the best Minoan production, the Mycenaean sequel tends to be competent but stiffer and more linear.

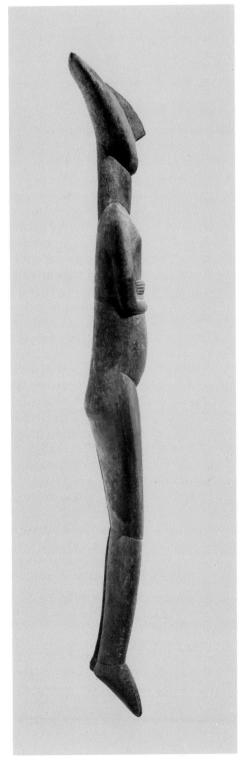 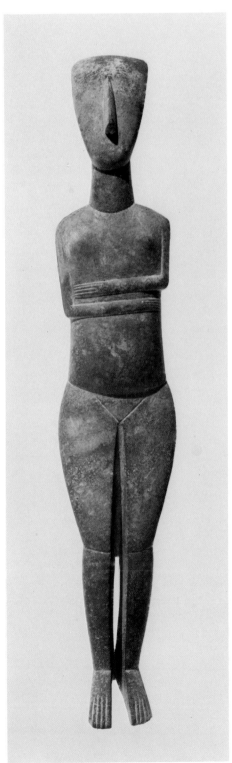 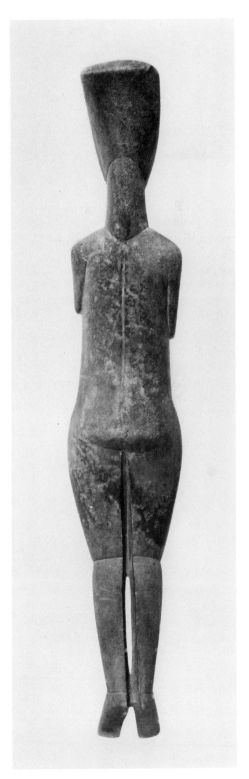

Statuette of a Female Figure (three views) Cycladic; c. 2500-2300 B.C. Marble; H. 24¾ in. (62.8 cm.) Gift of Christos G. Bastis, 1968. (68.148)

Widespread cultural and political upheaval, which seems to have been caused mainly by migrating populations, led to the downfall of the Mycenaean civilization. The Trojan War may have been one confrontation in a period of turmoil that is marked in Greece by the strengthening of forti-

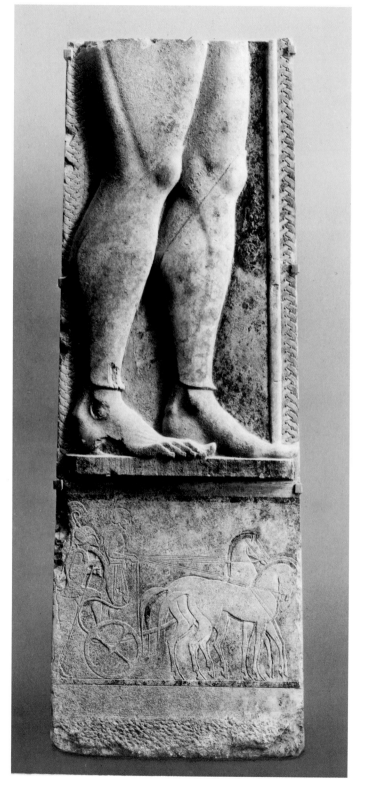

Lower Part of a Grave Relief
(legs of a warrior; chariot)
Attic; c. 530 B.C.
Marble; H. 55¹³⁄₁₆ in. (1.421 m.)
Fletcher Fund, 1938. (38.11.13)

fications, and the burning and destruction in all of the great palaces and enclaves. This era lasted about three centuries, from about 1200 until about 900 B.C., and although scholars are proving the traditional label "Dark Ages" exaggerated, it is a time during which artistic creativity all but ceased. The renewal began about 1000 B.C., and unlike the developments of the preceding millennia, it took place in mainland Greece. Its artistic manifestation is the "Geometric" style, a term derived from the curvilinear and rectilinear shapes that are used either as decorative motifs in themselves or as components in the depiction of more complex subjects, i.e. figures. Geometric art is best represented by terracotta vases as well as utensils and statuettes of bronze. Regional workshops existed throughout Greece, although for pottery, it was Athens that most rapidly and most fully exploited the expressive potential of the style.

Just as form and the material in which it is realized are inextricably linked, so also is subject matter and the manner in which it is presented. In this respect also, the Geometric period states the theme that classical art, like a great fugue, was to develop. The pottery of the time (see Plate 7) shows that figures and ornamental motifs comprise the decorative repertoire. Now, and in later periods, ornament serves particularly to articulate or to emphasize beautifully the surface to which it is applied. On the vase in Plate 7, the complex maeander on the lip reinforces our sense of the height of this part and of movement around the circumference. The figural representations record the dialogue between the artist's eye and imagination. The main zone of our example depicts a deceased person laid out upon a bier among members of his household and mourners. This is a subject that the painter surely had observed himself and that was appropriate to render on an object that served as a grave monument. The zone below shows a procession of horse-drawn chariots alternating with warriors armed for battle; they have helmets, spears, large figure-of-eight shields, and swords. The use of chariots in battle was no longer current in the eighth century B.C. The artist was familiar with racing chariots and could avail himself of an iconographical tradition, but he was not drawing something that he had actually seen. The subject, therefore, may be mythological; it does not provide us with sufficient information for a secure identification. Returning to the mourning scene above, we may ask whether these figures are meant to be the artist's contemporaries or participants in the funeral of a hero. While the former is likely, the significant point is that in much of classical art it is only by specific attributes—or by inscriptions or indications of a particular setting—that we can distinguish a mortal from a god or a hero.

There is a world of mythical animals that also begins to appear in late Geometric art: griffins, sphinxes, sirens, centaurs, and other composite creatures. While no one had ever seen or touched one of them, the sureness and frequency with which they are depicted makes clear that they had their own very definite existences and, thus, that the line between tangible and intangible realities in Greek art is a very fluid one.

Because the Geometric style is unnaturalistic, with its human figures and animals so closely resembling the triangles, lozenges, or circles around them, its images are re-

mote. During the latter part of the eighth century, a decisive change began to occur when contacts with, and imports from, the East confronted Greek artists with a new repertoire of subjects. It is now that the griffins and other fabulous beasts enter as well as ornaments like the lotos and palmette; worth mentioning in this context also is the introduction of the alphabet, probably from Phoenicia. By the end of the seventh century, the oriental stimulus had been assimilated. The Archaic period (ca. 700–480 B.C) saw an efflorescence of all the arts throughout Greece, from its colonies in southern Italy to the cities of Ionia. Perhaps the single most important development was the emergence of monumental stone sculpture, in the round and in relief. The marble islands of the Aegean seem, once again, to have played a significant, incubating, role, and again also, the sculptural types are as limited in number as the diversity within them is great. The paradigmatic type of figure is that of the nude youth, or kouros (see Plate 14). Its counterpart was the young draped woman, or kore. The kouroi were created for over one hundred fifty years, with the most accomplished series coming from Attica, the region of Athens. Compared with Geometric renderings, the body is lifelike, becoming ever more so as sculptors acquired the ability to render not only how it looked but also how it moved. The kouroi served as funerary monuments or dedications, but the representations themselves give us no evidence for deciding whether they are mortals or immortals. Only the inscriptions that occasionally accompany the statues indicate that they have to do with the deceased.

There is certainly no more clear, direct, and timeless image of man than a kouros, yet Archaic artists also devoted themselves to depicting humans and animals in the narrative situations provided by myths. The construction of public buildings like temples and treasuries at such sites as Athens, Delphi, Aegina, Foce del Sele (southern Italy), or Selinus (Sicily) called for sculptural embellishment. The programs offer a rich variety of iconographical themes —the war of the gods and giants, the exploits of the heroes Herakles and Theseus, the journey of the Argonauts, or the rape of Europa. In this respect, they complement the evidence of vases and of bronze objects like embossed shield bands that are veritable mythological compendia. By virtue of its three-dimensionality, however, together with the superlative execution and the precision obtained with marble, Archaic sculpture makes the realms of legend and imagination immediate and palpable. It is possible, even probable, that a large number of the subjects now readily recognizable existed in the previous period but have remained impenetrable to us because of the reticence of the Geometric idiom. The Museum's fragment with a lion about to savage a bull (Plate 17) illustrates the thoroughly Archaic reconciliation of sensitivity to detail with irrepressible vigor. If we compare it to the runners on the Panathenaic amphora (Plate 23), the same qualities are manifest. Indeed, in the art of the sixth century, men and animals, gods and heroes seem only to represent different provinces of one world.

This world, made possible by a long period of prosperity and stability, received a threat to its very existence when the Persians followed their conquest of western Anatolia with

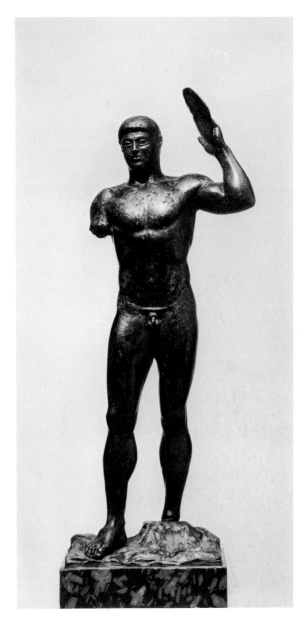

Statuette of a Diskos Thrower
Greek; c. 480–460 B.C.
Bronze; H. 9¼ in. (23.5 cm.)
Fletcher Fund, 1907. (07.286.87)

two attacks upon Greece in 490 and 480–479 B.C. The invader was repulsed. Yet, like the eastern influences that had shaken up the patterns of Greek art in the late eighth and seventh centuries B.C., so the renewed confrontation—of a far more critical nature—once again caused profound transformations. If the Archaic manner of representation rendered the appearance of a subject with maximum clarity, artists of the Classic period (480–323 B.C.) began to introduce the realities of space, time, and character (see Plate 40). Sculpture, again, provides particularly informative illustrations. The essence of the kouros (Plate 14) lies in its total and exclusive concern with human form, devoid of any reference whatsoever to episodic detail. The great studies of the male figure that follow—for instance, the charioteer in Delphi, the Doryphoros, the Diadoumenos (Plate 45), the Riace Warriors, not to speak of the Diskobolos—all show the individual in a specific situation.

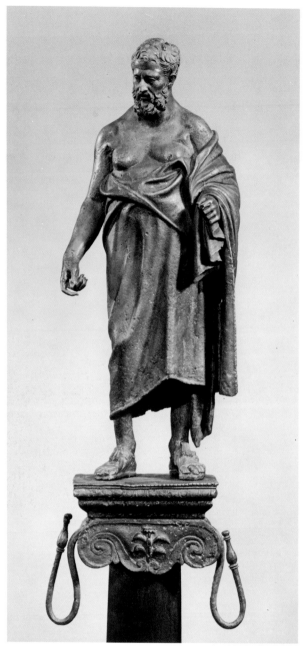

Statuette of a Philosopher
Roman copy, reduced from a Hellenistic
original of the 3rd century B.C.
Bronze; H. 10⅜ in. (26.3 cm.)
Rogers Fund, 1910. (10.231.1)

enters the repertoire of subjects to be investigated and represented.

The tendency to situate a figure within a definable context and to record the response of both body and mind is part of a more general interest in extending the limits of what is expressed by a work of art. This concern seems also to have been particularly explored in the medium of monumental wall painting. Literary descriptions are all that remains of great narrative scenes; they include the Battle of Marathon, the battle between Athenians and Amazons, the Trojan War, as well as a depiction of the Underworld on the occasion of Odysseus' descent. Of particular note in the account of Pausanias, the Roman traveler of the second century A.D., are the indications in these works of various levels and complex overlappings—in other words, of spatial articulation. Contemporary vases, like the calyx-krater (Plate 43), offer some idea of what the monumental painters like Polygnotos of Thasos or Mikon of Athens attempted. If one looks only at the position of the protagonists' feet, one recognizes a considerably more ambitious use of space than, for example, in Nearchos' tumultuous but planar engagement between pygmies and cranes (Plate 21). The frontal, mounted Amazon; her falling cohort half-concealed by a shield; or another attacking to the right with both hands wielding an axe are presented not only as formidable enemies but also as entities that occupy specific spaces and relate to each other with unprecedented complexity of movement.

The artistic innovations of the Classic period could not but lead to further change, as artists pursued their studies of personality and space. Moreover, historical events came into play as Macedon assumed the political primacy within Greece that Athens had once held, and Alexander the Great established an empire—however short-lived—that extended eastward as far as India. Starting with the ruler himself and continuing with the diversity of peoples whom he subjugated, artists depicted a wider range of figural types than ever before. They also drew children (Plate 53), old people (Plate 54), the deformed and infirm into their repertoires, representing them with penetrating realism. In some instances, the interpretation is tinged with the sting of caricature. In others, like the statue of the market woman (Plate 54), the unsparing detail is nonetheless tempered by the sensitivity with which the sculptor modeled the marble so that the effect is one of sympathetic observation, not mocking revelation.

A further manifestation of the change, both in subject and style, is the rise of portraiture. Previously, representations of historical individuals—people about whose lives something is known—were exceptional and, one might say, testimonial, as for example, the Archaic Kleobis and Biton in Delphi. During the late sixth and fifth centuries, images like those of Harmodios and Aristogeiton, the slayers of the Athenian tyrant Hipparchos, or of Perikles, the statesman, began to celebrate civically prominent persons. No Greek ruler was the object of such a cult of personality, during his lifetime, as Alexander the Great. Only the sculptor Lysippos was deemed capable of creating his likeness; most interestingly, it is also Lysippos' brother, Lysistratos, whom the Roman encyclopedist Pliny credits with being the first to make likenesses accurate that before had been beautiful.

A second major, and related, development is that the depiction of a figure addresses not only his pose and dress, but also the mind that is part of the body. The sculpture, notably the pediments, of the temple of Zeus at Olympia is a first watershed in this development, which reached its most exalted expression in the friezes, metopes, and pediments of the Parthenon. The significant point is not only the concern with perpetuating in marble something as complex as character but also the cast of character that is chosen. The aspects of human activity that Classic artists favored were those emphasizing human strengths: nobility in victory (Plate 45), valor in battle (Plate 43), restraint in mourning (Plates 47, 48). It is in the succeeding, Hellenistic, phase of Greek art that excess of all kinds, grotesqueness, often ugliness

The posthumous deification of Alexander established a new bond between the state, religion, and art that was to constitute a major legacy of the classical world to its medieval successors. During the Hellenistic period, however, and especially among the dynasties that followed Alexander in the East—the Ptolemies, the Seleucids, the Attalids—art in the service of the ruler, and by extension in the service of the state, acquired a new role. There is no question that, in the previous periods, most art on a large scale had served a public function, whether it was a temple, a fountain house, a meeting place for the regents of a city-state. One of the fundamental changes that followed in Alexander's wake, however, was that a historical person, even a living one, came to be seen as an embodiment of the state, and was celebrated as such.

The Hellenistic period saw the fields of creative energy displaced from the heartland of Greece, Attica, and the Peloponnesos, to the periphery, southern Italy and Asia Minor. Athens, to use the words of Perikles, remained the school of Hellas, but her vigor was past, not present. When the Romans conquered and destroyed Corinth in 146 B.C. and created the provinces of Achaea and Macedonia, the transfer of primacy was consummated.

Momentous as the consequences were, these political events formed part of a very long and significant history of interchange between Greece and Italy (which includes Sicily). While contacts extend back as far as the Mycenaean period, the establishment of Greek colonies began in the eighth century B.C. at such sites as Tarentum, Sybaris, Croton, Naxos, Syracuse, Gela. The Greek presence farther north, in the territory of the Etruscans, took the form mainly of imports, best attested by the great quantities of pottery that have come to light—notably of fine Athenian pieces of the sixth and fifth centuries. Many commodities must have been traded westward, probably in exchange for Etruscan ores. Cloth; other fibers like reed and wood; easily corroded metal like silver; perhaps certain foodstuffs like olives and wine would leave no traces today, unlike terracotta, which is virtually indestructible. Though we know all too little about the vehicles of Greek influence, the fact is established not only by actual imports but also by Etruscan assimilation of Greek iconography. The Museum's bronze chariot from Monteleone (Plate 31) exemplifies admirably an Etruscan interpretation of Homeric subject matter. Contact between Greece and Italy was maintained through trade and through ties of the colonial offspring to the mother country, as evidenced, for instance, by participants from Magna Graecia and Sicily in the Panhellenic festivals and games. War also was an ever-present factor because the wealthy and powerful cities in the West were drawn into the political conflicts between the Greek states; one such example is the ultimately disastrous Athenian expedition to Sicily of 415–413 B.C., during the Peloponnesian War (431–404 B.C.).

As the city of Rome pressed its expansion, with every territory it conquered it also acquired a cultural tradition upon which Greek influence had left its mark. This duality is a characteristic of Rome during the Republic. On the one hand, in its subjugation of the Italian peninsula and then of Spain, North Africa, and Asia, as well as in the establishment of a system of government that assured the capital control of its dependencies, Rome demonstrated what would always be its particular strengths: conquest and integration. On the other hand, campaign after campaign brought as booty Greek art in every form, especially sculpture and tableware of gold and silver. There was, therefore, continuous exposure to the tangible products bearing the iconography of the much admired civilization to which Aeneas, the Trojan founder of Rome, provided an ancestral link. The somewhat uneasy interplay between disparate cultural traditions appears, for instance, in the terracotta figure of a woman (Plate 64). A distinct indigenous concern with displaying the wearer's jewelry is combined with a classically inspired interest in rendering the interaction of different layers of dress with the underlying body. Though considerably more accomplished, the kithara player from Boscoreale (Plate 67) shows what seems originally to have been a Hellenistic composition adapted by Roman artists to the decoration of a patrician villa.

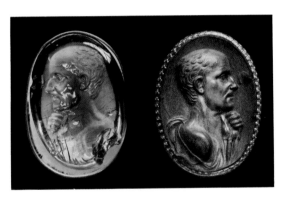

Intaglio Portrait of a Man
Late Republican; mid-1st century B.C.
Amethyst; H. 1⁵⁄₃₂ in. (27.4 mm.)
Rogers Fund, 1911. (11.195.6)

During the second half of the first century B.C., the Roman state achieved the power and organization at its center that were adequate to administer an empire whose greatest extent, under Trajan, reached from Britain to Mesopotamia. The centrality of the ruler was first established by Julius Caesar and was later to become formalized by Octavian's victory over Mark Antony at Actium (31 B.C.), followed by Octavian's creation of the principate with the titles of Caesar and Augustus. The qualities and capacities of each successive ruler exerted a real influence upon political developments, as well as upon the arts. In such media as architecture, sculpture, and coinage, they were used most effectively as manifestations of Roman presence in far-distant regions. Edward Gibbon, indeed, defined the hallmarks of civilization, in contrast to barbarism, as art, law, and manners. It is the Roman achievement to have held its vast and diversified domains by a formal system of laws (see Plate 103). Moreover, by endowing the symbols of its jurisdiction with the qualities so ardently assimilated from the Greek world (see Plates 71, 72) they became an integral part of what is called Western civilization.

Joan R. Mertens

GREECE

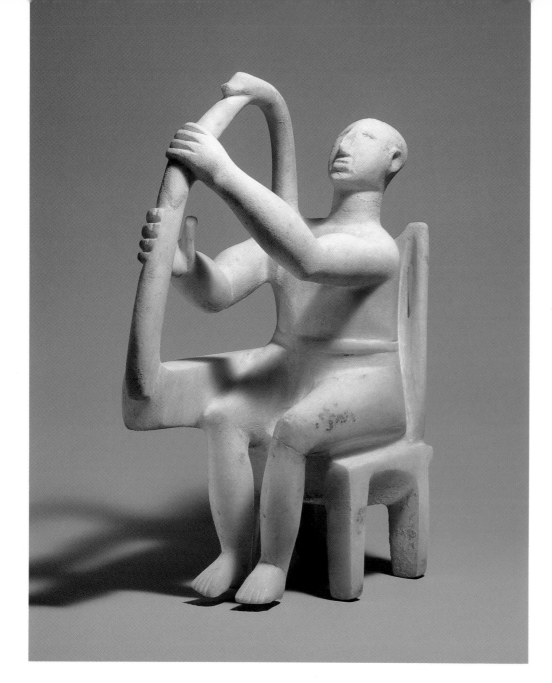

1 Harp Player
Cycladic, ca. 2700 B.C.
Marble; H. 11½ in. (29.2 cm.)
Rogers Fund, 1947 (47.100.1)

CYCLADIC HARP PLAYER

The earliest Greek art may be found in the figures and vases produced in the Cycladic Islands between about 4500 and 2200 B.C. While very little is known about their function and meaning, they seem to come to light primarily in burials. The predominant material for these objects is marble; the figures are usually women but sometimes also men; and the clear, simple forms were articulated with color to indicate details such as the eyes, hair, a headdress or tattoo. Usually, the statuette stood or lay, performing no action. This exceptional example shows a musician seated on a sturdy chair, his head tilted back. He appears to be accompanying himself on the harplike instrument he is holding. The light area at the very back of his head was once painted, probably indicating a close-fitting cap. Though the pigment has not survived, it protected the underlying stone, thus producing the contrast with the surrounding, "unprotected" areas. Simple though all of the forms are, details such as the muscles of the upper arm or the articulation of various parts of the chair give the work extraordinary immediacy.

MYCENAEAN STIRRUP JAR

Our main evidence for the cultures that successively flourished and declined in Greece between the period of Cycladic sculpture and the late eighth century B.C., when literacy began to spread, lies in the objects that these cultures produced. On the island of Crete the Minoans left abundant remains of a refined civilization that seems to have been centered in large palaces and to have flourished between about 2000 and 1400 B.C. Its downfall was due in part to the incursions of the Mycenaeans who, as bold traders and fierce warriors, extended the dominion of Mycenae, their capital on the Peloponnesos, as far west as Italy and as far east as the Levant. Mycenae was the city of the legendary king Agamemnon, and its period of greatest achievement, ca. 1600–1300 B.C., is reflected in the epic poems of Homer.

Control of the sea was essential for gaining and maintaining power over such a vast domain. The shape of this Mycenaean stirrup jar—easy to carry and stow, designed not to spill—and its octopus decoration testify to the importance of the sea as an avenue of communication and a source of food, wealth, and peril.

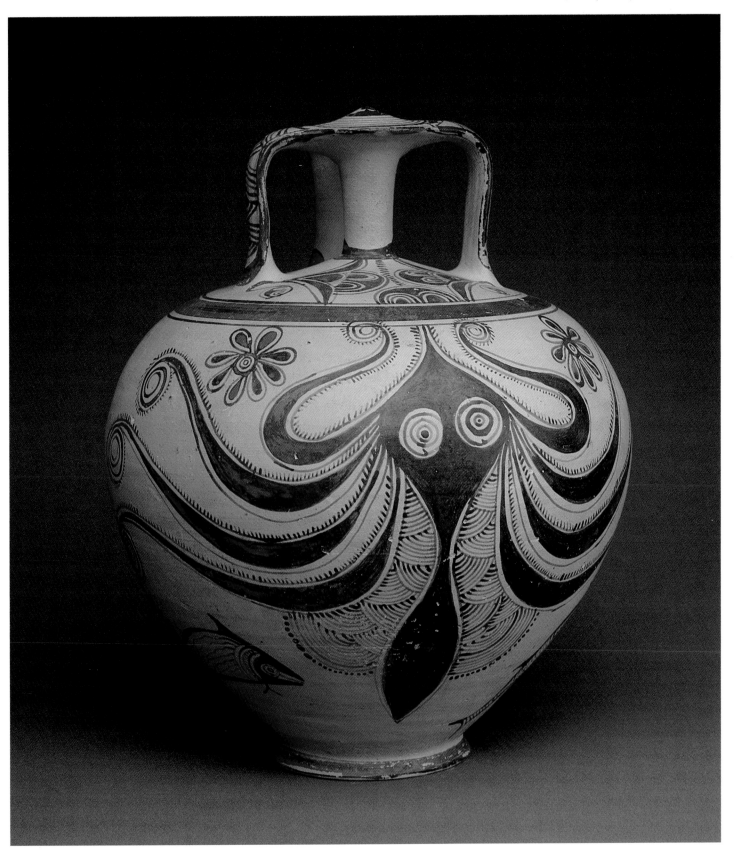

2 *Stirrup Jar with Marine Life*
Mycenaean, ca. 1200–1100 B.C.
Terracotta; H. 10¼ in. (26 cm.)
Purchase, Louisa Eldridge McBurney
Gift, 1953 (53.11.6)

Tripod with Hounds, Wild Goats, and Bull

Throughout its history, the island of Cyprus has been a meeting ground for the civilizations of Greece and Rome on the one hand, and the Near East on the other. Its importance in antiquity was due to its location, as a way station on long sea journeys, and to its rich deposits of copper. Alloyed with tin, copper produces bronze, the basic metal for utilitarian objects ranging from razors to shields.

Tripods survive in a considerable variety of sizes and types, reflecting their usefulness; they supported containers like round-bottomed bowls or cauldrons that could not stand of their own accord. Moreover, the three-legged design offered greater stability—with greater economy of valuable metal—than a four-legged stand would have. The stability, combined with the height of these supports, often allowed for a fire to heat the contents of a cauldron. In the tripod pictured here the ringed top and the legs were cast separately and then joined. Although the decoration on each part is conventional, the animals that circle the ring in an endless chase emphasize its shape as effectively as the chevron pattern brings out the verticality of the legs.

Silver Bowl with Gilded Decoration

The precious metals from which this bowl is made, the quantity and precision of its decoration, and the various oriental images of power reflect the prosperity of Cyprus between the late eighth century B.C. and the fifth, when the Persians subdued the island. The decorative motifs were derived from both Egypt and Assyria and, in the central medallion, include a figure with four wings in Assyrian dress attacking a lion. A narrow frieze around the medallion contains a hunting scene with a horse, sphinx, and bulls. A wider outer frieze shows a pharaoh dispatching captives, Egyptians killing a lion and a monster, and an Assyrian overcoming a griffin.

One inscription preserved on the object indicates that it belonged to a king of the city of Paphos named Akestor. A second inscription, reflecting a change of ownership possibly resulting from the Persian conquest, records an owner named Timukretes. In addition to being a splendid work quite literally fit for a king, the bowl may have served to pour liquid offerings or, following oriental practice, as a drinking cup.

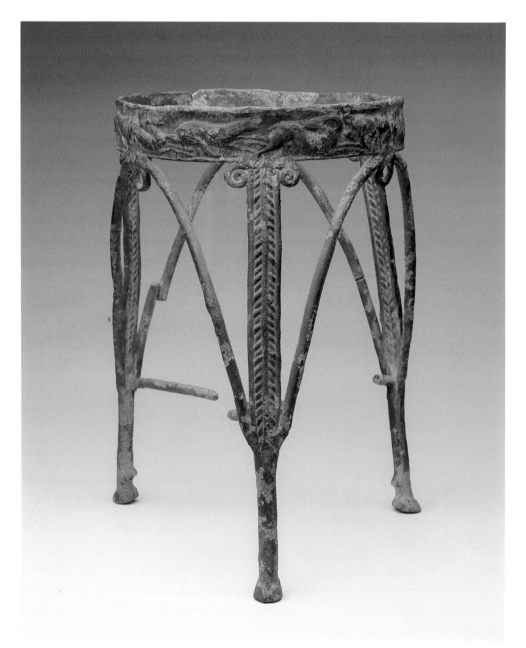

3 Tripod with Hounds, Wild Goats, and Bull
Cypriot, 12th c. B.C.
Bronze; H. 14¾ in. (37.5 cm.)
The Cesnola Collection, Purchased by
subscription, 1874–76 (74.51.5684)

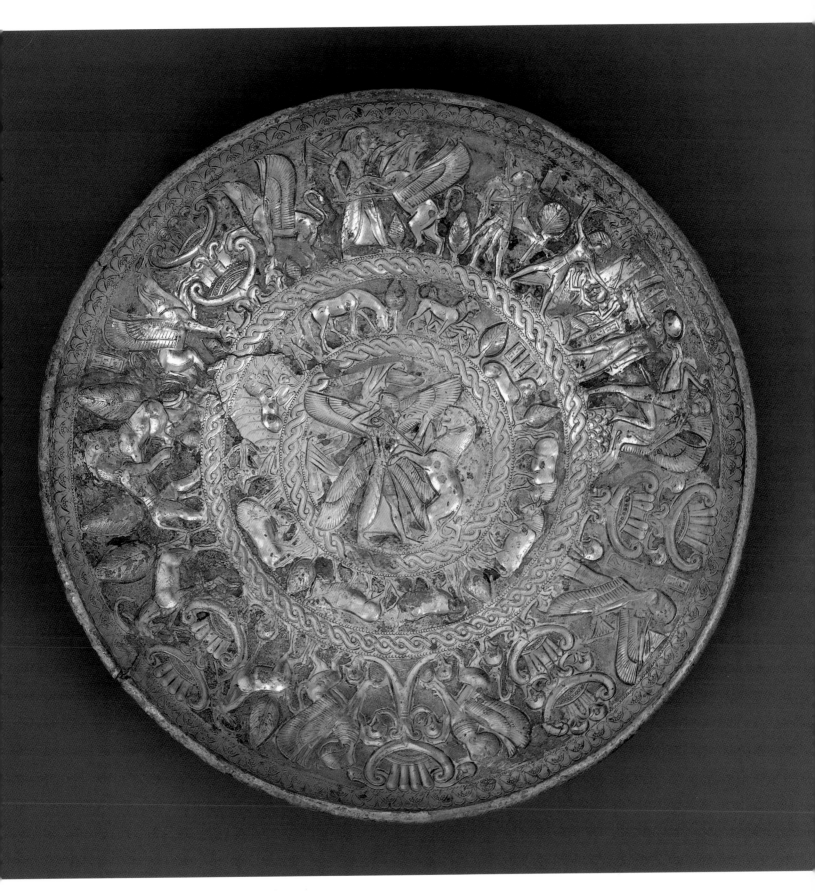

4 Silver Bowl
Cypriot, 7th c. B.C.
Silver with gold; D. 6¹¹/₁₆ in. (16.9 cm.)
The Cesnola Collection, Purchased by
subscription, 1874–76 (74.51.4554)

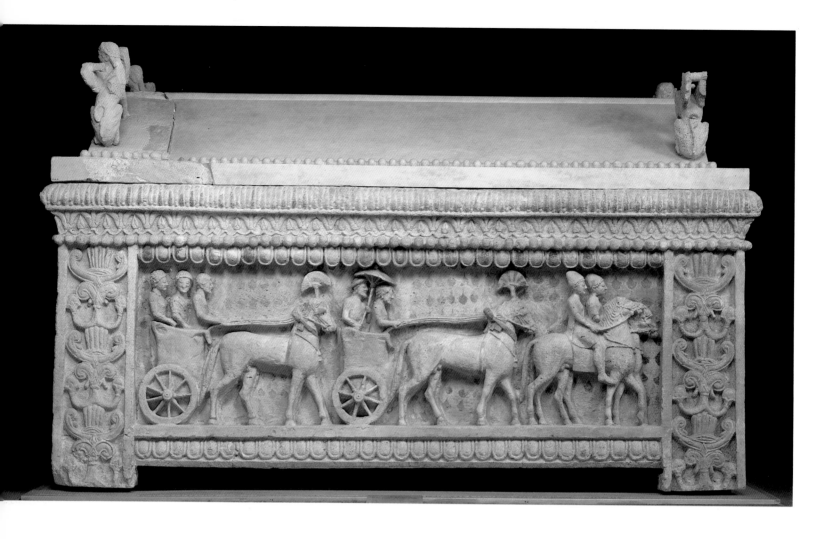

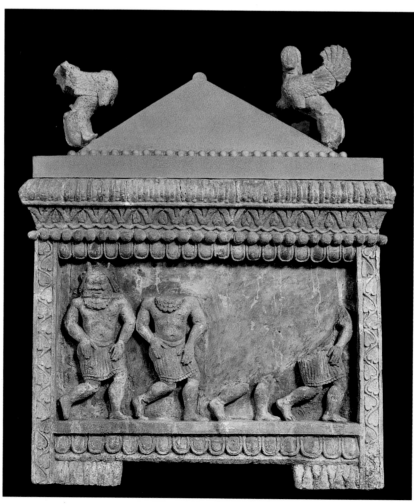

18

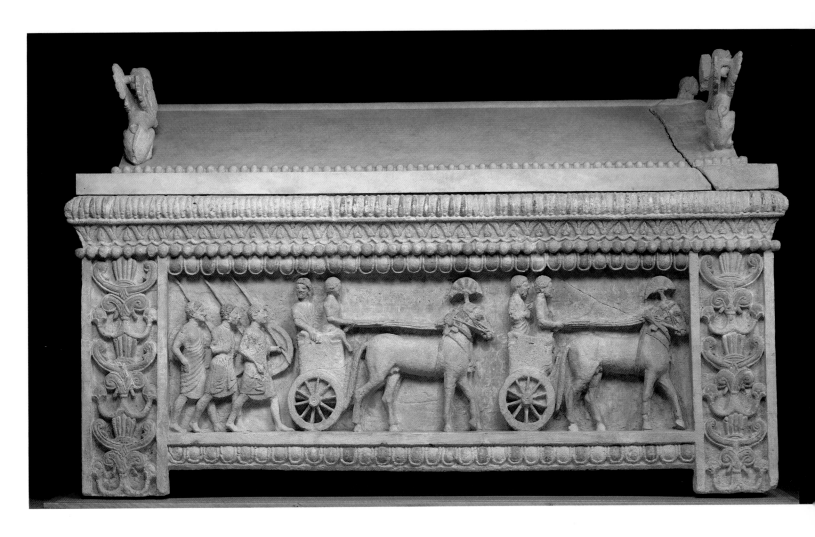

5 *Sarcophagus from Amathus*
Cypriot, 1st quarter of 5th c. B.C.
Limestone; H. 62 in. (1.575 m.),
L. 7 ft. 9⅛ in. (2.366 m.)
The Cesnola Collection, Purchased by
subscription, 1874–76 (74.51.2453)

Page 21: text

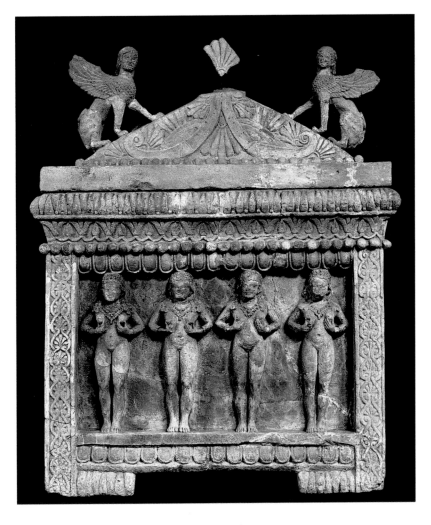

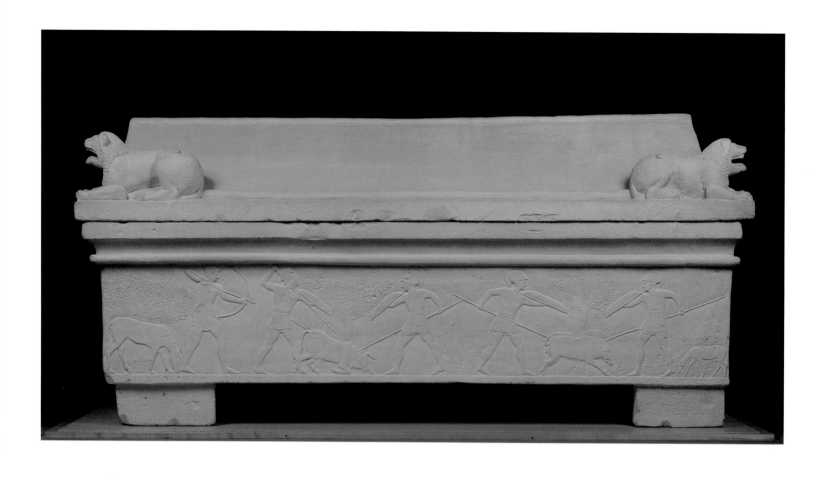

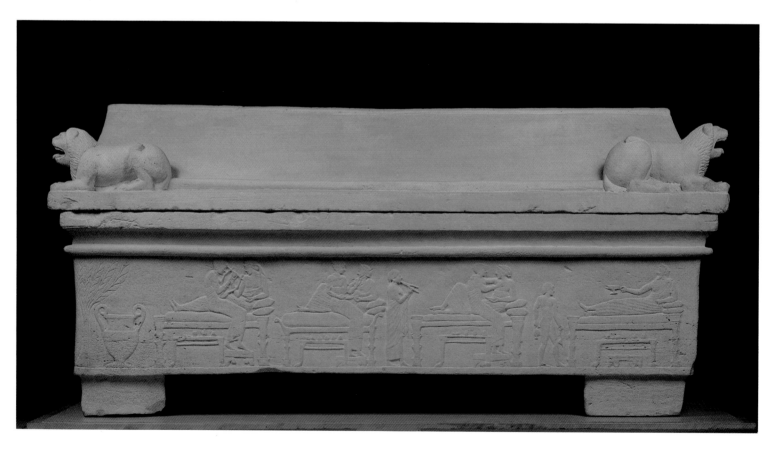

Sarcophagus from Amathus

(Pages 18–19)

The special character of Cypriot sculpture is determined not only by the particular combination of Greek and oriental elements but also by the local limestone, whose soft, grainy texture and brownish tonality contrasts sharply with the marble that was native to the Cycladic Islands and the region of Athens. This imposing coffin derives both its shape and the sphinxes on the cover from the classical world. The procession of chariots on the long sides, however, as well as the figures of the Egyptian god Bes and the fertility goddesses on the ends come from the East. As abundant surviving remains of pigment show, the whole was once painted; the effect would probably have been more colorful than refined.

Sarcophagus from Golgoi

While the scenes on this sarcophagus introduce decorative details foreign to mainland Greek iconography, the figural subjects were common in Greek art during the sixth and fifth centuries B.C. One long side shows a bull and a boar being hunted by an archer, and warriors armed for battle. The other side shows a drinking party, complete with flute player and a large volute krater. The ends depict, respectively, two men in a chariot, and Perseus walking off with his dog and with the head of Medusa, as Chrysaor and Pegasos emerge from her neck. The scenes on the two long sides provide a charming if somewhat simple picture of two pastimes that people enjoyed in real life, and they have, therefore, a vitality that is lacking in the lions on the cover. Lions, though customary as symbolic guardians of the tomb, were animals that this artist probably never saw alive.

6 Sarcophagus from Golgoi
Cypriot, 2nd quarter of 5th c. B.C.
Limestone; H. 38 in. (.965 m.), L. 79½ in. (2.02 m.)
The Cesnola Collection, Purchased by subscription, 1874–76 (74.51.2451)

Below: detail

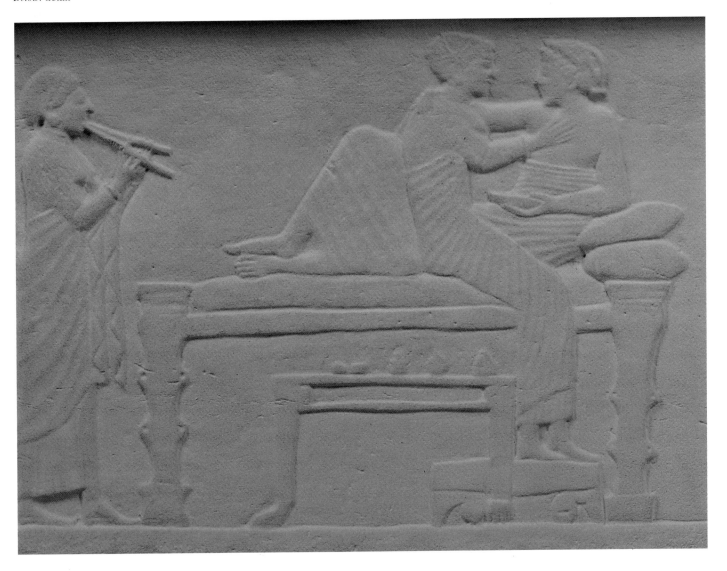

FUNERARY VASE

One of the wonders of Greek art is that it developed so homogeneously over an immensely wide geographical area. While regional styles can be discerned, the similarity among contemporary products of distant centers is at least as remarkable as the differences between them. If there is a region that led all others in creativity, it was Attica, with its chief city, Athens. While not preeminent in all media at all times, between roughly 1000 and 400 B.C. Athens produced works that consistently stand out for their quality and informativeness, especially in sculpture and vase painting.

After a period of artistic dormancy between about 1200 and 1000 B.C. following the downfall of the Minoan and Mycenaean civilizations, a style emerged that is called "Geometric" today because of the basic rectilinear and curvilinear shapes that were used for both figures and ornament. Vases like this one were among the signal achievements of the Geometric period (ca. 1000–700 B.C.). The piece served as a grave marker, and in the handle zone it is decorated with a representation of the deceased lying on a bier surrounded by mourners. In the zone below appear warriors in chariots and on foot, some with their bodies covered by great round or figure-eight-shaped shields. Although none of the forms is naturalistic, who the figures are and what they are doing is clearly indicated. The vase is, therefore, a precious source of information about early Greek funerary ritual.

7 *Funerary Vase*
Attic, 2nd half of 8th c. B.C.
Terracotta; H. 3 ft. 6⅝ in.
(1.082 m.)
Rogers Fund, 1914 (14.130.14)

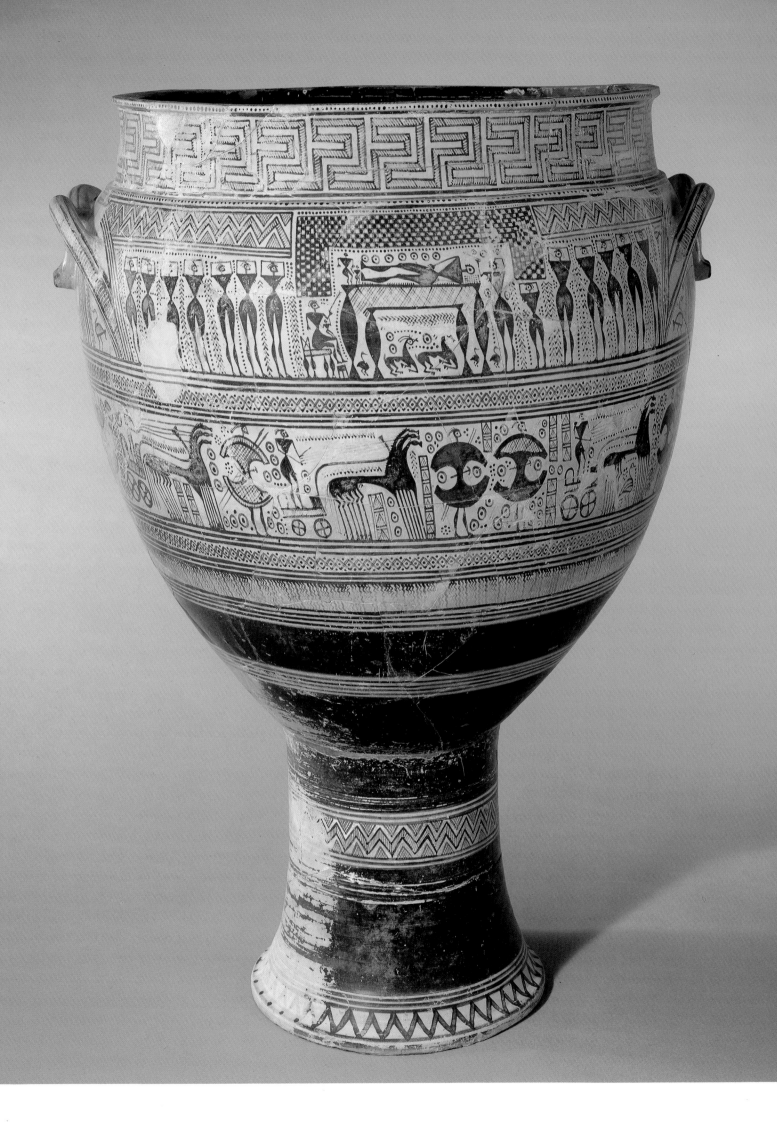

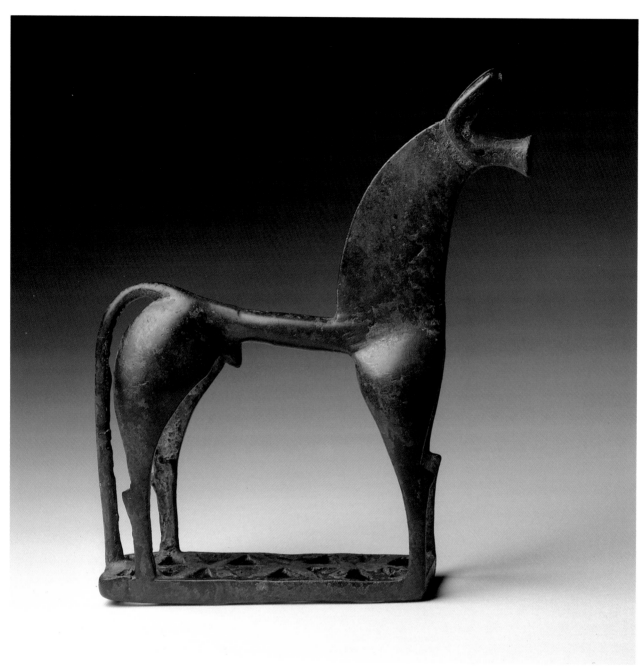

8 Horse
Greek, 3rd quarter of 8th c. B.C.
Bronze; H. 6¹⁵⁄₁₆ in. (17.6 cm.)
Rogers Fund, 1921 (21.88.24)

BRONZE HORSE

The directness of Geometric art is as effective in a three-dimensional piece of sculpture as it is in a two-dimensional painting. Bronzes, often quite small in scale, were produced in workshops throughout the Greek mainland and represent the most innovative sculptural achievements of the period. This horse is thought to have been produced in Corinth. Figures were made as parts of utensils or, when freestanding with their own bases like this one, to be dedicated in a sanctuary. The horse exemplifies Geometric art at its best through the way in which such flat parts as the neck and legs are combined with the cylindrical muzzle and body. The shape and articulation of the base further contribute a sense of volume and give definition to the space occupied by the figure.

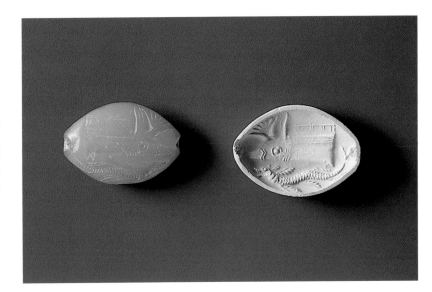

9 *Steatite Intaglio*
Greek, late 7th c. B.C.
Steatite; L. 1¹⁄₁₆ in. (2.7 cm.)
Purchase, Joseph Pulitzer
Bequest, 1942 (42.11.11)

Right: impression

STEATITE GEM AND IVORY PLAQUE

Much Greek art was made on a small scale from precious, exotic materials. The gem, which was probably worn as a pendant or in a ring, served as a seal for purposes of identification or to mark ownership. The ivory plaque, which lacks the head of one figure and arms from both, would have decorated an object such as a chest or casket. In both cases, while the execution and detail are remarkable, the story being told eludes us. Possibly made on the island of Melos, the gem provides one of the first-known depictions of a sea monster. The ladies depicted on the plaque—one half undressed, the other almost completely so—are certainly derived from a myth like that of the daughters of Proitos, king of Argos. While the story exists in several versions, the crux of it is that because the women did not recognize the god Dionysos, they became mad and committed all manner of wild acts, even destroying their own children. They were ultimately healed by the seer Melampus.

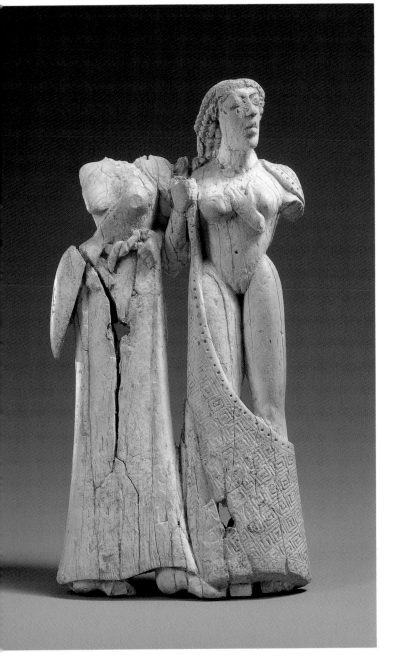

10 *Plaque with Two Women*
Greek, 2nd half of 7th c. B.C.
Ivory; H. 5⅜ in. (13.7 cm.)
Gift of J. Pierpont Morgan,
1917 (17.190.73)

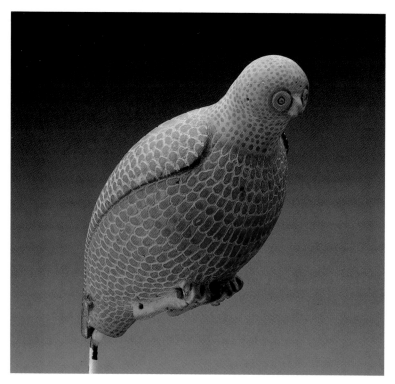

11 Vase in the Form of a Bird
Protocorinthian, mid-7th C. B.C.
Terracotta; L. 6¼ in. (15.8 cm.)
Rogers Fund, 1947 (47.100.2)

12 Aryballos
Protocorinthian, 2nd quarter of 7th C. B.C.
Terracotta; H. 2⁷⁄₁₆ in. (6.2 cm.)
Gift of Edward Robinson, 1918 (18.91)

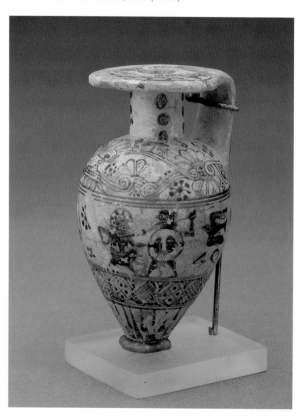

VASE IN THE FORM OF A BIRD AND ARYBALLOS

The basic forms and subjects of Greek art were established during the Geometric period. The succeeding period, known as the Archaic (ca. 700–480 B.C.), saw the gradual emergence of greater realism in the rendering both of individual motifs and of situations. In contrast to the warriors on the funerary vase (Plate 7), those on the aryballos, or oil container, have a more human shape and are engaged in a convincing duel. They are depicted in the black-figure technique that was developed in Corinth. The technique is remarkable for its economy. The decoration was applied in glaze to the surface of a vase after it had dried to a leather-hard consistency. As a result of the firing process, the decoration is black against the unglazed surface that has fired orange. The articulation of detail was achieved by incision with a pointed tool and the addition of red or white clay colors.

While the Greeks developed a repertoire of vase shapes to fulfill many essential functions like drinking, storing, and pouring, they also created more elaborate receptacles in the form of human figures, animals, and objects. The bird, like the aryballos, most likely contained perfumed oil. The artist's figural talents integrated function with the sympathetic representation of the animal.

NECK AMPHORA

The rapid diffusion and acceptance of the black-figure technique together with the introduction of new decorative motifs and subject matter from the Near East—such as palmettes or scenes of animal combat—quickly dissipated the extreme discipline of the Geometric style. For much of the seventh century B.C., especially in the vases of Attica and its environs, there is an exuberance, boldness, and colorfulness that the present amphora, a storage vessel, admirably illustrates. In the main zone, Herakles strides to the left with sword in hand, about to kill the centaur Nessos; Herakles's chariot waits at the right. Two horses graze on the shoulder of the amphora, while on the neck a fearsome lion sinks its teeth into the hindquarters of a deer.

13 Neck Amphora
Attic, 2nd quarter of 7th C. B.C.
Terracotta; H. 42¾ in. (1.085 m.)
Rogers Fund, 1911 (11.210.1)

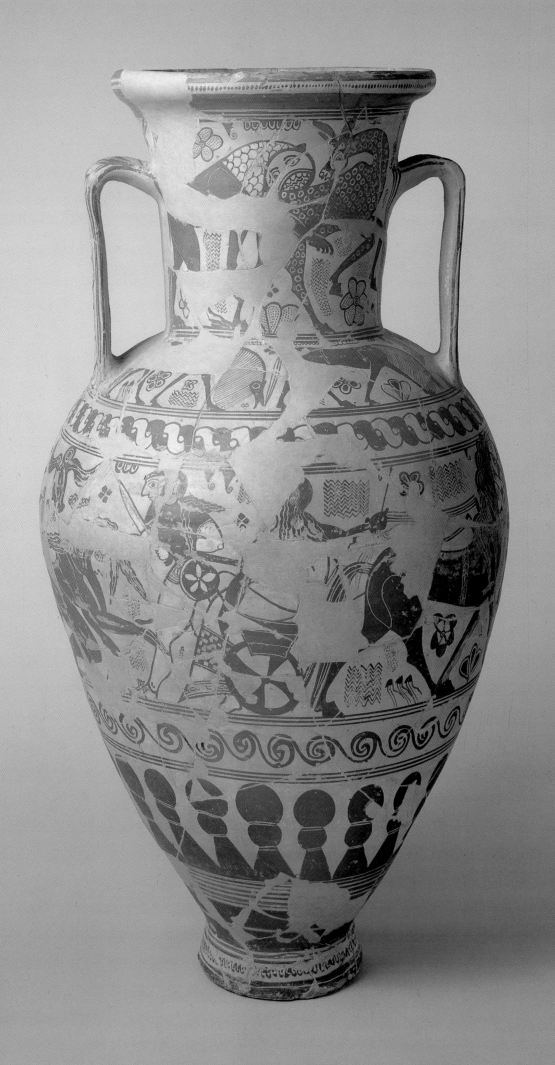

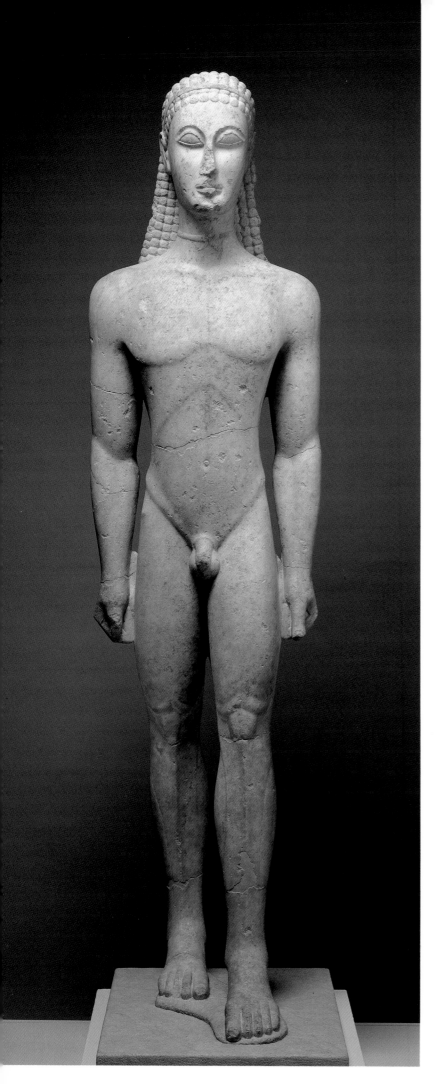

14 Kouros
Attic, ca. 610–600 B.C.
Marble; H. 76 in. (1.93 m.)
Fletcher Fund, 1932 (32.11.1)

Opposite: detail

KOUROS

Marble sculpture reemerged as one of the primary media in Greek art around the middle of the seventh century B.C., evidently in the Cyclades where some of the finest marbles were quarried. A noteworthy feature of many of the earliest works is their large size, which is also shared by contemporary and earlier vases. The types of freestanding statues are few and distinct. One of the most important, the kouros, was that of the nude youth with arms at his side and one foot advanced. In Greek the word *kouros* means a "youth." The great series of examples produced in Attica, of which this is one, documents the artists' progressive mastery of the human body; while the articulation is primarily sculptural, details were also painted, as traces on the figure reveal. A kouros probably served most often as a funerary monument or as a dedication in a sanctuary.

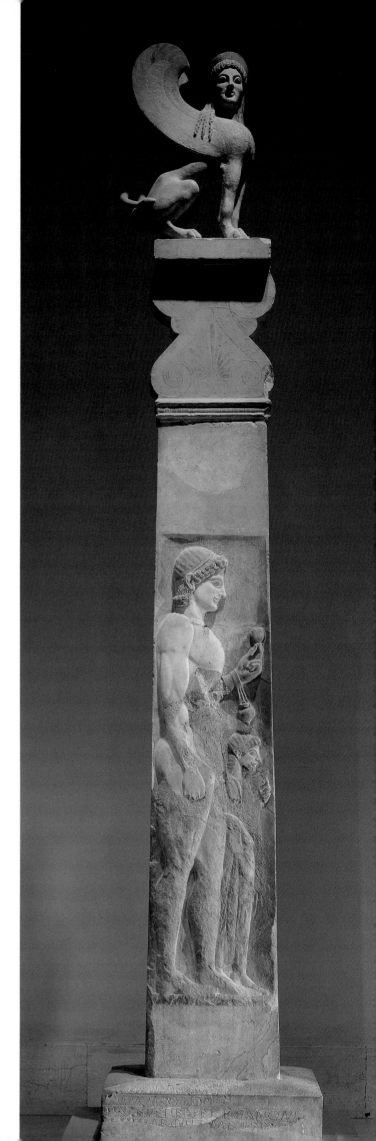

15 *Sphinx*
Attic, 2nd quarter of 6th c. B.C.
Limestone; H. 18½ in. (47 cm.)
Rogers Fund, 1943 (43.11.6)

SPHINX

Incomplete though she is, the sphinx pictured here appears
ready to rise on her haunches and deploy her wings. The
figure originally crowned a funerary monument similar to
the one pictured in Plate 16, which consisted of a base and a
rectangular shaft that might be decorated in relief, painted,
or left plain. Like the sphinxes on the cover of the Amathus
sarcophagus (Plate 5) or the lions on the Golgoi sarcopha-
gus (Plate 6), she was intended to guard the tomb. As remain-
ing details show, the head was originally turned sharply to
the left and the forelegs were straight while the hind legs
assumed a crouching position; she was painted with red
and black.

GRAVE MONUMENT

This exceptionally complete monument was made in three parts joined together with molten lead. A guardian sphinx, carved in the round, is the crowning element. The shaft proper is executed in relief and shows a youth accompanied by a little girl. The plinth in which the shaft is set has a metrical inscription on it telling that the memorial was erected by a father and a mother to their dead son; his name has been reconstructed as Megakles. He is shown with an aryballos and a pomegranate next to his little sister, who smells the flower in her left hand. (Her head, shoulder, and left hand have been restored in plaster from the original fragments, now in the Staatliche Museen, West Berlin.) The nudity of the youth, his advanced left leg, and his wholly dispassionate expression are all qualities of a kouros (see Plate 14), but here the figure is on his way to or from the palaistra, or exercise ground. Such elaborate commissions were restricted to wealthy and noble families who were landowners in the Attic countryside.

16 Grave Monument
Attic, ca. 540 B.C.
Marble; H. 13 ft. 10¹¹⁄₁₆ in.
(4.233 m.)
Frederick C. Hewitt, Rogers, and
Munsey Funds, 1911, 1921, 1936,
and 1938; and Anonymous Gift,
1951 (11.185)

Right: detail

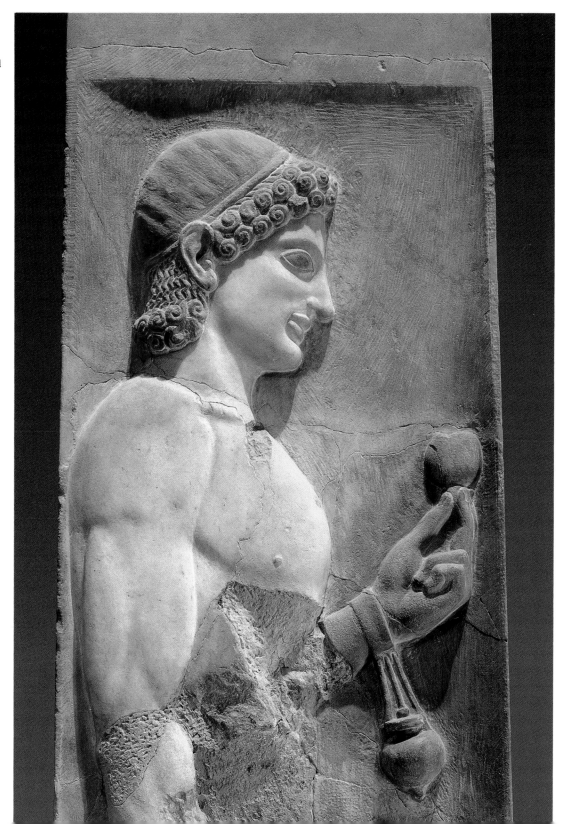

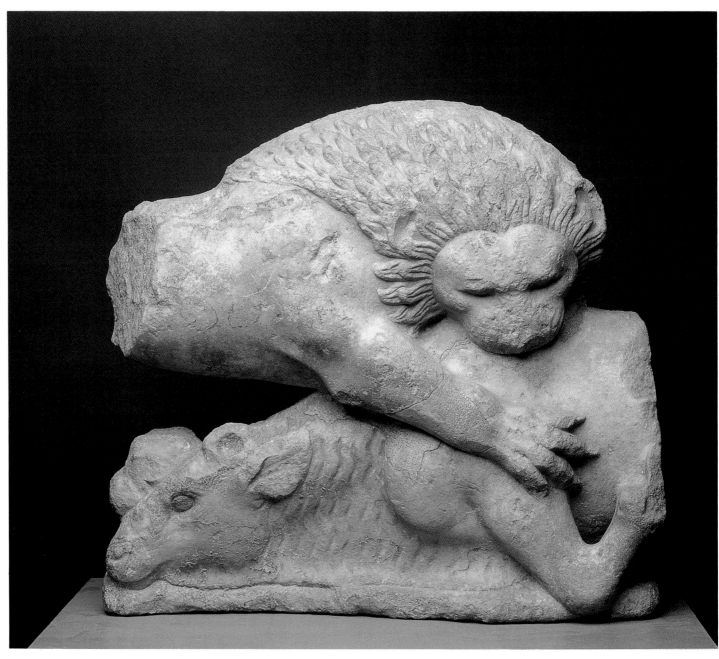

17 Lion Attacking a Bull
Attic, ca. 530–510 B.C.
Marble; H. 24⅛ in. (61.3 cm.)
Rogers Fund, 1942 (42.11.35)

LION ATTACKING A BULL

This portion of a relief, with a lion biting fiercely into the shoulder of a bull, formed part of the pediment of a small building. It is completed by a piece in Athens that gives more of the bull's body and the forepart of a second lion that is a mirror image of the first. The subject is familiar from the neck of the Nessos amphora (Plate 13), and was favored in the sixth century B.C. not only as decoration for vases but also for architectural sculpture, though comparatively little survives. Although the situation is savage, and made all the more immediate by the depth of the relief, the predominant impression is created by the artist's clear and orderly rendering of the lion's mane and of its victim's dewlap and delicate head.

HEAD OF A HORSE

In Archaic art the horse is probably rendered with more care more consistently than any subject aside from the human figure. Not only was it valued for such qualities as beauty and speed, but ownership of a horse was available only to men of means. In Athens, for example, the middle class of citizens were called the "knights," being those who could maintain a horse and fight in battle on horseback. Horse-drawn war chariots, so often depicted in vase painting, did not represent contemporary reality but rather the heroic past described, for instance, by Homer.

This extraordinary piece shows every possible sensitivity to the articulation and texture of the horse's face; at the same time, the mane and forelock are ordered into stylized locks that convey the resilience of horse hair but that would hardly fall so regularly in real life. There are remains of red color within the ears. Based on analogous examples now in the Akropolis Museum, Athens, the head may have been part of a complete statue offered as a dedication.

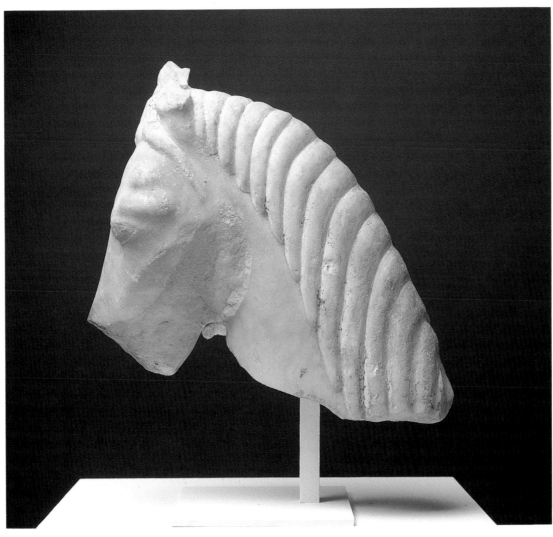

18 Head of a Horse
Attic, 2nd quarter of 6th c. B.C.
Marble, H. 13⅞ in. (35.2 cm.)
Bequest of Walter C. Baker, 1971
(1972.118.106)

LAMP

Marble carving on a small scale is admirably illustrated by this oil lamp with three nozzles, each of which contained a wick. The main panel on each of the three sides shows a pair of facing mythological creatures: sirens, griffins, and sphinxes; on the nozzles appear pairs of lions, of rams' heads, and of birds perched atop lotos flowers growing from palmettes. Archaic lamps of such a fine material and so elaborately decorated are rare, suggesting that they may have been used in a special location, such as a temple. The soft light illuminating the low-relief decoration must have created a most splendid effect.

HEAD OF A GRIFFIN

This griffin originally decorated a large bronze cauldron, a favored form of offering in the Archaic period. The griffin had a separately worked neck that was attached to the shoulder of the vessel, which, in turn, rested on a tripod. A cauldron would have had three or four such heads, either of griffins or lions, whose purpose was as much to inspire respect in the viewer as to embellish the object. Although both the griffin and the cauldron with mythological attachments originated in the Near East, the griffin cauldron was a specifically Greek development and has been found in great numbers at the sanctuary sites of Olympia and Samos.

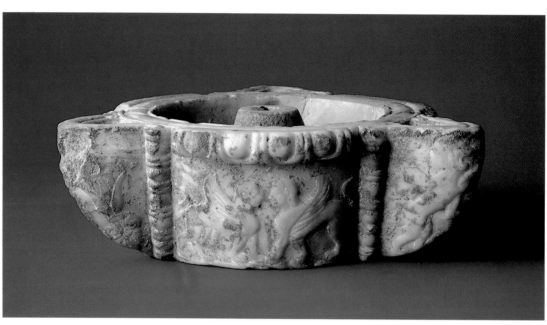

19 Lamp
Greek, 3rd quarter of 6th c. B.C.
Marble; D. 6½ in. (16.5 cm.)
Rogers Fund, 1906, and Lent by Boston
Museum of Fine Arts (06.1072 & L. 1974.44)

Above and below: two sides

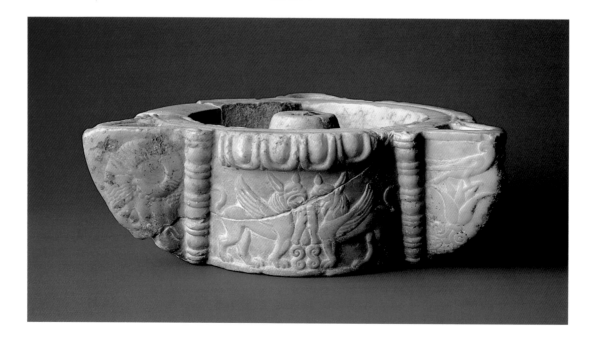

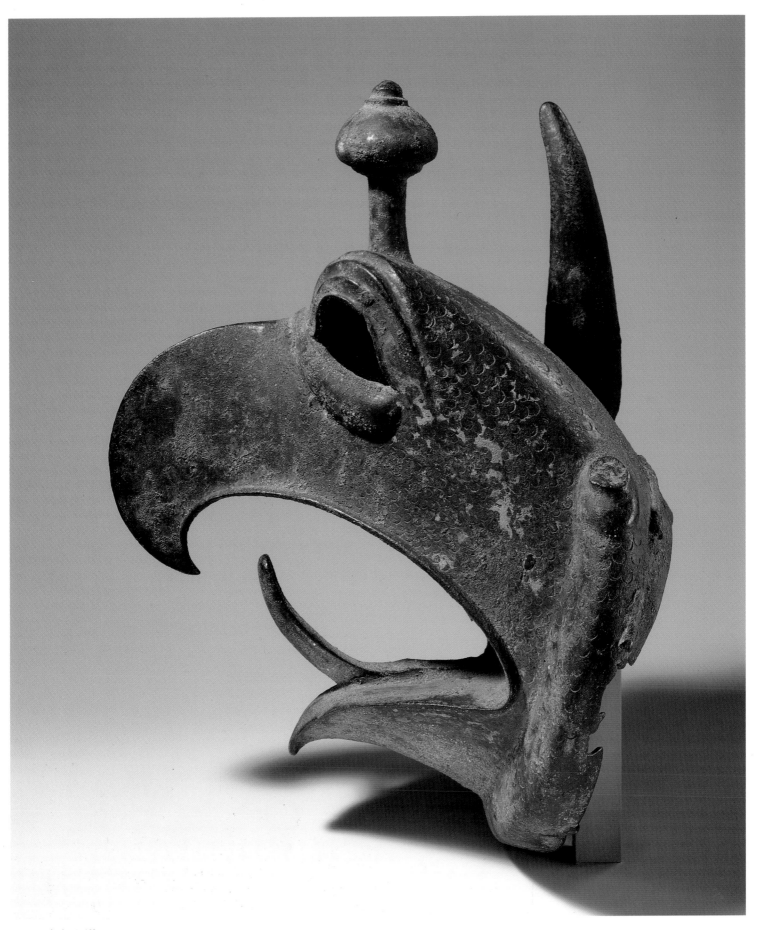

20 Head of a Griffin
Greek, 3rd quarter of 7th c. B.C.
Bronze; H. 10⅛ in. (25.8 cm.)
Bequest of Walter C. Baker, 1971
(1972.118.54)

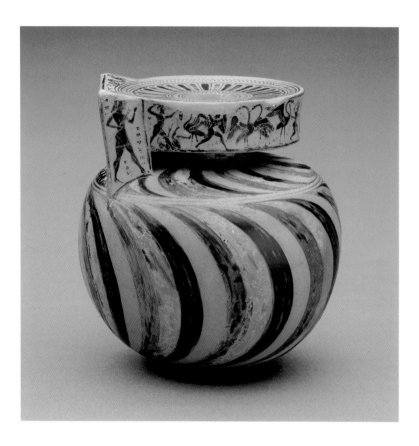

ARYBALLOS SIGNED BY NEARCHOS

During the first quarter of the sixth century B.C., with the period of flamboyant experimentation (represented by works such as that in Plate 13) behind them, Attic black-figure vase painters embarked upon roughly a hundred years of creative achievement. Some artists are known by name. This vase bears the signature of Nearchos, who made it and probably also painted the decoration. The globular body is subdivided into the shoulder, the main zone, and the bottom, each with crescents in red, white, black, and the color of the clay. Around the vertical surface of the lip runs a spirited depiction of the mythological combat between pygmies and cranes. The strap handle shows three satyrs on its main surface, Hermes and Perseus on the sides, and two tritons on top.

21 Aryballos signed by Nearchos as potter
Attic, ca. 570 B.C.
Terracotta; H. 3¹⁄₁₆ in. (7.8 cm.)
Purchase, The Cesnola Collection,
by exchange, 1926 (26.49)

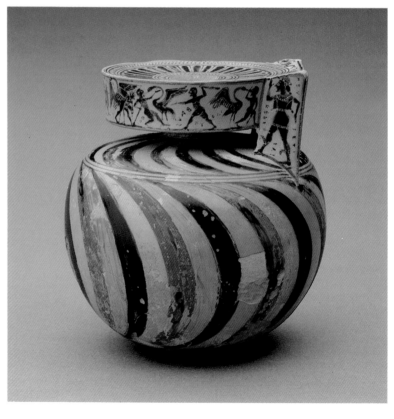

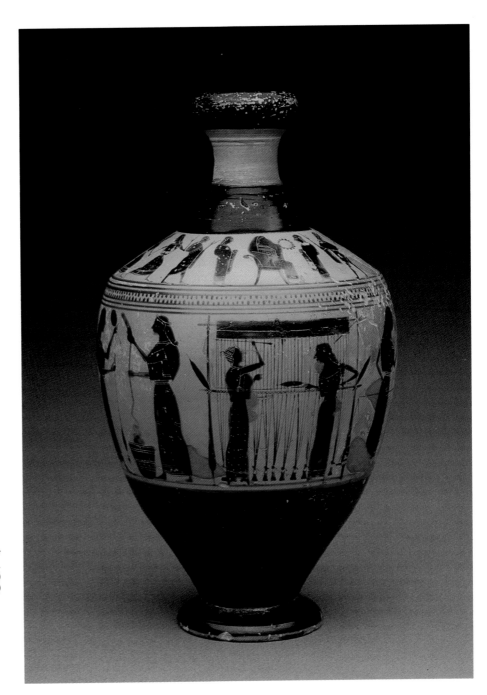

22 *Lekythos attributed to the Amasis Painter*
Attic, ca. 540 B.C.
Terracotta; H. 6¾ in. (17.1 cm.)
Fletcher Fund, 1931 (31.11.10)

LEKYTHOS ATTRIBUTED TO THE AMASIS PAINTER

Greek vases are as rich in depictions of contemporary life as of myth and legend. This lekythos, or oil container, shows women working wool. In the center of the main zone, two are weaving at a vertical loom, while at either side, others are preparing wool to be spun, spinning, weighing balls of wool, and folding finished lengths of cloth. On the shoulder of the lekythos, above the loom, a woman sits in a chair with a shawl covering her head and a wreath in one hand. She may be a bride around whom youths and maidens are gathering. Such scenes probably render quite accurately the appearance and activities of people in Athens during the sixth century B.C. Like Exekias (Plate 24), the Amasis Painter was one of the foremost black-figure artists active during the second half of the sixth century B.C. This lekythos displays the characteristic features of his art: the relatively small scale of the figures, the meticulous precision of the drawing, and the keen observation.

OVERLEAF:

PANATHENAIC PRIZE AMPHORA
SIGNED BY NIKIAS
(Pages 38–39)

Panathenaic prize vases are the best example of a vase shape made to serve an official function. These particular amphorae contained oil from sacred olive groves and were awarded to victors in the Great Panathenaic games held in Athens every four years. They have a standardized capacity (one *metretes*, about 40 liters), shape, and decoration; the obverse always depicts Athena, the patroness of Athens and of the festival, while the reverse illustrates the competition in which the prize was won. In this example, the event is even labeled "men's foot race." The inscriptions on the other side give the official designation of the vase as a prize, as well as the signature of the potter, Nikias, a rare occurrence on vessels of this shape.

23 Panathenaic Prize Amphora signed by Nikias as potter
Attic, ca. 560–555 B.C.
Terracotta; H. 24⅓ in. (61.8 cm.)
Classical Purchase Fund, 1978 (1978.11.13)

Opposite: reverse *Page 37:* text

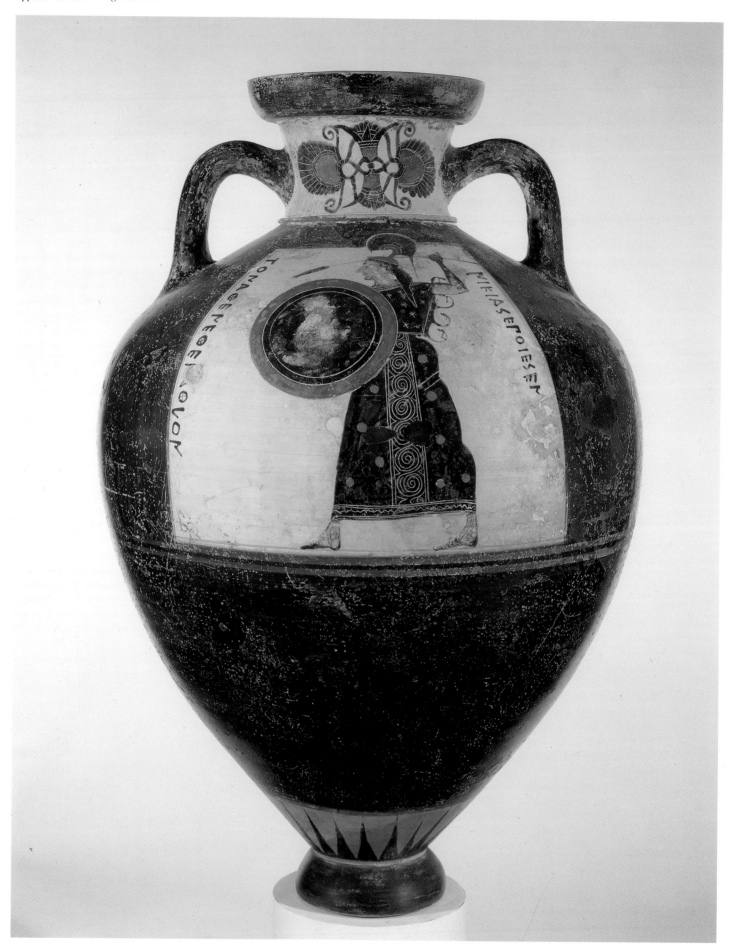

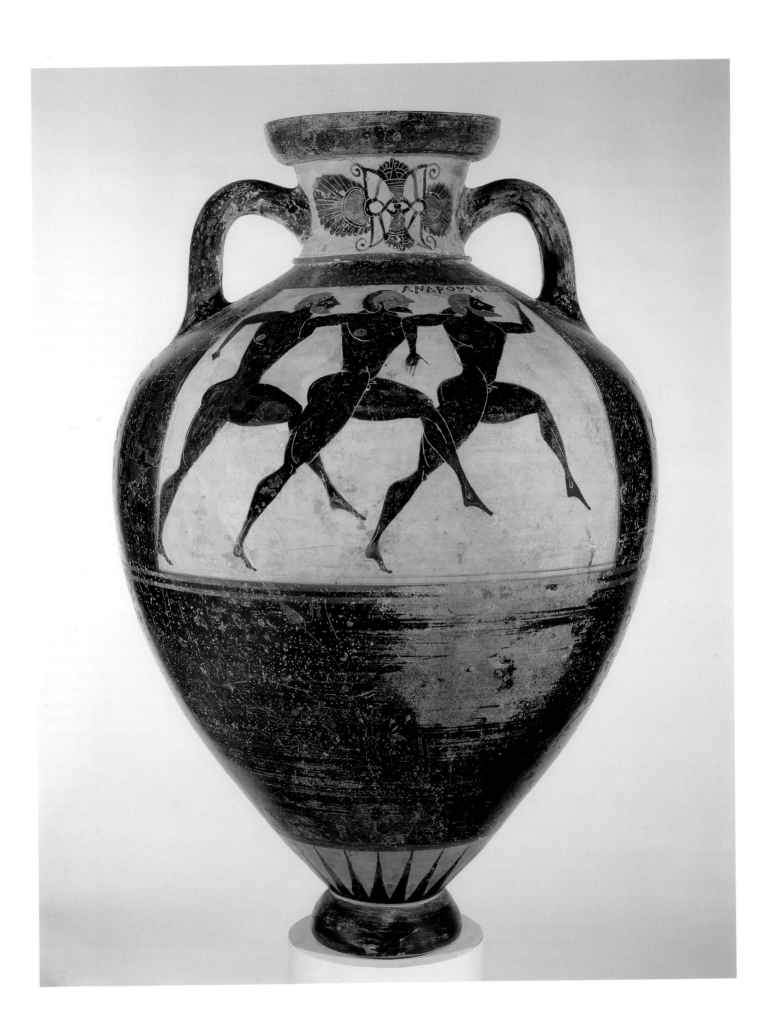

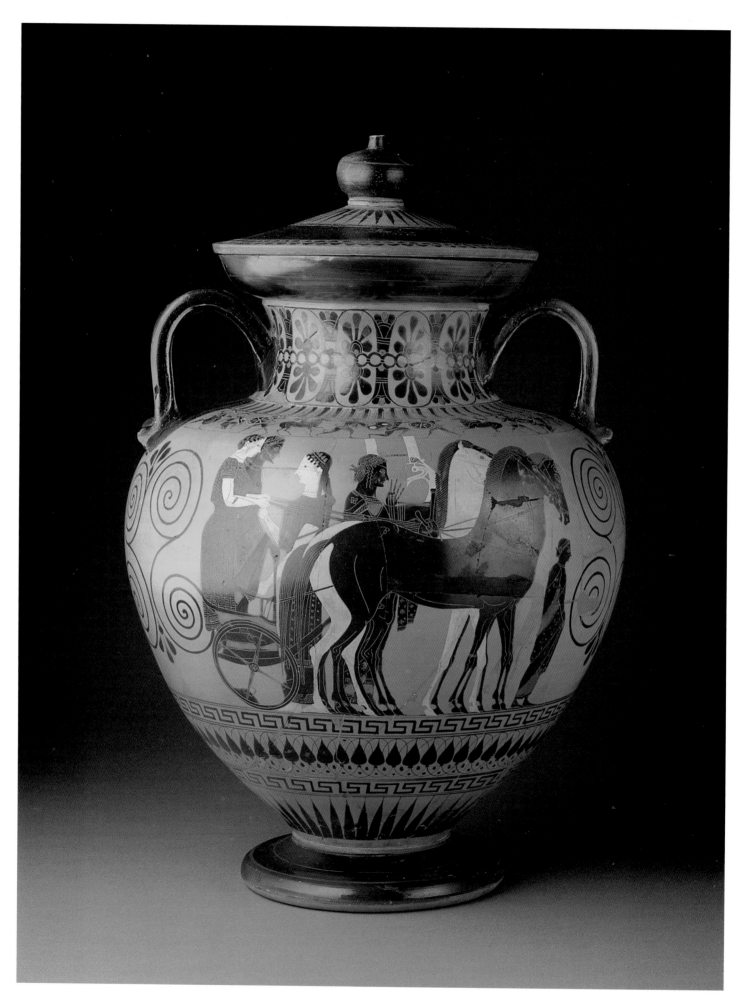

Neck Amphora attributed to Exekias

In addition to being rich sources of information about the ideas, practices, and material goods of the Greeks, most vases are also extraordinary artistic achievements. Exekias, perhaps the greatest of all black-figure artists, has covered virtually the entire surface of this pot with decoration, yet the effect is one of great order, and every motif is appropriate to its particular place. The majestic scene of a wedding chariot setting out occupies the fullest part of the substantial body. The ample shoulder accommodates a subordinate depiction of warriors fighting. The floral and geometric bands on the neck and body emphasize both the measured cadence of the action and the conformation of the pot itself.

24 Neck Amphora attributed to Exekias
Attic, ca. 540 B.C.
Terracotta; H. 22⅛ in. (55.4 cm.)
Rogers Fund, 1917 (17.230.14)

Two Scaraboid Intaglios

Masterly representation of the human body in its structure and in action progressed with remarkable consistency among artists of diverse media. Because male figures were traditionally represented nude, they lent themselves best to such anatomical studies. The youth shown testing his arrow in the scaraboid shown in Plate 25 and the satyr leaning against a wineskin in the scaraboid shown in Plate 26 are as much kinsmen of the musician (Plate 37) as of Ganymede (Plate 38).

While details like hair, musculature, and garment folds remain stylized, all of these figures display the capacity for integrated movement. Moreover, although warriors and satyrs are familiar subjects from vase painting and sculpture, the renderings here introduce the additional factors of difficult scale and material. Each figure seems to fit effortlessly into the available space. The amount of detail and articulation that was achieved with the rudimentary tools that were available is even more impressive. It is understandable that the engraver of the satyr proudly included his name, Anakles. Epimenes is known to us from a gem in Boston that he signed as maker.

25 Scaraboid Intaglio attributed to Epimenes
Greek, ca. 500 B.C.
Chalcedony; L. ⅔ in. (1.7 cm.)
Fletcher Fund, 1931 (31.11.5)

Bottom: impression

26 Scaraboid Intaglio By Anakles
Greek, ca. 480 B.C.
Black jasper; L. ⅝ in. (1.6 cm.)
Purchase, Joseph Pulitzer Bequest,
1942 (42.11.16)

Right: impression

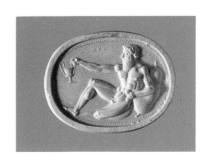

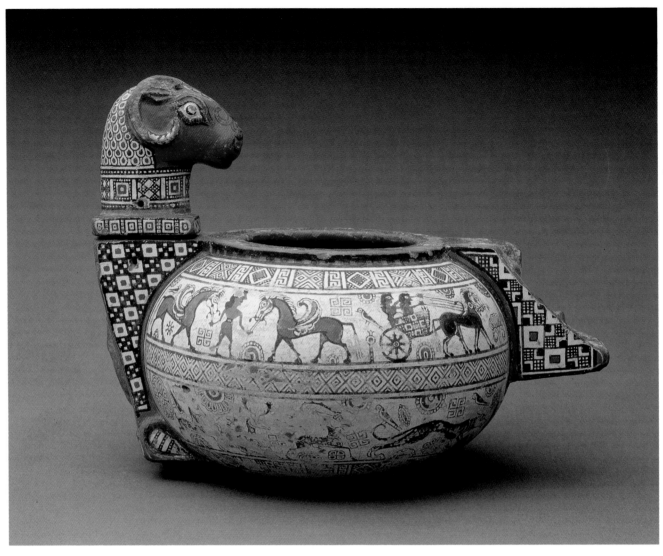

27 Cosmetic Vase
East Greek, late 7th c. B.C.
Terracotta; H. 3⅞ in. (9.8 cm.)
Classical Purchase Fund, 1977
(1977.11.3)

Cosmetic Vase

During the Archaic period, the culture of western Anatolia
was quite distinct from that of mainland Greece. It reveals a
varied and colorful mixture of Greek elements with other
indigenous and Near Eastern ones. The prosperity of the
time is reflected in the luxuriousness of many artistic cre-
ations. On this unique cosmetic vase, the zone showing a
youth with winged horses and a chariot recalls a Corinthian
vase like the one in Plate 12, while the wild goat, coursing
hound, birds, and other motifs in the band below, as well as
the ram's head, resemble features associated particularly with
Rhodes. The diverse square patterns framing the scenes and
decorating the ram's chest and hindquarters find their clos-
est parallels in Anatolia and Phrygia. The ram's head
can be removed and may have held an instrument for ap-
plying the vase's contents. The delicacy of the modeling and
of the painted decoration as well as the precious quality
contributed by the white, rather than orange, surface points
to a contemporary demand for and availability of particu-
larly refined ceramic objects.

UNGUENT FLASK

Greek production of small faience containers was localized in the trading settlement at Naukratis in the Egyptian Delta as well as in other centers, notably on the island of Rhodes. The form of the present work is exceptional in the pairing of a beautiful young woman with a tight-skinned, open-mouthed demon. The head of a lion has as its counterpart that of a youth with somewhat Nubian features and men-

acing teeth. The source of these motifs appears to be more Near Eastern or Levantine than Egyptian. The contents of the vase may have been perfumed oil or another cosmetic. The iconography, however, suggests the possibility of a drug such as opium, which is known to have been used and traded in antiquity.

28 Unguent Flask
East Greek, late 6th–early 5th c. B.C.
Faience; H. 2⅛ in. (5.4 cm.)
Classical Purchase Fund, 1992 (1992.11.59)

29 Necklace with Monkey Pendant and Head
Italic, 7th–5th c. B.C.
Carved amber; Necklace: L. 13⅝ in. (34.5 cm.); Head: H. 2½ in. (6.3 cm.)
Purchase, Renée E. and Robert A. Belfer, Mrs. Patti Cadby
Birch and The Joseph Rosen Foundation, Inc. Gifts, and
Harris Brisbane Dick Fund, 1992 (1992.11.50 and 1992.11.28)

CARVED AMBERS

The use of amber in the classical world was most prevalent on the Italian peninsula. Carved ambers occur in significant quantity and variety from the seventh century B.C. onward and continued to be produced through Roman times. The material itself came predominantly from the rich deposits around the Baltic Sea, thus attesting to far-flung trade connections. In the diverse Italic centers that worked amber, the majority of pieces seem to have been used for making necklaces, pendants, and embellishments for fibulae, the ancient safety pin. Whether these objects were worn in life or destined primarily for the grave, they demonstrate a consummate inventiveness and sensitivity to form as well as mastery of an exceptionally friable substance.

30 *Thunderbolt* and *Five Quails*
Italic, 7th–5th c. B.C.
Carved amber; Thunderbolt: L. 2 in. (5.2 cm.);
Quails: L. ca. ¾ in. (2 cm.)
Purchase, Renée E. and Robert A. Belfer, Mrs. Patti Cadby
Birch and The Joseph Rosen Foundation, Inc. Gifts, and
Harris Brisbane Dick Fund, 1992 (1992.11.22 and 1992.11.29)

31 *Hippocamp* and *Three Rams' Heads*
Italic, 7th–5th c. B.C.
Carved amber; Hippocamp: L. 2⅛ in. (5.4 cm.);
Rams' heads: L. ca. 1 in. (2.5 cm.)
Purchase, Renée E. and Robert A. Belfer, Mrs. Patti Cadby
Birch and The Joseph Rosen Foundation, Inc. Gifts, and
Harris Brisbane Dick Fund, 1992 (1992.11.23 and 1992.11.18)

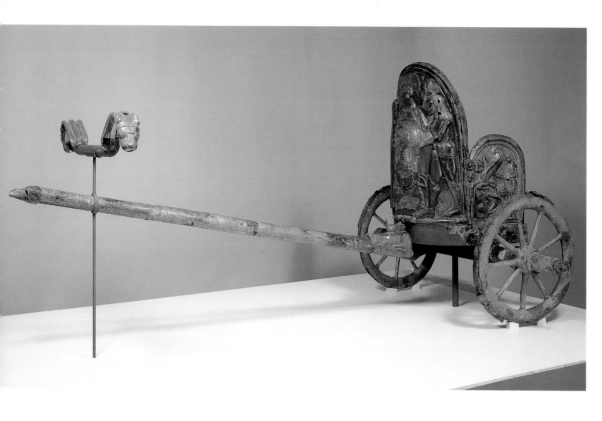

32 *Chariot*
Etruscan, 3rd quarter of 6th c. B.C.
Bronze; H. 51½ in. (1.309 m.)
Rogers Fund, 1903 (03.23.1)

Below and opposite: details

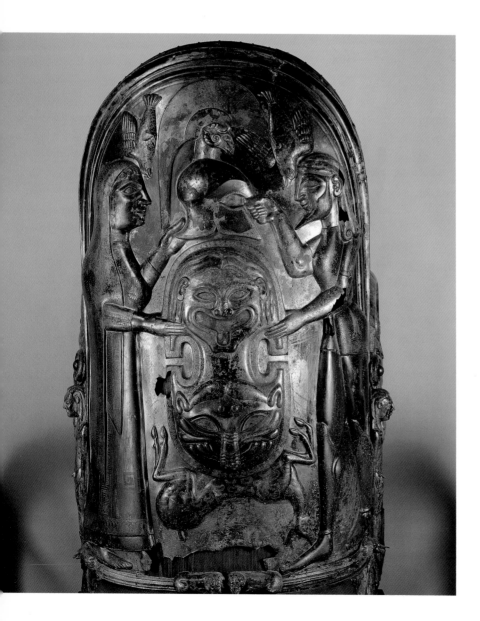

Etruscan Chariot

The Etruscans inhabited northern and central Italy from the Po River southward and westward as far as Rome. The apogee of their culture may be dated between the seventh and fifth centuries B.C. The fertility of the land and the important deposits of metal ores in the Appenines, as well as on the islands of Elba and Corsica, assured the Etruscans considerable prosperity.

The availability of ores also contributed to the excellence of Etruscan metalwork, particularly in bronze but also in precious metals. The character of Etruscan art is determined very much by the interrelation of indigenous Italic features with Greek influence coming from both the Greek colonies in Italy and imports from mainland Greece itself (notably terracotta vases). The surviving ceramics, tomb paintings, and metalwork are stylistic hybrids, much as those from Eastern Greece. During the fifth century B.C. Rome began to push its expansion northward into Etruscan territory, a process that continued until the peninsula had been subjugated. This development, along with the incursion of the Gauls, disrupted the general stability that had existed during the Archaic period and left its mark as well on contemporary artistic production (see Plate 64).

The bronze chariot was found in a tomb at Monteleone near Spoleto in central Italy; it need not actually have been driven. The scenes decorating the chariot box derive from Greek mythology; they may possibly represent Thetis bringing armor to Achilles on the central panel, Achilles fighting Memnon to the left of it, and the apotheosis of Achilles to the right. While the iconographical source is recognizable, the inflated appearance of the figures and details like the predilection for winged creatures are distinctly Etruscan.

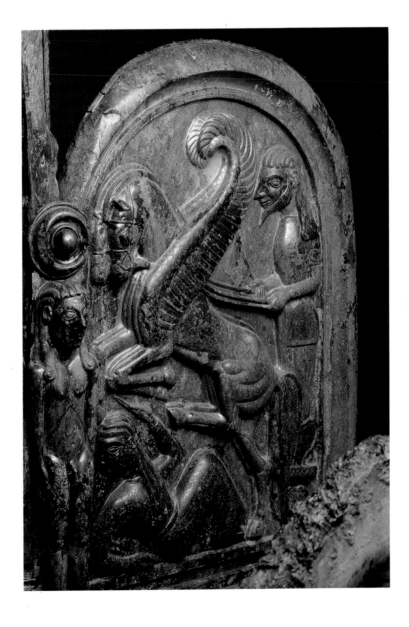

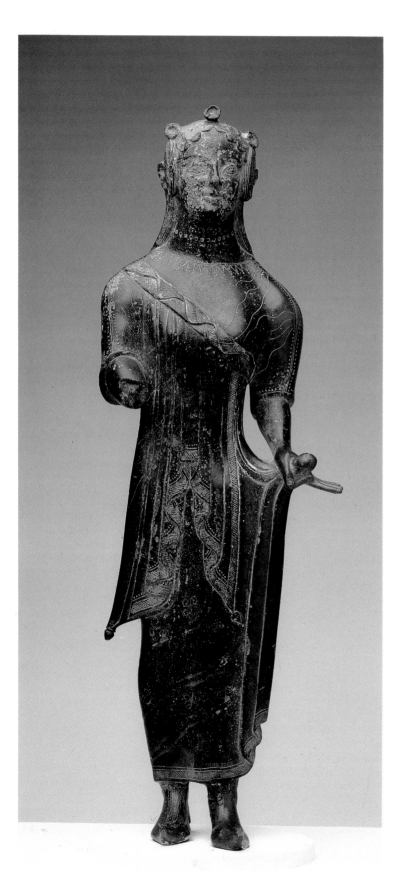

STANDING MAIDEN

This young Etruscan lady is shown elaborately dressed in a finely crinkled undergarment with a heavier overgarment draped diagonally across her chest. She also wears pointed shoes, a fillet with three rosettes on her head, earrings, and a necklace. She gathers part of her dress with her left hand, while her right arm would have been extended and probably bent up at the elbow. Her pose and her two garments find many parallels in contemporary Greek works, and like her Greek counterparts, she would have been offered as a dedication in a sanctuary. Such features as shoes and the considerable use of incised rather than modeled articulation are thoroughly Etruscan.

33 Standing Maiden
Etruscan, last quarter of 6th c. B.C.
Bronze; H. 11⁹⁄₁₆ in. (29.4 cm.)
Gift of J. Pierpont Morgan, 1917
(17.190.2066)

STANDING YOUTH

Juxtaposed with the Etruscan lady, this youth demonstrates the features that distinguish the best late Archaic Greek works. Although the lady is beautifully and carefully represented, she does not give the sense of a three-dimensional body, nor do the texture and fall of her garments come across as credible. The youth, by contrast, was made with the clear intention to render the structure of the body, as well as the respective consistencies of bone, muscle, and flesh, and the wholly different quality of the hair. The Etruscan artist has created a stylized composition while his Greek counterpart renders something he has seen.

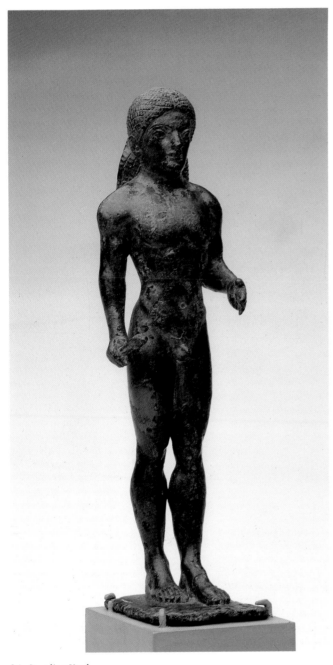

34 Standing Youth
Greek, 3rd quarter of 6th c. B.C.
Bronze; H. 6 in. (15.2 cm.)
Bequest of Walter C. Baker, 1971
(1972. 118.101)

O V E R L E A F :

AMPHORA SIGNED BY ANDOKIDES AS POTTER
(Pages 50–51)

In Attic vase painting, the striving for ever more expressive renderings of figures and situations led to the emergence, in about 530 B.C., of the red-figure technique. The subjects were now drawn with glaze lines, allowing both contours and internal articulation to be executed with far greater fluency; thus, the figures have the color of the clay ground while the surrounding area, or background, is black. On this vase, the old black-figure technique was used on the lip, modified by the addition of a white ground to the surface of the vase.

The amphora was made in the workshop of Andokides, who was probably responsible for establishing the new technique. His signature appears on the foot. The decoration on the front of the vase shows Herakles who, in connection with his expiation for the murder of Iphitos, son of Eurytos of Oichalia, went to Delphi to seek an oracle from Apollo. When the priestess refused to grant him an oracle, he took away the sacred tripod in order to establish his own oracle. He thus became involved with the god Apollo in a tug-of-war over the sanctuary's sacred tripod. Herakles is assisted by his protectress Athena, Apollo by his sister Artemis. The reverse of the vase depicts Dionysos between a dancing satyr and a maenad playing the *krotala* (castanets). On the lip, Herakles wrestles the invulnerable Nemean lion, the first of the hero's labors.

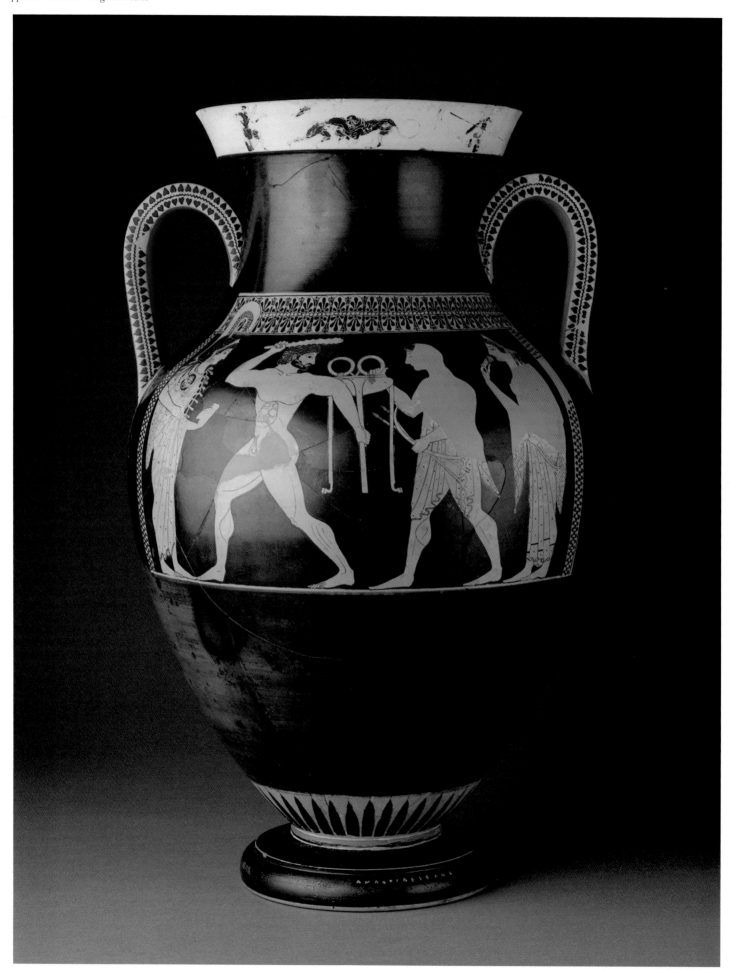

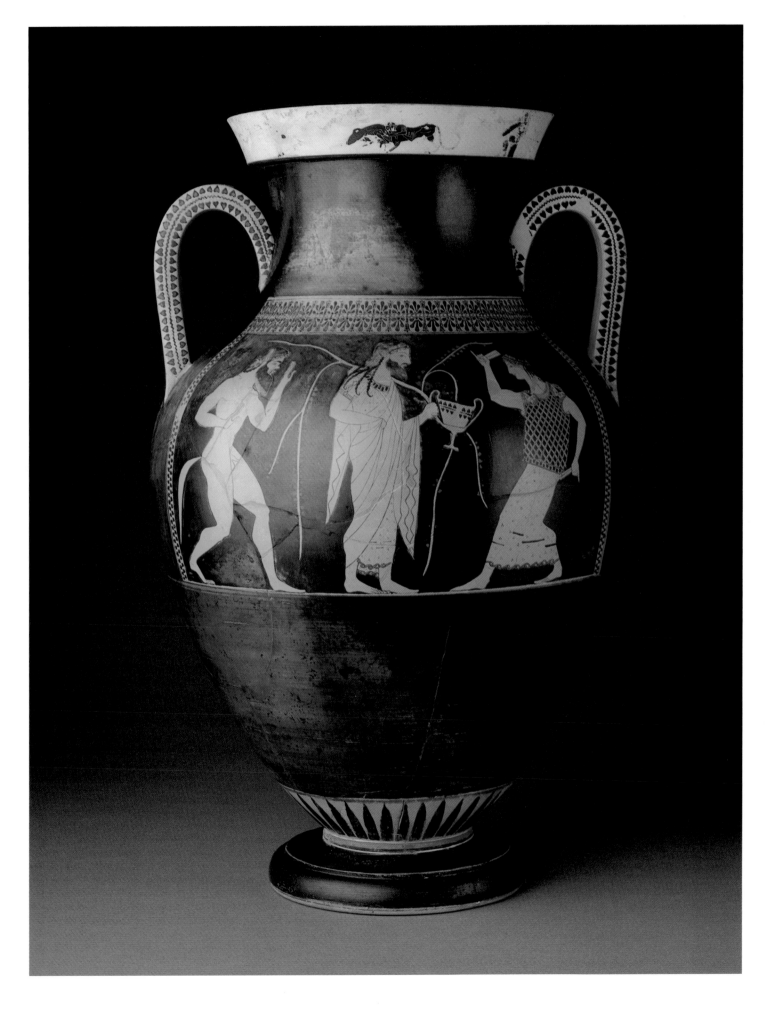

CALYX KRATER BY EUPHRONIOS AND EUXITHEOS

The new red-figure technique was quickly adopted by Athenian artists of the late sixth century B.C. and its potential richly demonstrated by a group of painters among whom Euphronios was probably the most prominent. Attic pottery never was, nor would be, rich in color, but as this vase admirably illustrates, the painter's glaze could be applied so as to produce effects as varied as the dilute tone of the fallen hero's hair, the meticulous scales of the wings of Sleep and Death, and the wiry outline of a muscular arm.

Euphronios illustrates an episode of the Trojan War on this vase, which would have held the wine mixed with water that was drunk at a symposium, or drinking party. The scene shows Sarpedon, a son of Zeus and leader of the Lycian allies of the Trojans, just after his death at the hand of Achilles' friend Patroklos. Under the direction of Hermes, the messenger of the gods, Sleep and Death are lifting the hero and are about to convey him to his native land for burial.

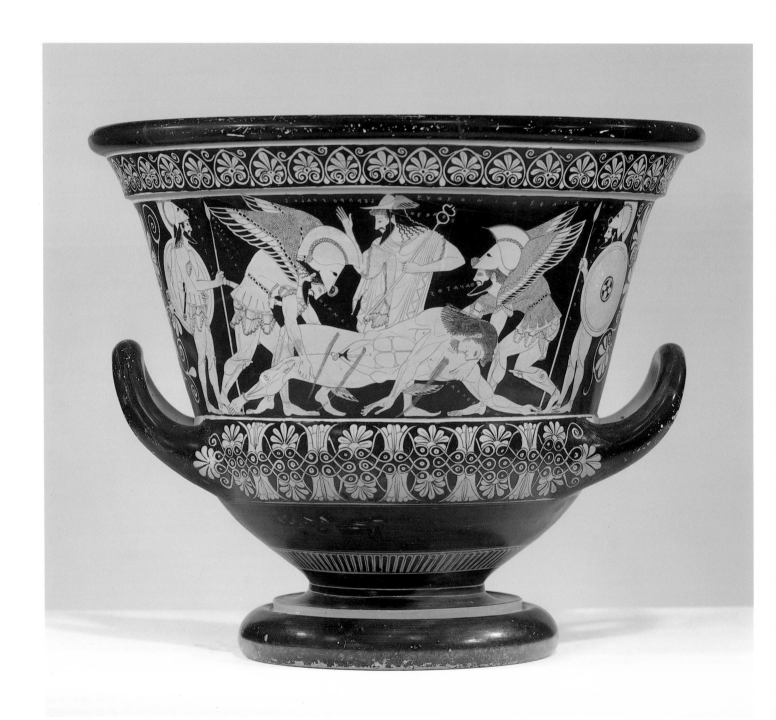

36 Calyx Krater by Euphronios and Euxitheos
Attic, ca. 515 B.C.
Terracotta; 18 in. (45.7 cm.)
Purchase, Bequest of Joseph H. Durkee,
Gift of Darius Ogden Mills and Gift of
C. Ruxton Love, by exchange, 1972 (1972.11.10)

Opposite: detail

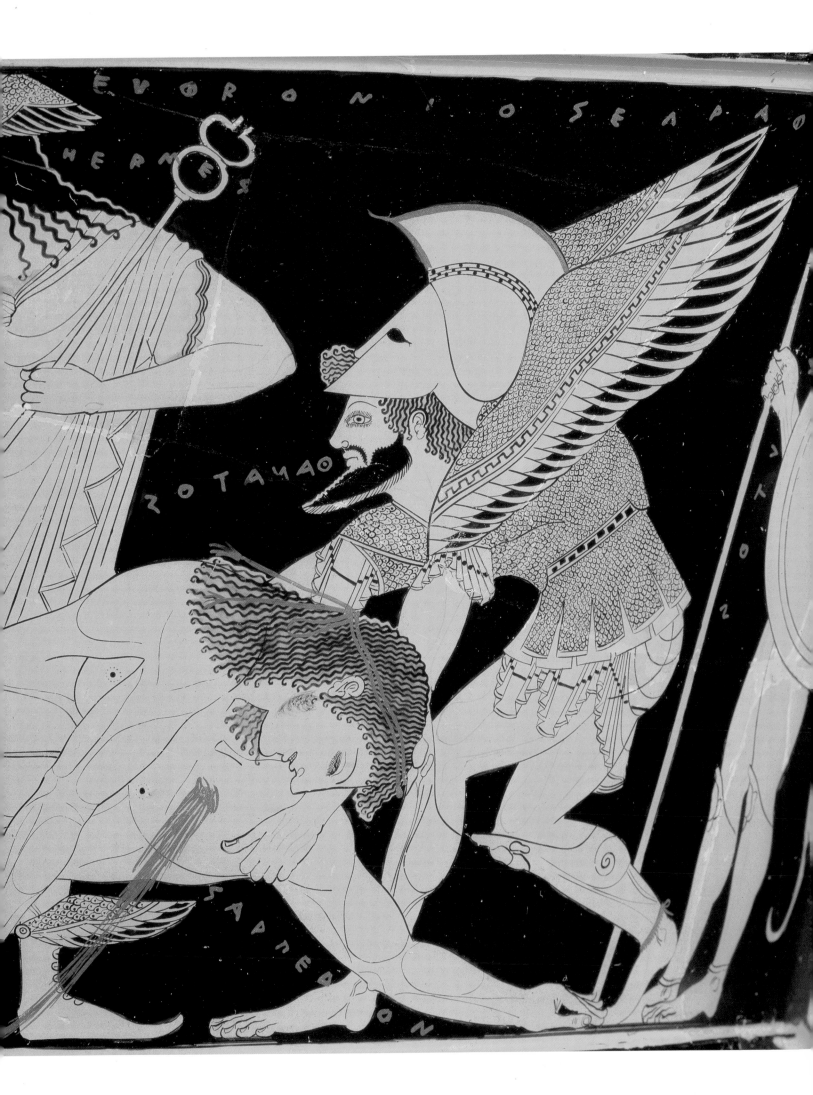

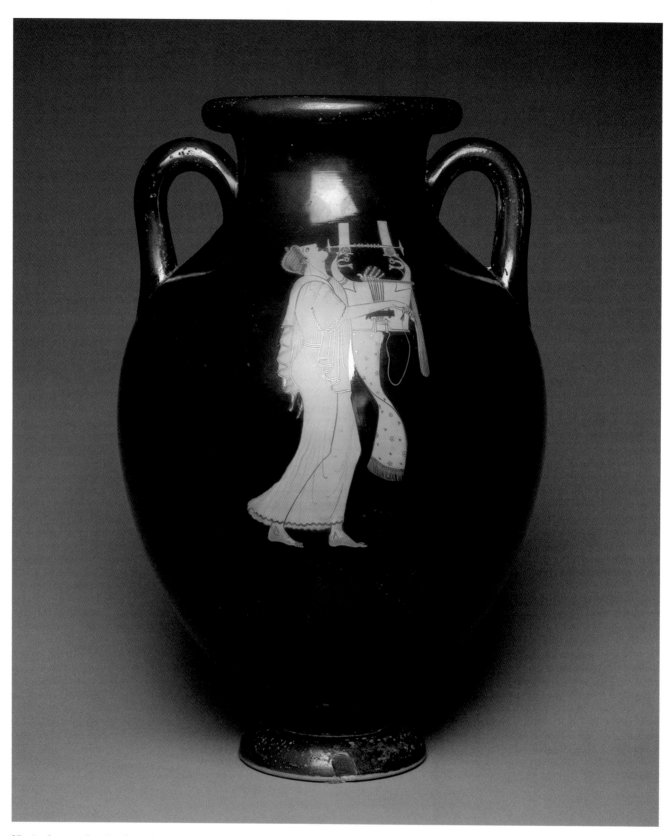

37 Amphora attributed to the Berlin Painter
Attic, ca. 490 B.C.
Terracotta; H. 16⅜ in. (41.5 cm.)
Fletcher Fund, 1956 (56.171.38)

Opposite: reverse

AMPHORA ATTRIBUTED TO THE BERLIN PAINTER

The symbiosis between vase shape and decoration is extraordinarily displayed in this amphora attributed to the Berlin Painter. The subject on the obverse is a young man singing and accompanying himself on the kithara, a variety of lyre used especially in performance. He wears the long belted robe characteristic, for instance, of musicians and charioteers, with the addition of a short cloak. The cloth hanging from his instrument is decorative, but by its gentle movement, it also conveys the effect of the music. On the reverse, a judge—identifiable by the wand in his left hand—listens intently and extends his right arm toward the young musician. The immediacy of the figures is heightened by their placement over the fullest curvature of the vase and by the perfect consistency and sheen of the black glaze.

Oinochoe attributed to the Pan Painter

Ganymede was a Trojan prince whose beauty caused Zeus to carry him off to serve as his cup-bearer on Mt. Olympos. The choice of Ganymede to decorate this vase shape is particularly appropriate since oinochoai were used for pouring wine. The depiction of the boy here as running forward but looking back implies the proximity of his pursuer. The hoop and stick in his right hand emphasize his young age while the cock in his left hand was a favored pet of youths who often engaged in cockfights; it may also have been a gift from Zeus. As so often in Greek art, no visible attributes distinguish an Athenian youth from a Trojan prince, or an immortal cup-bearer.

38 Oinochoe attributed to the Pan Painter
Attic, ca. 470 B.C.
Terracotta; H. 6½ in. (16.5 cm.)
Rogers Fund, 1923 (23.160.55)

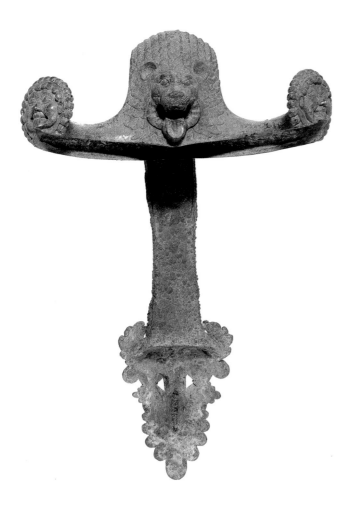
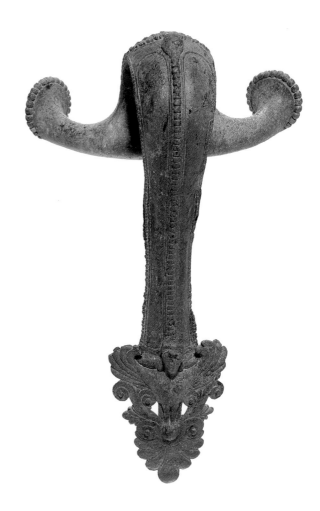

39 Vertical Handle from a Hydria
Greek, mid–5th c. B.C.
Bronze; H. 11¼ in. (28.5 cm.)
Gift of Christos G. Bastis, 1993 (1993.133)

VERTICAL HANDLE FROM A HYDRIA

The hydria was a type of vase originally intended for the transport of water; the vertical handle at the back facilitated pouring, while a pair of horizontal handles at the sides were for lifting. Other known uses for this versatile shape included that of ballot box and funerary urn. From the sixth into the fourth century B.C., bronze hydriai of extraordinary artistic accomplishment were produced throughout the Greek world. The neck and body of the vase were usually hammered and, owing to the thinness of the metal, have often disintegrated. The handles, by contrast, were cast solid. The present example shows extraordinary articulation of the lion's mane and of the siren's body below.

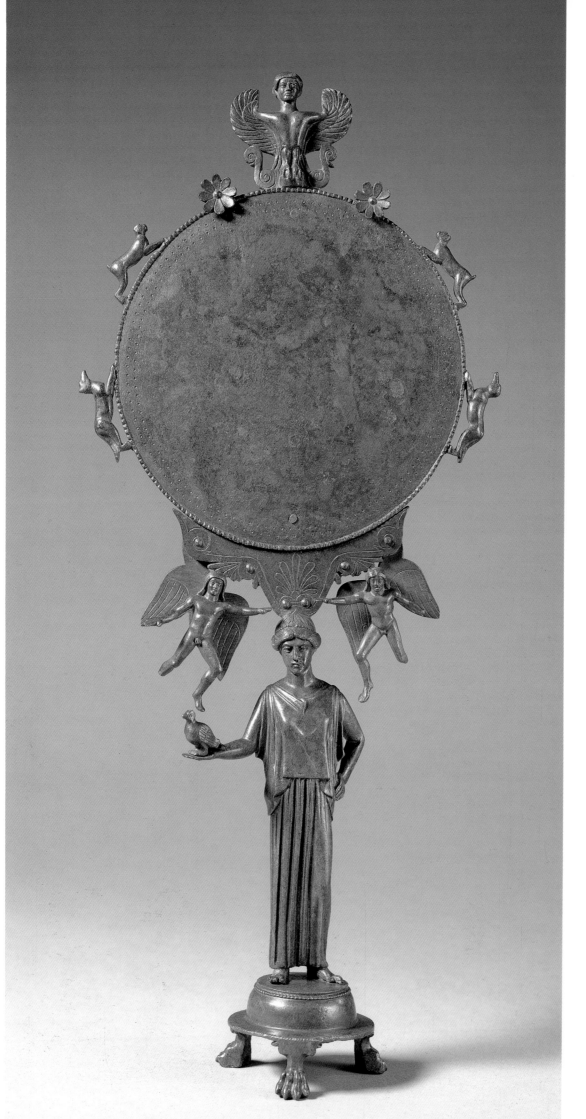

40 Mirror
Greek, mid-5th c. B.C.
Bronze; H. 16⅛ (40.4 cm.)
Bequest of Walter C. Baker,
1971 (1972.118.78)

Mirror

The Persian Wars (490–479 B.C.) mark a watershed in Greek history, for they saved Greece from Persian domination and, for a short time, brought together the individual states against a common enemy. While a multitude of factors were responsible for the new introspectiveness and equilibrium that characterize the art of the Classic period (480–323 B.C.), the preservation of their country and culture had a profound effect on Greek artists.

This splendid mirror exemplifies the ordered richness and serenity of the new style at its best. It consists of a base, supported by three lion's paws, on which stands a woman who has her left arm akimbo and holds a bird on her extended right hand. The transition to the mirror disk itself is accomplished by a support ornamented with engraved palmettes and embellished at either side by two airborne Erotes (their wings are modern). The edge of the disk shows a guilloche pattern and beading, while along the circumference two hounds pursue two hares, and two rosettes flank a frontal siren. The disparity of the ingredients is not obvious because they are disposed symmetrically and because they remain subordinate to the supporting figure. Her pose, which is quiet without being stiff, and her self-contained expression, emphasized by the slightly bent head, give a sense of measure that is carried through the rest of the composition.

Kylix attributed to the Villa Giulia Painter

The interior of this kylix, or drinking cup, was covered with a white slip that gives even greater resonance to the painter's exquisite use of line and color than does the usual orange background. The addition of a thin layer of a special, very fine white clay to the surface of a vase was practiced in Athens—as well as other regions like Laconia—from the late seventh century B.C. on. It occurs with some frequency on late Archaic vases (see Plate 35) and enjoyed a period of particular favor from the second quarter to the end of the fifth century B.C.

The scene on the cup shows a woman, identifiable as a goddess by her scepter, who pours a libation from the phiale in her right hand at an altar. The jewelry that she wears, the fillet in her hair, the ends of her scepter, and her libation bowl would originally have been gilded. Like other cups of high quality with representations of deities on a white ground, this piece may have been specially commissioned for dedication at a sanctuary.

41 Kylix attributed to the Villa Giulia Painter
Attic, ca. 470 B.C.
Terracotta; W. (including handles)
8½ in. (21.67 cm.)
Classical Purchase, Fletcher and Rogers
Funds, 1979 (1979.11.15)

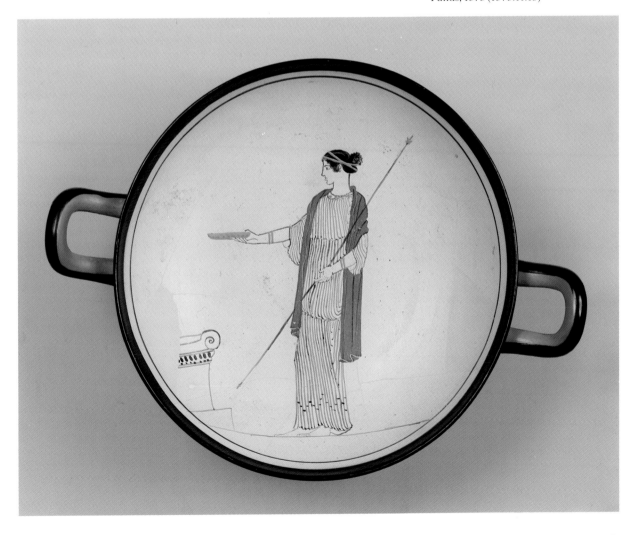

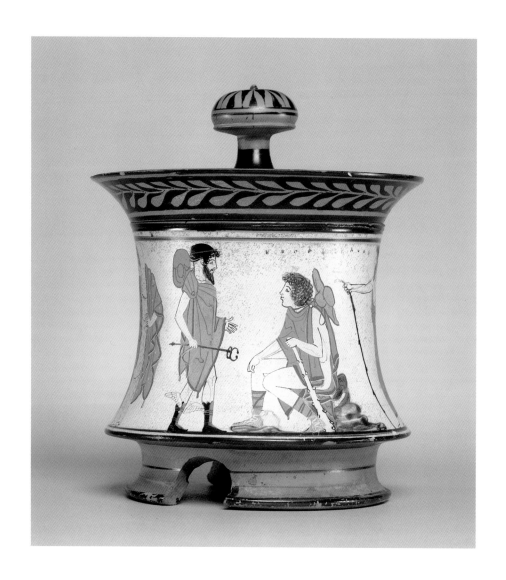

Pyxis attributed to the Penthesilea Painter

A pyxis served as a container for cosmetics, toilet articles, jewelry, and other items of feminine embellishment. The subject that decorates its circumference is the Judgment of Paris, an appropriate story for such a vase. Paris was tending his flocks on Mount Ida when called upon to decide which of three goddesses was the fairest. He appears, here, seated on a rock wearing sandals and gaiters, a short cloak, and sun hat. Hermes presents the three goddesses: Hera with a scepter and magnificent attire, even to the veil over her head; Athena carrying her spear and helmet; and Aphrodite, Paris's ultimate choice, who holds a phiale and seems to be conferring with her companion, Eros, the personification of love.

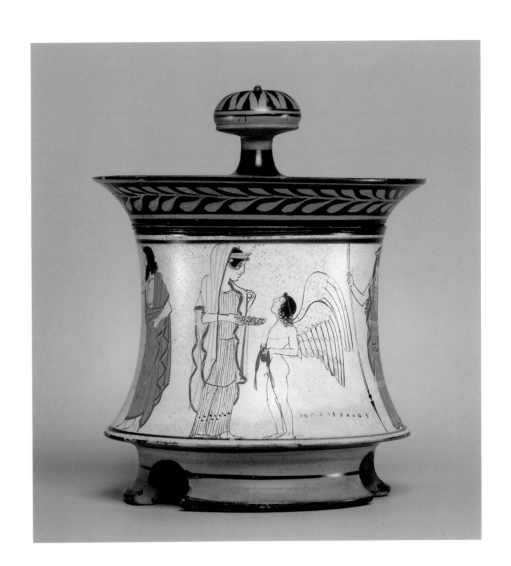

42 Pyxis attributed to the Penthesilea Painter
Attic, ca. 460 B.C.
Terracotta; H. 6¾ in. (17.2 cm.)
Rogers Fund, 1907 (07.286.36)

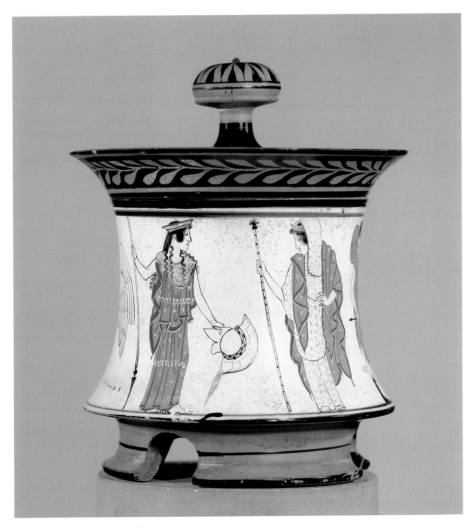

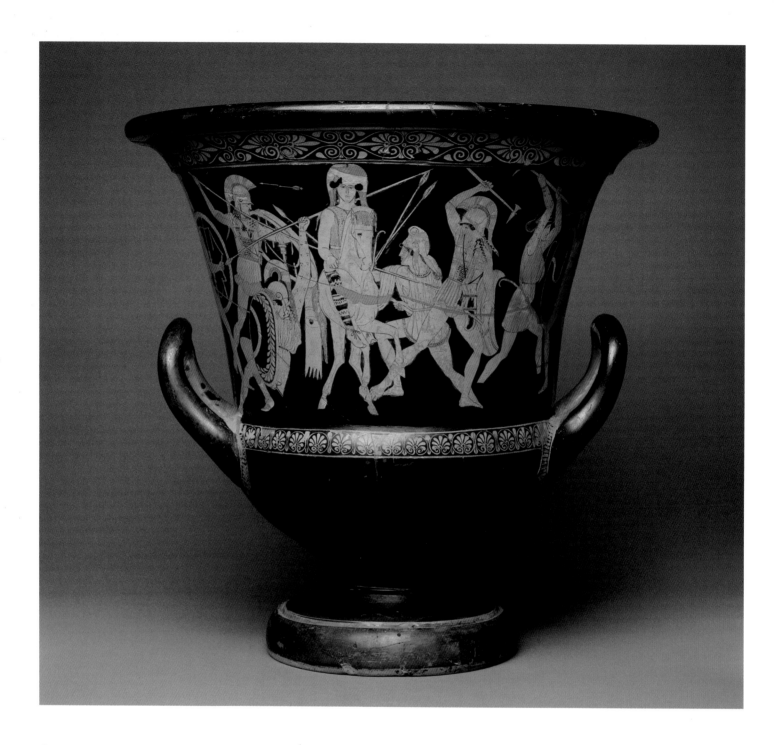

CALYX KRATER ATTRIBUTED TO THE PAINTER OF THE BERLIN HYDRIA

During the mid-fifth century B.C., Attic vase painters produced large pots with complex narrative scenes as well as small, delicate works. Influenced by contemporary monumental wall painting—of which only literary accounts survive—artists experimented with compositions that included overlapping figures on staggered ground levels, foreshortening, and strenuous movement. The battle between the Athenians and the Amazons, a mythical race of warrior women, found great favor in the decades after the Persian Wars both because of their reference to the Persian defeat and because of the virtuoso artistic effects they prompted.

WOUNDED WARRIOR

The unstable pose of the warrior wounded under the right armpit bears comparison with those on the calyx krater (Plate 43). But the achievement in sculpture is even more remarkable because it required that a figure represented over-life-size and leaning backward nonetheless stand perfectly solidly. The original work was in bronze. Though the practice existed earlier, copies and adaptations of important statues were made in great number for the Romans, and it is to them, therefore, that we owe our knowledge of many originals that perished in antiquity. While the identification of the statue is still debated, the work has been attributed to the sculptor Kresilas. The figure has been called either Protesilaos, the first Greek killed in the Trojan War, or the *vulneratus deficiens* ("falling warrior") mentioned by the Roman writer Pliny as being among the works of Kresilas.

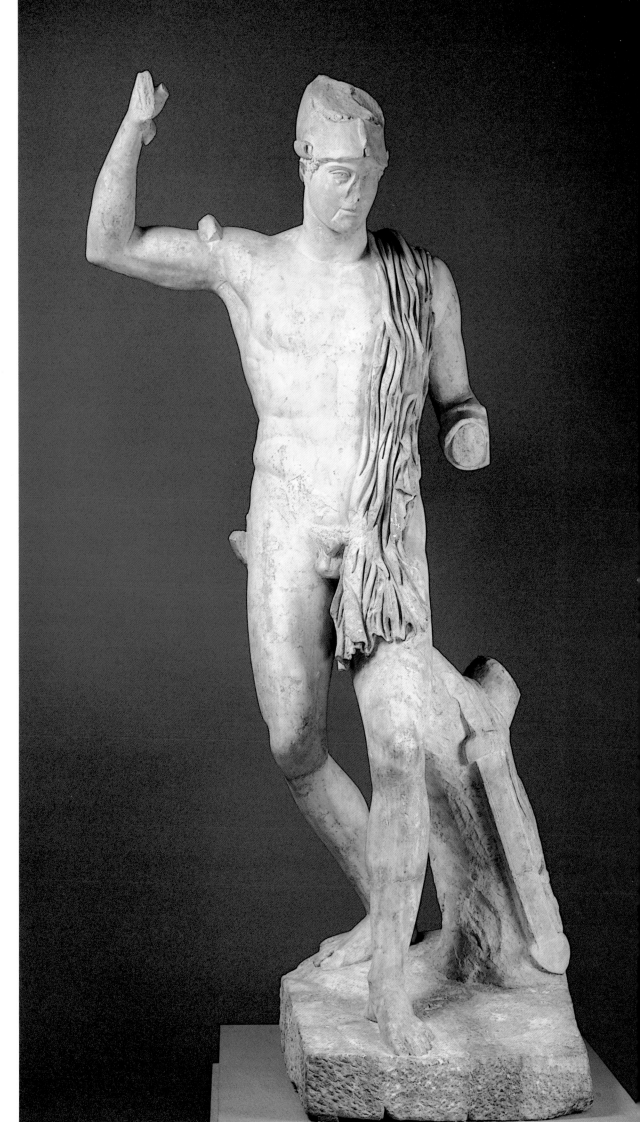

*43 Calyx Krater attributed to
the Painter of the Berlin Hydria*
Attic, ca. 460 B.C.
Terracotta; H. 22 in. (55.8 cm.)
Rogers Fund, 1907 (07.286.86)

44 Wounded Warrior
Roman copy of Greek
original of mid-5th c. B.C.
Marble; H. 87 in. (2.21 m.)
Frederick C. Hewitt Fund,
1925 (25.116)

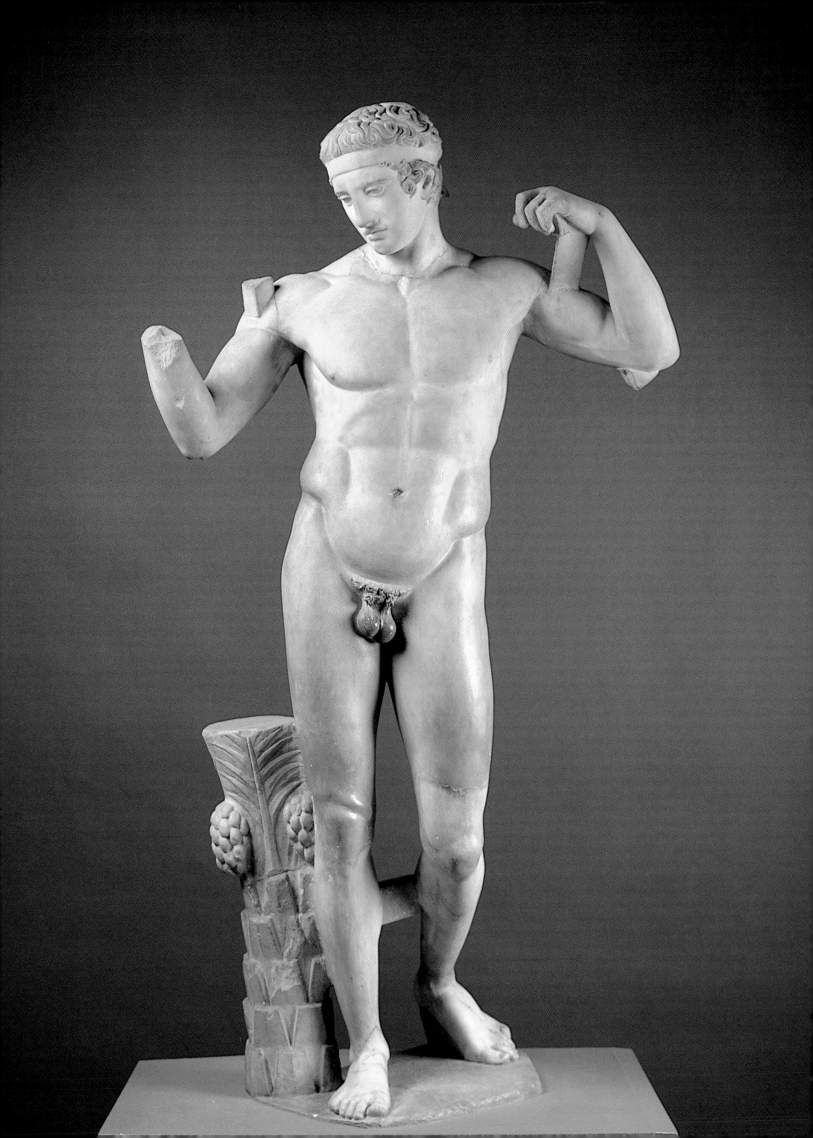

DIADOUMENOS

In the vocabulary of Greek sculptural types, a Diadoumenos is a young athlete who is tying a fillet or band, the mark of victory, around his head. This is a Roman copy of a Greek bronze that was one of the most renowned creations of the sculptor Polykleitos, as ancient literary accounts and a great number of copies testify. In this example, the head, arms, lower legs, support, and part of the plinth are ancient; the rest of the figure is a plaster cast of another surviving copy. Nonetheless, the work reveals the reason for Polykleitos's fame. Both in his sculpture and in a written work, the *Canon*, he sought to represent the nude male figure with perfect harmony among all parts and according to principles that could be reproduced by others. Although the athlete's pose carries a greater implication of movement, the equilibrium that prevails finds a perfect counterpart in the bronze caryatid (Plate 40).

HEAD OF A YOUTH

This beautiful head belonged to a statue of a victorious young athlete, as indicated by the fillet around his brow and the remains, on the top of his head, of a support for what would have been his bent arm. He was probably shown in a relaxed pose after a competition. Despite the high polish of the marble and hardness of the curls, both introduced by the Roman copyist, the head illustrates very well the "idealized" and "classic" qualities that characterize Greek art of the fifth century B.C.

45 Diadoumenos
Roman copy of Greek original
of ca. 440–430 B.C.
Marble; H. 73 in. (1.852 m.)
Fletcher Fund, 1925 (25.78.56)

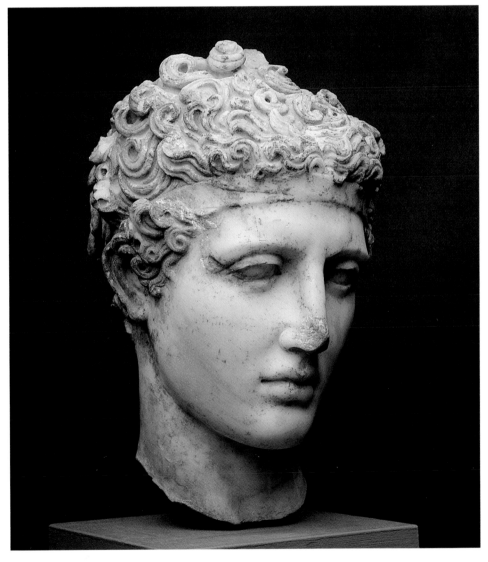

46 Head of a Youth
Roman copy of Greek original
of 3rd quarter of 5th c. B.C.
Marble; H. 13½ in. (34.3 cm.)
Rogers Fund, 1911 (11.210.2)

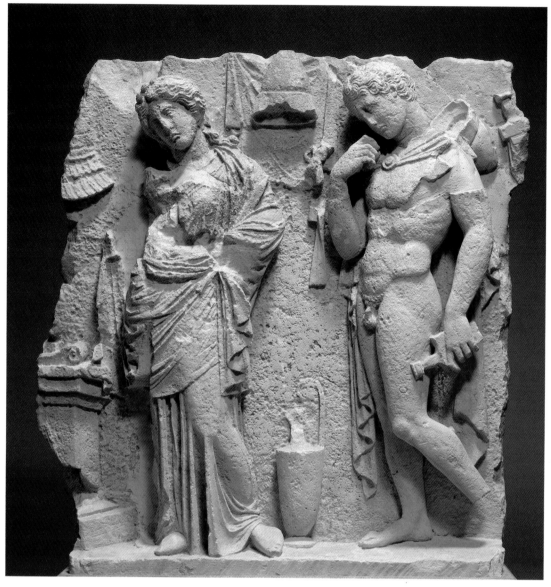

47 Grave Relief
Greek, mid-4th c. B.C.
Limestone; H. 23 in. (58.5 cm.)
Fletcher Fund, 1929 (29.54)

48 Fragment of a Grave Relief
Attic, ca. 400 B.C.
Marble; H. 48⅛ in. (1.22 m.)
Harris Brisbane Dick Fund,
1948 (48.11.4)

GRAVE RELIEF

This relief is a fine example of the kind of frieze used for grave monuments in the Greek colony of Tarentum in southern Italy. The porous, now rather grainy limestone was of local origin and creates a very different impression from the hard, smooth Greek marbles. The scene can be recognized as funerary from the mournful attitudes of the figures; the bent head and hand of the warrior are similar to those of the woman in Plate 48. Compared with the Athenian grave relief shown on the facing page, the Tarentine work is remarkable for its implied narrative ingredient and for the paraphernalia depicted. The identities of the warrior and his companion elude us, as does the precise setting, which includes an altar, lekythos, and armor attached to the rear wall. Based on analogous contemporary Tarentine tomb sculpture, the subject is probably mythological.

FRAGMENT OF A GRAVE RELIEF

This regrettably incomplete figure of a woman seated in an elaborate chair was part of a relief that would have been erected over the tomb of the deceased. Another person, perhaps a family member or a maidservant, may have stood before her. The work conveys, in a way that even the best copies cannot, the ability of Classic artists to represent the human form and spirit. The position of the woman's head and right hand, as well as the heavy downward movement of the drapery, express sorrow without sentimentality, while the volume of her body and the different textures of chair, folds, and flesh make her presence palpable and immediate.

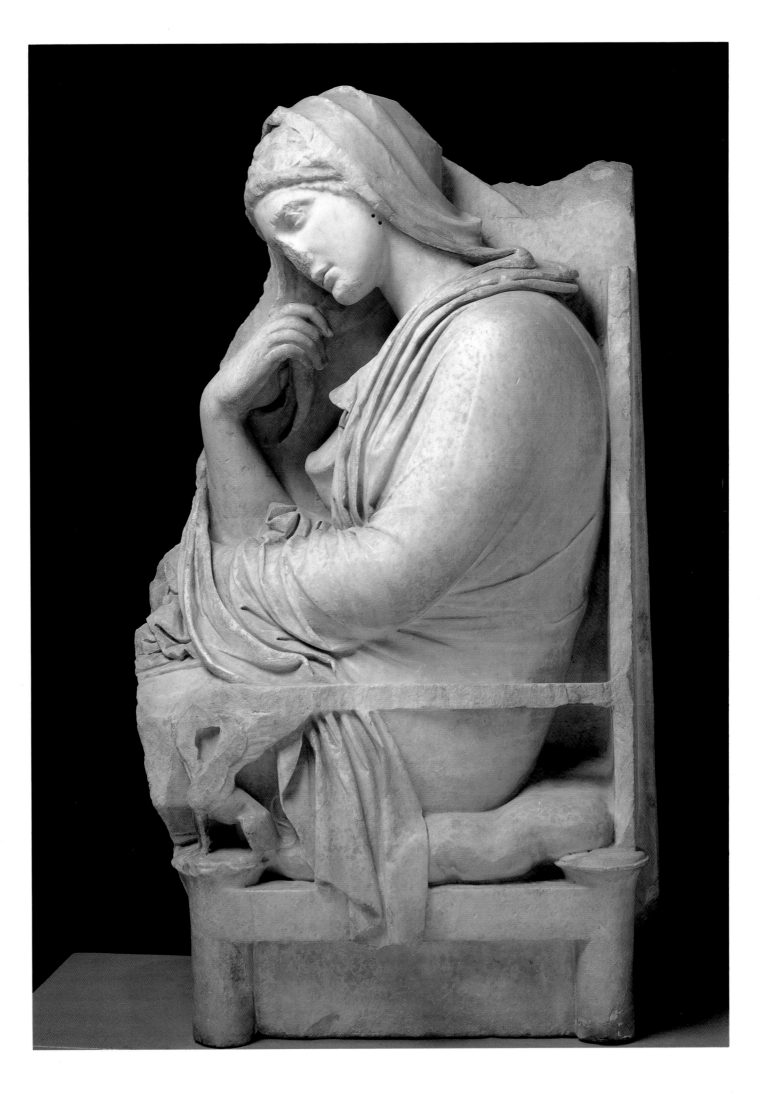

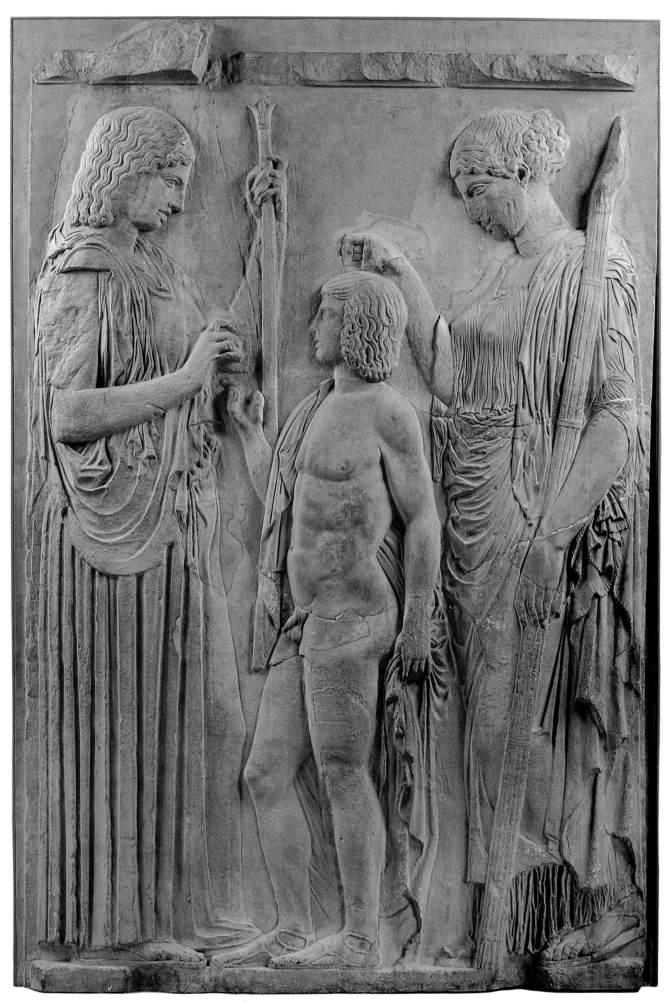

VOTIVE RELIEF

This is one of the exceptional instances in which a Greek original survives to corroborate its Roman copy. The original, found in Eleusis and now in the National Museum, Athens, shows the goddess Demeter, on the left, giving to young Triptolemos the ears of wheat that he will introduce to mankind. On the right, Demeter's daughter, Persephone, or Kore, crowns him with a wreath. The relief is significant because it presents the deities central to the mystery cult at Eleusis, which flourished from Classic through Roman times. Its impressive size, solemn tenor, and beautiful execution make this one of the great monuments of the fifth century B.C. The copy, which was found in Rome and is dated to the Augustan period, seems to have been taken directly from the piece now in Athens, though minor changes have crept in, notably in the rendering of the drapery folds.

49 Votive Relief
Roman copy of Greek original of ca. 440 B.C.
Marble; H. (as restored) 89⅜ in. (2.27 m.)
Rogers Fund, 1914 (14.130.9)

50 Relief of a Maenad
Roman copy of Greek original
of late 5th c. B.C.
Marble; H. 56⁵⁄₁₆ (1.43 m.)
Fletcher Fund, 1935 (35.11.3)

RELIEF OF A MAENAD

The motif of the dancing maenad—a female attendant of Dionysos—seems to have been established in the Greek sculptural repertoire at the end of the fifth century B.C. Though the sculptor has often been identified as the Kallimachos mentioned in literary sources, he remains unknown. The conceit, however, became especially popular with Roman artists who have left copies and adaptations showing swirling maenads with varying poses and attributes. In this beautifully executed example the figure holds an object characteristic of maenads, the thyrsos, which consists of a fennel stalk provided at one end with ivy leaves and korymboi (ivy berries). The figure's introspective expression contrasts most effectively with the exuberance of her drapery.

 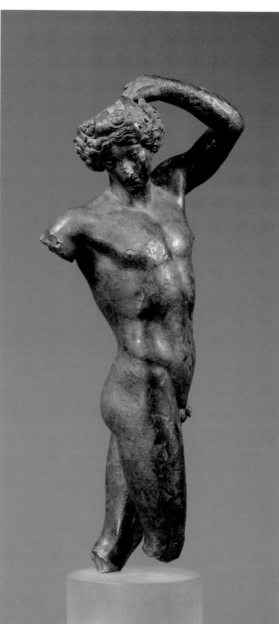 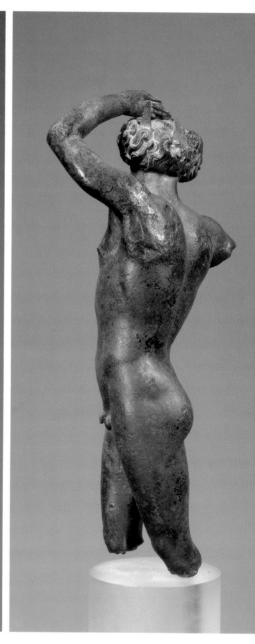

DANCING YOUTH

The moment of political and artistic balance that the Classic period represented could not endure; it was broken by such events as the defeat of Athens in the Peloponnesian War (431–404 B.C.) and the rise of Macedon, which culminated in the domination of Greece by Alexander the Great (356–323 B.C.). The art of the Hellenistic period (323–31 B.C.)—or the period following the death of Alexander and lasting until the Battle of Actium—was decisively influenced by Alexander's conquests, and its iconography was expanded to include new subjects such as Africans, Asians, and Celts. Stylistically, Hellenistic art is characterized by an emphasis on realism that often tended toward the ugly, even grotesque. The dancing youth shows the beginnings of the change. Although his features and body fully display the achievement of Classic artists, the active and unstable pose and the interest in characterizing a state of abandon are something new.

VEILED AND MASKED DANCER

The artistic direction shown by the dancing youth (Plate 51) finds a culmination in this lady: an entertainer—part mime, part dancer—for which Alexandria, the city in Egypt founded by Alexander the Great, was famous. The artist has characterized her through the interaction of her dramatic and complex pose with her equally complex dress. Over a rather heavy undergarment, the dancer wears a large mantle whose lighter consistency produces the crisp folds and impressions of the drapery underneath. Below her left hand the undulating fringe of her mantle falls away. A veil covers her face to the hairline, except for her eyes. In the relief of the maenad (Plate 50), body and drapery still move together; in this bronze statuette the drapery has acquired a life of its own.

51 Dancing Youth
Greek, end of 4th c. B.C.
Bronze; H. 7⅞ in. (20.1 cm.)
Bequest of Walter C. Baker,
1971 (1972.118.94)

52 Veiled and Masked Dancer
Greek, late 3rd to early 2nd c. B.C.
Bronze; H. 8⅟₁₆ in. (20.5 cm.)
Bequest of Walter C. Baker, 1971
(1972. 118.95)

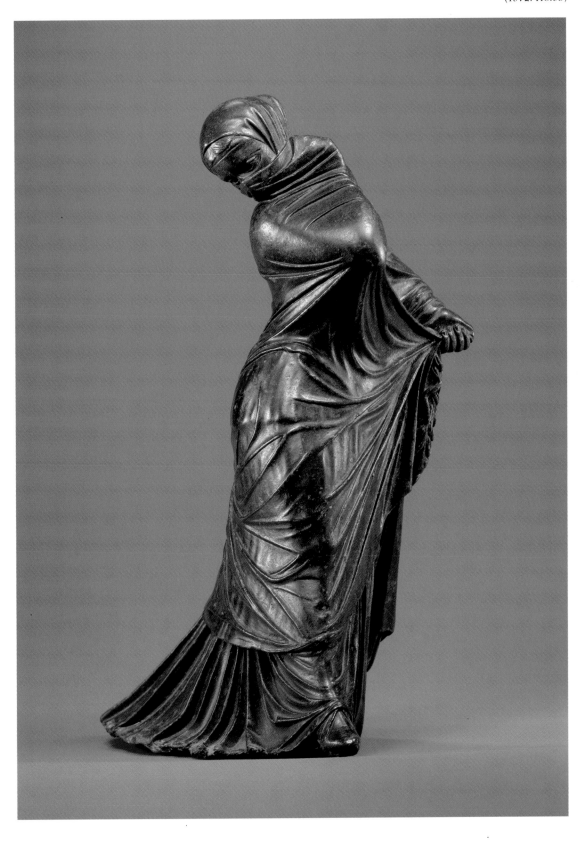

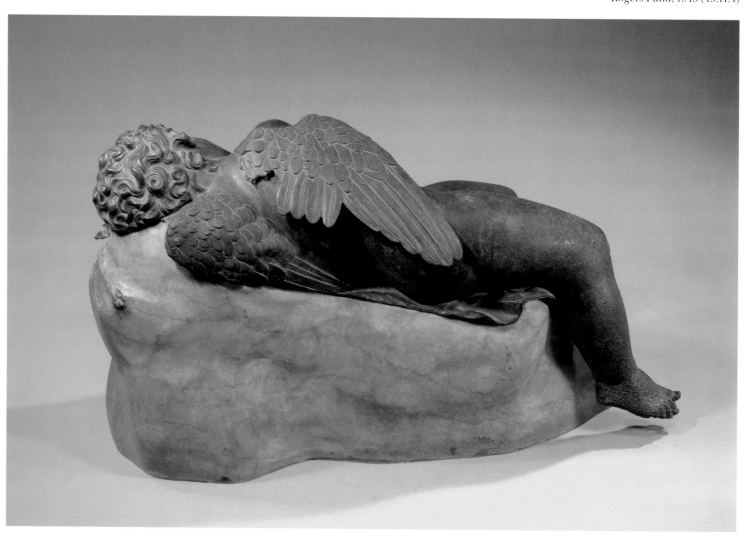

Sleeping Eros

During the Hellenistic period, children became favored subjects and, for the first time in Greek art, they were depicted as they appeared and not as diminutive adults. Though Eros, the personification of love, was originally shown as a boy or youth (see Plate 42), the Hellenistic artist revels in the pudginess of his body and in the juxtaposition of flesh, ringlets, and feathers. Moreover, where in previous times Eros appeared awake, if not in action, the Hellenistic artist has chosen to present him asleep, with no indication of the narrative episode in which he has just played a part.

OLD MARKET WOMAN

This statue of a woman bent by age, shuffling awkwardly, and burdened by the chickens and basket in her left hand could hardly be more realistic. Yet, the artist's straightforwardness, as well as his extraordinarily sensitive handling of the marble, dispel any sense of ugliness. Though she is an antithesis of the Eros (Plate 53) in virtually every respect, both works exemplify the new kinds of subjects considered worthy of attention during the Hellenistic period; more importantly, they show how the progressive mastery of form in Greek art, especially human form, led to ever greater richness and depth of representation.

PORTION OF A COLUMN

Sardis, the capital of Lydia, was one of the cities of western Asia Minor in which Greek influence was continually interwoven with local tradition. After the conquest by Alexander the Great, it became part of the Seleucid empire, which spanned Asia Minor, the Levant, Persia, as far east as India. Around the turn of the third century, a temple dedicated to Artemis began to be built at Sardis. Consistent with the predilection for enormous scale already manifested in Archaic temples, for instance at Ephesos and Didyma, the one at Sardis ranks among the seven largest of all Greek temples. The column reconstructed here would have risen over 56 feet in its original location. Its shortened form, which omits most of the intervening drums, makes it easier to appreciate the fine carving of the foliate ornaments on the capital as well as the scale pattern on the torus at its base.

54 Old Market Woman
Possibly a Greek original of 2nd c. B.C.
Marble; H. 49⅝ in. (1.26 m.)
Rogers Fund, 1909 (09.39)

55 Portion of a Column
Greek, 3rd to 2nd c. B.C.
Marble; H. (as exhibited):
11 ft. 10 in. (3.61 m.)
Gift of The American Society
for the Excavation of Sardis,
1926 (26.59.1)

56 Fragment of a Skyphos attributed to the Palermo Painter
South Italian, Lucanian, last 3rd of 5th c. B.C.
Terracotta; H. 7¹⁵⁄₁₆ in. (20.1 cm.)
Rogers Fund, 1911 (11.212.12)

FRAGMENT OF A SKYPHOS AND A DINOS

During the fourth century B.C., the political and artistic centers of Greece moved not only northward and eastward but also westward. Italy and Sicily flourished, giving rise, in vase painting, to workshops that continued the art while those in mainland Greece declined and finally expired late in the fourth century B.C. The earliest South Italian vase painting was influenced by Attic examples and also rivaled their standards, as the fragment of a skyphos (or two-handled drinking vessel) in Plate 56 shows. Enthroned and sceptered, Zeus is about to be crowned by Eros. An arm of a woman—perhaps Aphrodite—is preserved; she was proba-

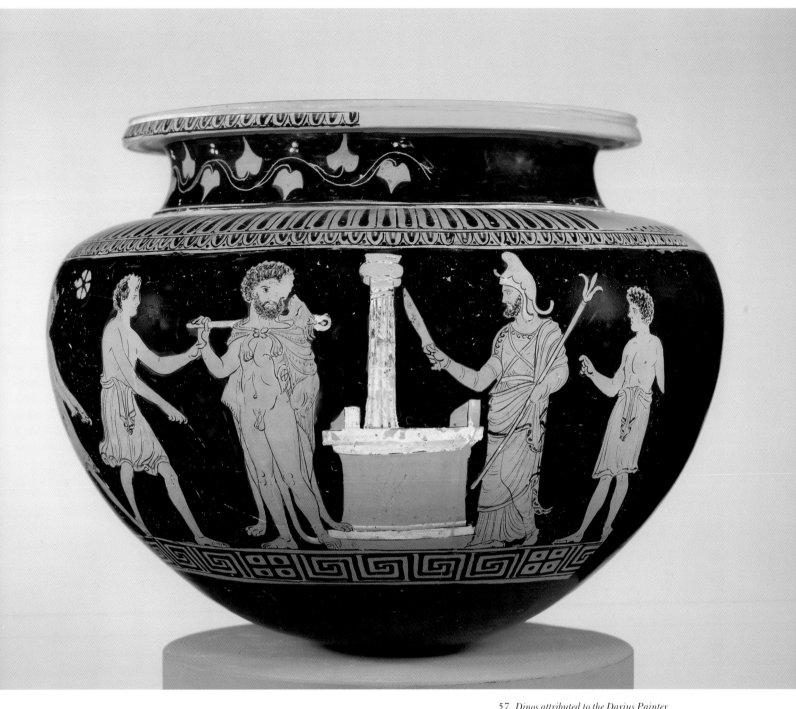

57 *Dinos attributed to the Darius Painter*
South Italian, Apulian, 3rd quarter of 4th c. B.C.
Terracotta; H. 9¾ in. (24.8 cm.)
Classical Purchase and Rogers Funds, and Norbert
Schimmel and Helen H. Mertens Gifts, 1984
(1984.11.7)

bly seated before him. As indigenous artistic elements began
to assert themselves, South Italian vase painters tended to
favor elaborate, often abstruse, iconographical subjects, ep-
isodes from the theater, and motifs from daily life. The
dinos is a deep bowl often set in a stand. It illustrates the
time-honored tale of how the Egyptian king Busiris unsuc-
cessfully sought to sacrifice Herakles. The principals are
most effectively characterized: Busiris appears resolute,
Herakles unperturbed in a deadpan way. On either side,
attendants bring the equipment intended for butchering and
cooking the hero.

GOLD RING

The subject on the bezel of this ring is Cassandra seeking refuge at the cult statue of Athena at Troy as the Greek warrior Ajax is about to seize her. Cassandra, one of the daughters of the Trojan king Priam, was loved by Apollo who showered her with gifts, including that of prophecy. When she refused to yield to him, Apollo cursed her with the fate that whatever she foretold would not be believed. Thus, her warnings about the Greeks went unheeded, and she finally sought refuge at the image of Athena. As on the sheathing (Plate 59), the artist's concern on this ring is to render the volume of the figures and the violence of the situation as graphically as possible, here by juxtaposing suppliant and statue.

58 Gold Ring
Greek, 4th c. B.C.
Gold; L. (of bezel): ¾ in. (2 cm.)
Rogers Fund, 1953 (53.11.2)

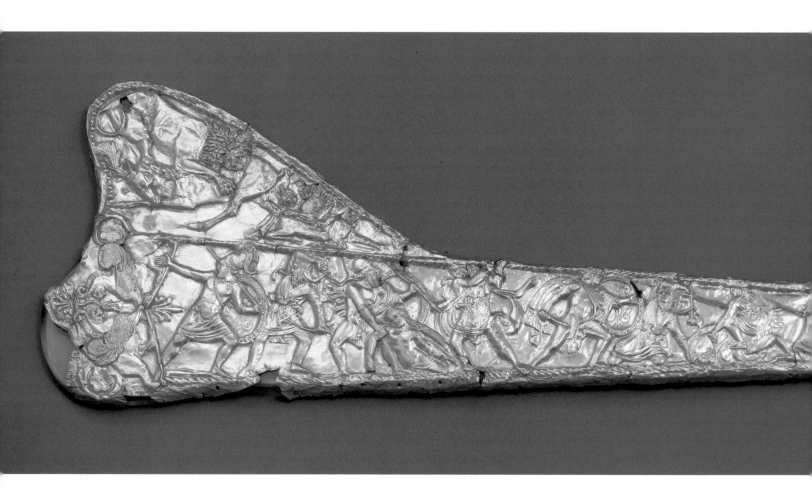

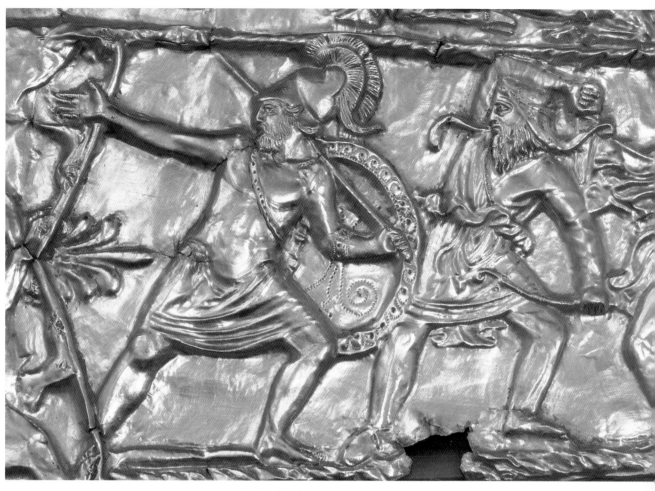

59 Sheathing for a Scabbard
Greek, 4th c. B.C.
Gold; L. 21⁷⁄₁₆ in. (54.5 cm.)
Rogers Fund, 1930 (30.11.12)
Above: detail

SHEATHING FOR A SCABBARD

The Greek colonies in southern Russia, along the northern shores of the Black Sea, represent yet another region whose importance and prosperity during the Hellenistic period fostered remarkable artistic creativity, particularly in metalworking. It was a Scythian practice to cover scabbards and bowcases with gold foil. The example illustrated here was richly embellished with a combination of Greek and local motifs. A scene of combat between Greeks and barbarians fills the main zone. The physiognomies and dress of the latter are depicted with particular vividness, as is the horse on the far right, a more rugged animal than his aristocratic Greek counterpart (see Plate 18). It is worth noting how carefully the artist has adapted the poses of the figures to the space available at every point along the sheath. At the far left end of the main zone and at right angles to the combat, two confronted griffins appear amid palmette and rosette ornaments. The irregularly shaped field rising above the left third of the sheath presents yet another variant of the animal-combat motif: a lion felling a deer and a griffin killing another (see Plates 13 and 17).

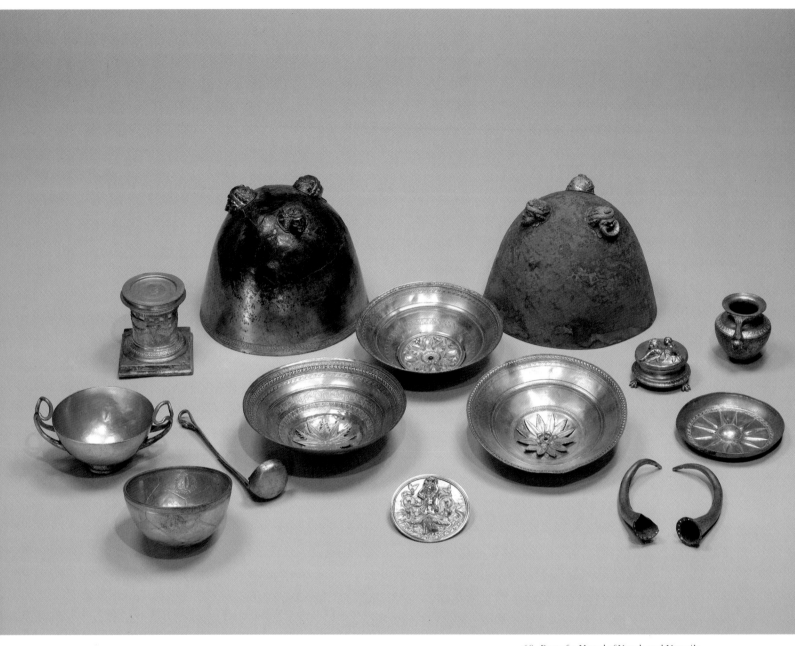

60 Part of a Hoard of Vessels and Utensils
Greek, 3rd c. B.C.
Silver with gilding
Purchase, Rogers Fund, Classical Purchase Fund, Harris
Brisbane Dick Fund and Anonymous, Mrs. Vincent
Astor, Mr. and Mrs. Walter Bareiss, Mr. and Mrs.
Howard J. Barnet, Christos G. Bastis, Mr. and Mrs.
Martin Fried, Jerome Levy Foundation, Norbert
Schimmel, and Mr. and Mrs. Thomas A. Spears Gifts,
1981-1982 (1981.11.15-22, 1982.11.7-13)

Opposite: details

PART OF A HOARD OF VESSELS AND UTENSILS

Greek metalworking of the Hellenistic period could be as
magnificently simple as its Archaic precursors (Plates 26–28).
This group of objects—attributed, by comparable material,
to Tarentum—includes an altar on a square base, small cir-
cular receptacles perhaps intended for incense, a pair of
horns that may have been attached to a helmet, a squat jug,
a ladle, and a variety of bowls ranging from a phiale and
other drinking cups to the pair of deep, bucketlike contain-
ers each of which rests on three actor's masks. Most sump-
tuous are the three bowls with zones of gilded ornament
and exquisite floral attachments in the center.

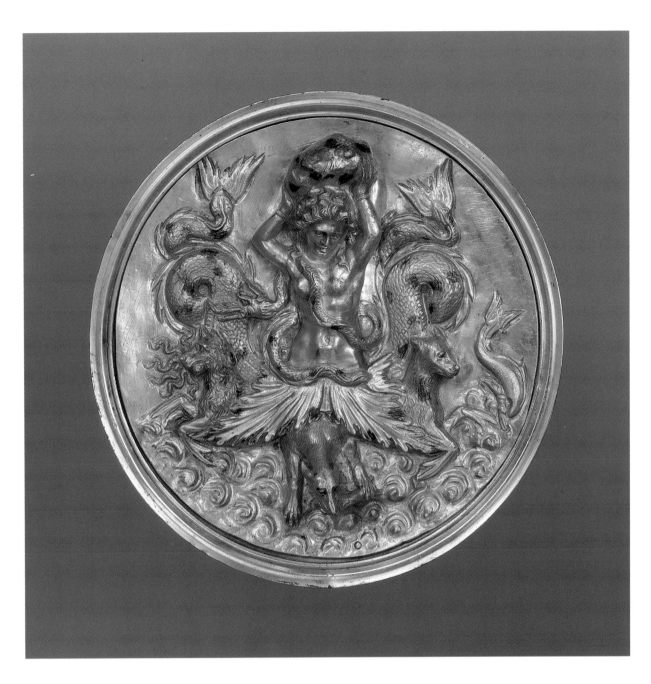

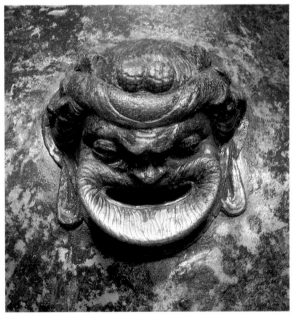

61 Phiale
Greek, perhaps 4th c. B.C.
Gold; D. 9¼ in. (23.5 cm.)
Rogers Fund, 1962 (62.11.1)

PHIALE

Like the preceding hoard (Plate 60), this phiale was probably made for a special purpose or individual. Though relatively large, it fits the hand comfortably. The decoration is arranged in four concentric bands: one of beechnuts, two of acorns, and the fourth of acorns alternating with bees. On the outside, around the concavity of the central boss, appear two inscriptions. One, in Greek, gives the first letters of a name. The second, written in the Carthaginian alphabet and datable to the third century B.C., indicates the object's weight. Wealth in such portable form would have changed hands readily so that the weight notation need not have been made by its first owner.

SPIRAL ARM BANDS

During the Hellenistic period, the artistic interest in strong, colorful effect extended even to jewelry. These serpentine bands would have been worn on the upper arm and would have been sewn to the shoulders of the wearer's garment by the small loops that project at the top and back of each. The spirals that comprise the lower portion of the bands are articulated as snakes. They develop, above, into a triton and tritoness, each of whom cradles an Eros in his arm. While the energy in these figures recalls that of bronzes (Plates 51, 52), as well as of the ring and the sheathing (Plates 58, 59), the special quality of the arm bands is that their forms and movements partake of the motions of the wearer.

62 Spiral Arm Bands
Greek, 3rd c. B.C.
Gold; left: H. 5¾ in. (15 cm.);
right: H. 6¼ in. (15.9 cm.)
Rogers Fund, 1956 (56.11.5-6)

FUNERARY VASE

Vases of this class were made exclusively for funerary pur-
poses. The cover is of a piece with the body and the paint-
ing, confined to the front, was not done with ceramic colors
before firing but in tempera after the vase had been fired.
The subject is a bride accompanied by three attendants, one
of whom plays a tympanum. For the first time on Greek
vases, and influenced no doubt by wall painting, there is
full polychromy: soft tonalities of pink, purple, and blue,
for instance. It is for this reason that the relatively small
class of vases from Centuripe is important. Since no mon-
umental Greek painting of the Classic period is preserved,
there exists little knowledge of how and what colors were
used by the masters mentioned by ancient writers. The
Centuripe material supplements the material from other
Hellenistic sources—stelai, mosaics, wall painting, other
types of pottery—in documenting the level reached by this
art at the end of its Greek history and its contribution to
later Roman developments.

63 *Funerary Vase*
South Italian, Centuripe, early 3rd c. B.C.
Terracotta; H. 15⅞ in. (37.7 cm.)
Purchase, Joseph Pulitzer Bequest, 1953
(53.11.5)

ROME

THE REPUBLIC

(509–27 B.C.)

An early Republican suspicion of art vanished in the second century B.C.; Romans were exposed to Greek art on a vast scale as statues, paintings, and precious objects were imported as booty from various conquests. These displays of sophistication were soon cherished by well-to-do landowners of the regions around Naples and Rome, and private collections sprang up, filled not only with Greek originals, but with highly imaginative Roman copies and adaptations of famous mythological statues and decorative motifs. When the first wave of imports had crested, the awakened Roman imagination began to add to and change the familiar motifs of Greek art, and in the last half of the first century B.C. something truly original can be found in Roman art.

STATUE OF A YOUNG WOMAN

From various ancient authors we learn that the legendary King Aeneas, father of the Latin race, fled from Troy to Macedonia, Sicily, and finally to the Italian peninsula, where he founded a city called Lavinium. In its distinctive clothing and jewelry, this life-size statue closely resembles fourth- and third-century B.C. works from Lavinium (modern Pratica di Mare), a site twenty-eight kilometers south of Rome.

The elaborate pendants and arm bracelet appear to be reproduced from molds of actual jewelry, decorated with classical themes in the case of the arm bracelet and the oval and trapezoidal pendants, and a native Italic type in the case of the round *bulla* above the figure's left breast. Typical of sculptures from Lavinium are the schematic transparent undergarment and heavy mantle. When complete, the statue was probably free-standing in an enclosed sanctuary and showed the young woman holding an offering or incense box in each hand. Despite the body's mannered attenuation, the artist was clearly mindful of classical sculptural style, at least as it was then represented in the region of Latium. This rare statue is thus an example of the burgeoning sophistication of Italic artists, who over the next two centuries fused native traditions with imported taste and created the multifaceted art of late Republican Rome.

64 Statue of a Young Woman (upper part)
Italic, late 4th–early 3rd c. B.C.
Terracotta;
H. (as preserved) 29½ in. (74.8 cm.)
Rogers Fund, 1916 (16.141)

65 *Room M of the Villa of P. Fannius Synistor at Boscoreale*
Late Republican, 40s B.C.
Wall painting; Room: H. 8 ft. 8½ in. (2.62 m.), L. 19 ft.
1⅞ in. (5.83 m.), W. 10 ft. 11½ in. (3.34 m.)
Rogers Fund, 1903 (03.14.13)

Opposite: detail

BEDROOM FROM BOSCOREALE

The persistent public image of late Republican Romans as sober, ascetic men of state clashes sharply with the surviving evidence of their private taste: Luxury and comfort were cherished then as now. Upper-middle-class families with country estates lived in lavishly decorated homes, as this magnificent bedroom from a villa in Boscoreale, near Pompeii, demonstrates.

We can look into the bedroom as if we were house guests in the 40s B.C., and find, on the long walls, fanciful rows of painted columns in red marble, silver gilt, and studded with gems, which rest on a knee-high base and afford a view onto a series of buildings and balconies of a dizzying complexity.

In the center of each long wall is a religious sanctuary with a statue of a female divinity. Toward the window of the bedroom, deep vistas seen through a broken pediment separate the area reserved for the bed (here occupied by a bone couch) from the more open views of the countryside. Against the back wall, a painted waterfall and fountain enliven the rustic scenes. A monochrome yellow painting or relief seems to hang just above the couch, and a tempting bowl of fruit sits on a shelf within reach of the bedroom's occupant.

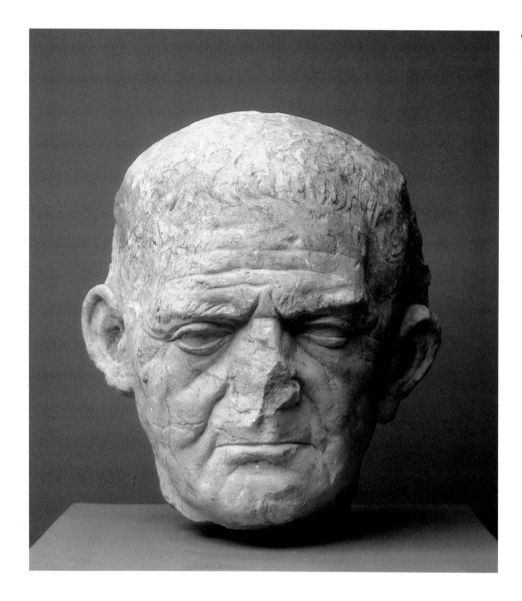

ROMAN REPUBLICAN

Creases and worry lines are meant to remind us that our subject is sober and dignified and takes the old-fashioned values of the Roman Republic seriously. Although he lived at the time of the emperor Augustus's rise to power, the sitter eschews the current preference for fuller hair and a more relaxed appearance. His *dignitas* recalls the sculpted wax images of Roman ancestors carried through the forum in funeral processions during the Republic.

Republican portraiture was influenced by the emotionalism common in Hellenistic portraits from the East, which arrived with victorious Roman generals as spoils from the second century B.C. onward. However, at the very end of the first century B.C., it became fashionable to emulate the aloofness of classical Greek statues. Both of these trends implied a worldliness that contrasted with the homespun values of the Republic.

The civilization that produced Cato, Caesar, and Cicero was eventually swept up in artistic internationalism after its conquests, and men like our Republican were left behind in their attachment to a simpler world.

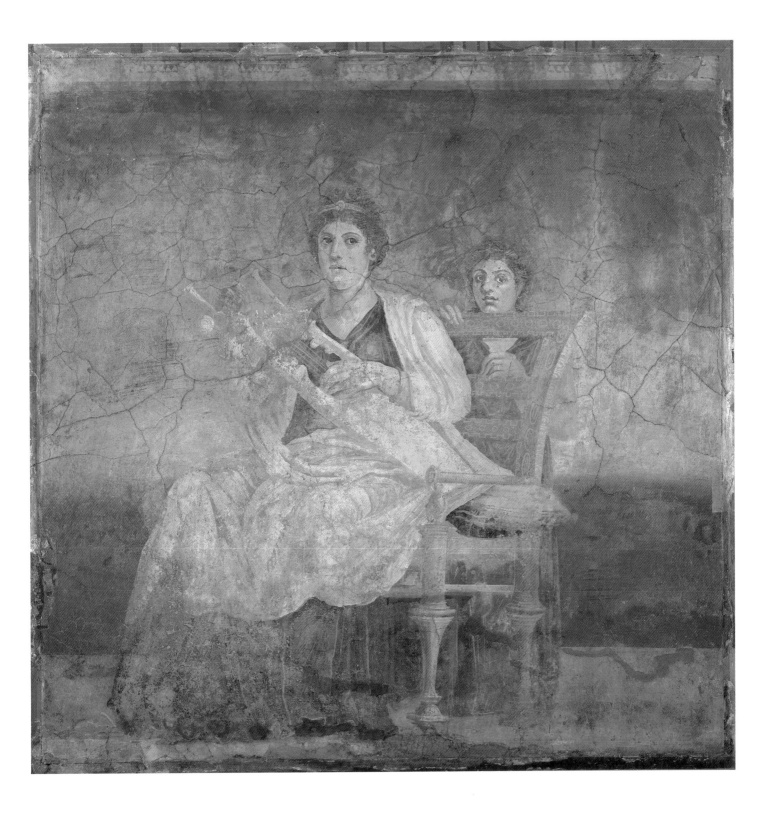

CITHARIST AND HER ATTENDANT

The painted walls of Room H of the villa at Boscoreale, now framed in wood and hung as separate paintings, depict large figures in various scenes on a red background. Scholars have long debated their identities. The most recent explanation is that the paintings, once separated by bossed Corinthian columns, were not an interrelated cycle with a single iconographic theme, but a series of isolate copies of lost Hellenistic masterpieces. They would have decorated the walls of the villa's largest room—about twenty-five feet long and wide— much as unrelated statues of athletes and divinities stood outside such villas. These were perhaps testimonials of newly acquired Roman cultivation rather than emblems of a mysterious cult. On the rear wall of the room were paintings of

Aphrodite, Dionysos and Ariadne, and the Three Graces. On the side walls were paintings of Hellenistic portrait types, some familiar, like Epicurus, and some less so.

The seated cithara player in this panel wears a purple chiton and a white himation, and she rests the gold-colored instrument in her lap. A young girl stands behind her elaborate chair. The young girl's informal pose, her resemblance to the older woman, and the similarity of her diadem suggest that she is the citharist's daughter. The pair may represent a Macedonian queen and princess. Whatever the exact subject, these paintings were admired as excellent copies of Greek art, which emphasized the erudition and worldliness of the villa's owner.

THE "TIVOLI HOARD"

We learn details of the Roman devotion to haute cuisine in the late Republic through the cookbook of Apicius and the writings of Petronius, Juvenal, and Martial. Seafood, poultry, game, and eggs, as well as more exotic fare like peacocks, flamingos, and cranes, graced the tables of well-to-do Roman families, and wine was considered a necessary part of the meal. These examples of an elaborate mid-first-century B.C. silver service are said to be from Tivoli, near Rome, and include *scyphi* (wine cups), a ladle, a *trulla* (spouted pitcher), and spoons. The *cochlearia* (snail spoons) hint at the sophistication of the Roman palate. Elegant soup spoons give a clue to the diverse courses favored in the Roman meal, and the ample bowl of the ladle, like that of the cups, shows an appreciation of wine. The dietary preferences of the Romans were remarkably close to the habits of modern-day Italians. After a light breakfast, a three-course midday meal was served. The *gustatio*, or first course, consisted of shellfish, eggs, or salad. The *cena*, or main course, featured a succession of roasted meats. The meal ended with sweetmeats and fruit.

Tivoli was the site of dozens of villas of the wealthy in the late Republic, and was to Rome what Boscoreale and Boscotrecase in the Campanian countryside were to Naples.

68 *The "Tivoli Hoard"*
Late Republican, mid-1st c. B.C.
Silver; Pair of *scyphi* (wine cups): H. 3¾ in. (9.5 cm.); Ladle: L. 6⅞ in. (17.5 cm.); *Trulla* (spouted pitcher): H. 2⅝ in. (6.7 cm.); Four spoons: L. from 5¾ to 6 in. (14.6 to 15.3 cm.); *Cochlearia* (snail spoons): L. 4⅞ and 4½ in. (12.3 and 11.4 cm.)
Rogers Fund, 1920 (20.49.2-9.11-.12)

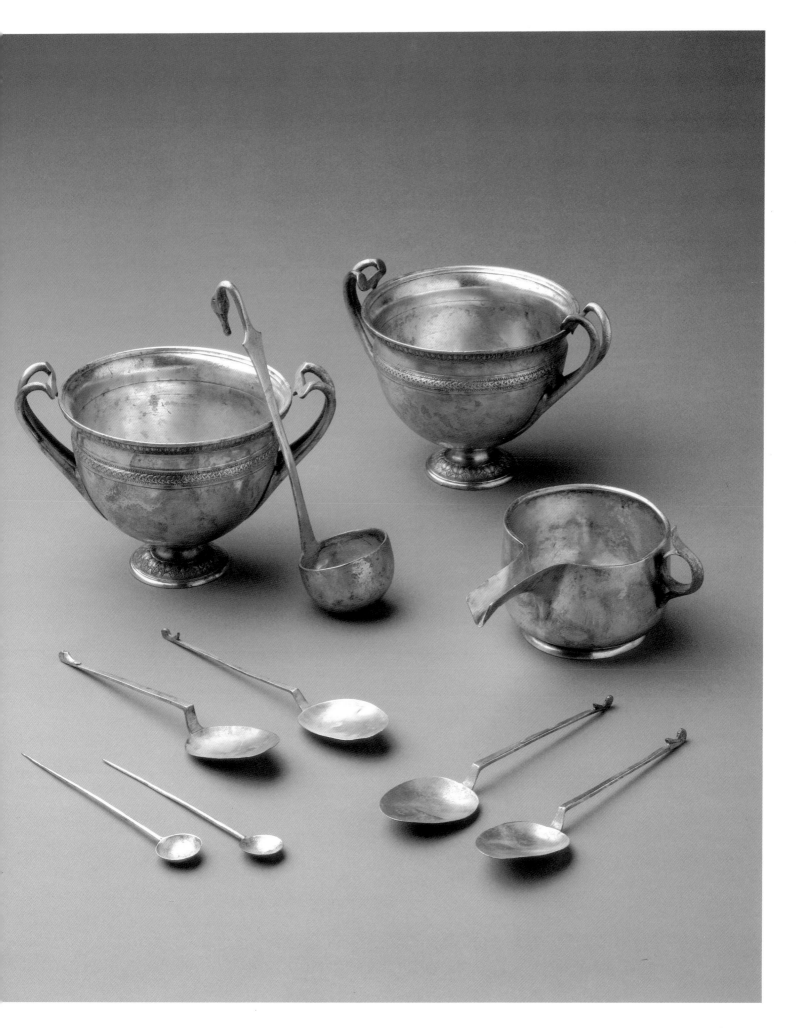

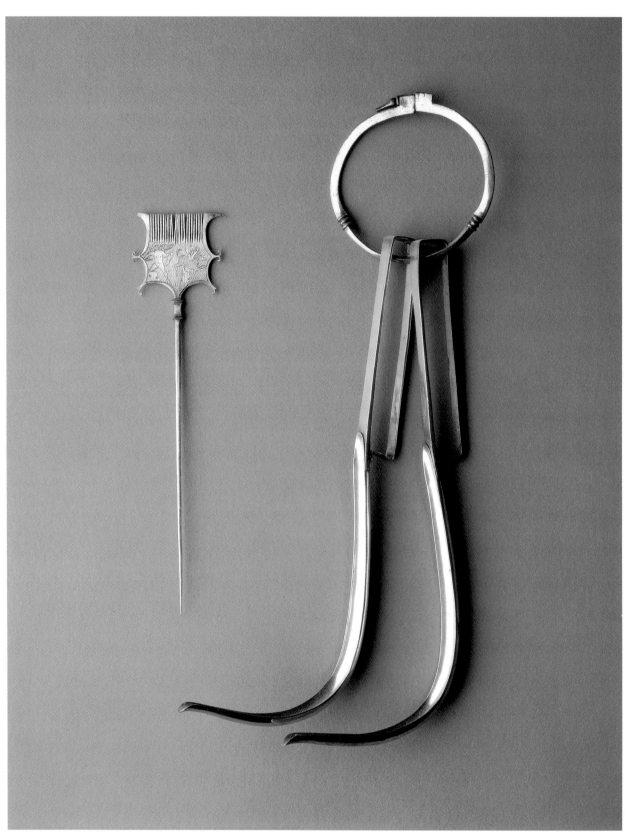

69 Silver from Lake Trasimene
Late Republican, mid-1st c. B.C.
Silver; Combination comb and hair pin: L. 7 in. (17.7 cm.);
Pair of strigils on a ring: D. (of ring) 3 in. (7.5 cm.),
L. (of strigils) 8½ in. (21.7 cm.)
Comb and pin: Fletcher Fund, 1947 (47.100.27); Strigils:
Gift of H. Dunscombe Colt, 1961 (61.88)

SILVER FROM LAKE TRASIMENE

Lake Trasimene has yielded many treasures, including the bronze statue known as the Arringatore in Florence (ca. 89 B.C.) and these fine utensils—a silver comb and strigils (instruments used in cleaning the skin after bathing) on a ring (ca. 50 B.C.). Like the bronze portrait statue of an Etruscan orator, the small scene engraved on the Trasimene comb shows an Etruscan tradition in the process of conversion to Roman ways. An Eros has become a cherubic Amor, and the dog who aids him in the hunt for the lion on the comb's back is less a stylized Etruscan figure than a lifelike Roman one.

These delicate accoutrements of a lady's toilette were used after the bath. The comb could be inverted and worn as a pin. The graceful attenuation of the strigils marks them as a Roman variant of a somewhat stubbier Greek type.

MILLEFIORI BOWL

Mold-pressed glass is known as early as the Archaic period in Greece, but it became popular only in the Hellenistic world. The technique involves heating ground or molten glass in a mold, and finishing the surface after it has cooled. Unlike the monochrome Hellenistic examples of the technique, those of Roman date, like this one, are highly colored.

This wheel-polished bowl, with a splayed rim and ring base, is made in the millefiori, or "thousand flowers" technique, also known as mosaic glass. Made from fused rods of various colors, the bowl is composed of white-centered yellow spirals in a blue ring, as well as opaque squares of white, green, blue, and purple, and a twisted strand rim. It is related to other hemispherical bowls found in a shipwreck off Antikythera and may be dated to the late second or first century B.C. The bowl is an example of late Republican luxury art, vying with vessels of precious metal for the ancient collector's attention. The technique was employed throughout the first century A.D., until it was replaced by blown glass.

70 Millefiori Bowl
Late Republican, 2nd–1st c. B.C.
Glass; H. 2¹³/₁₆ in. (7.1 cm.),
D. 4¹¹/₁₆ in. (11.9 cm.)
Edward C. Moore Collection,
Bequest of Edward C. Moore,
1891 (91.1.1400)

THE AGE OF AUGUSTUS AND THE JULIO–CLAUDIANS

(27 B.C.–A.D. 68)

In addition to founding the Roman empire, the emperor Augustus (r. 27 B.C.–A.D. 14) established many of the social and political traditions now taken for granted in democracies around the world. Augustus was also a great patron of the arts, presiding over one of the largest building campaigns in antiquity. He stimulated the creation of new architectural forms and of portraiture in marble and metal, and encouraged public uses of art.

The Julio-Claudian period involved a continuation of Augustus's programs and preferences. Tiberius (r. A.D. 14–37), Caligula (r. A.D. 37–41), and Claudius (r. A.D. 41–54) inspired little change in the arts, although by the time of Claudius we do find a more matter-of-fact quality in portraits. The forty years after Augustus's death in A.D. 14 were a time of consolidation of the vast empire he had created, and it was not until the Flavian emperors (A.D. 69–96) that the next great phase of Roman art began.

71 Cameo Portrait of the Emperor Augustus
Claudian, A.D. 41–54
Sardonyx; H. 1⁷⁄₁₆ in. (3.7 cm.)
Ex colls.: Arundel; Marlborough; Evans Purchase, Joseph Pulitzer Bequest, 1942 (42.11.30)

CAMEO PORTRAIT OF THE EMPEROR AUGUSTUS

This masterpiece of miniature carving may date from the reign of Claudius. It shows the deified Augustus as a mythological figure wearing an aegis, the scaly cape of Athena with trailing snakes, traditionally embossed with the severed head of the gorgon Medusa. Here it is also adorned with the head of a wind god, perhaps a personification of the Etesi, the summer winds of Egypt. Augustus is triumphant, wearing a laurel wreath and baldric, and carrying a spear. He was decreed a god by the Roman Senate upon his death in A.D. 14.

Cameos were a highly developed art form that involved carving details on colored glass or multilayered gemstones so as to leave a white surface in relief against a dark background, usually blue or brown. They were extravagant keepsakes, which, since they were not public monuments, could afford to exaggerate the stature of the imperial family without alienating the senate or the Roman people. As a god, Augustus was entitled to the attributes described here; other images of the imperial family carved in their lifetimes are often no less adulatory.

72 Portrait of Gaius Julius Casear
Octavianus (called Augustus)
Tiberian, ca. A.D. 14–38
Marble; H. 12 in. (30.5 cm.)
Rogers Fund, 1907 (07.286.115)

PORTRAIT OF THE EMPEROR AUGUSTUS

Augustus (r. 27 B.C.–A.D.14) achieved more for the empire he created than anyone who followed him, transforming, as he boasted, a city of brick into a city of marble. He modernized the Roman state with a network of roads, baths, aqueducts, sewers, postal services, fire brigades, and a myriad of innovations we now take for granted but that did not exist before his reign. His contribution was such that many of these conveniences, introduced in the first century B.C., were not improved upon to any extent until the late eighteenth century.

The first emperor of Rome set about creating a series of portraits that commemorated him not as he appeared, but as he wished the people of Rome and her subject nations to perceive him. We know from the biographer Suetonius that Augustus suffered from ill health throughout his life. But while a Republican official might have been represented with his physical defects, compensated by a severe expression, Augustus preferred to create an entirely new image, based upon a fifth-century B.C. "classical" type. Thus was born the Prima Porta type of Augustus, so named because its most familiar example is the life-size marble statue of the emperor in armor that was found in the villa of Augustus's wife Livia at Prima Porta, near Rome, in 1863. This version of the type may date from the time of Augustus's successor Tiberius, to judge from the figure's full head of hair. Although the Prima Porta Augustus is ultimately derived from Polykleitos's canonical statue of the Doryphoros, for the inspiration of his portrait type Augustus went beyond the Greek world and foreshadowed the future.

A Grandson of Augustus

One of the Metropolitan's finest bronzes from antiquity probably portrays one of the two grandsons of the Emperor Augustus, either Gaius (20 B.C.–A.D. 4) or Lucius (17 B.C.–A.D. 2) Caesar, sons of Agrippa and the emperor's daughter, Julia. The resemblance to portraits of Augustus shows that the tradition of idealizing the traits of the Julian family did not end with the emperor. The young man wears a pallium, a Roman garment like a Greek himation, rather than a toga. The statue was found on the island of Rhodes and is presumed to have been made there. Gaius and Lucius were given a classical education on Rhodes by Greek teachers until they were ready for military service.

The young man has a haughty air. He may have held an offering dish in his lowered left hand, and perhaps a bud in his raised right hand. Based on the example of a comparable dedication found at Corinth, the statue might be one of a group that included his brother and grandfather. Both boys were to die in battle, leaving Tiberius a clear path to the throne.

73 Portrait Statue, perhaps of Gaius
(20 B.C.–A.D. 4) or Lucius
(17 B.C.–A.D. 2) Casear
Augustan, ca. 10 B.C.–A.D. 4
Bronze; H. 49½ in. (1.23 m.)
Rogers Fund, 1914 (14.130.1)

Portrait Bust, perhaps of Agrippina the Elder

Agrippina the Elder (ca. 14 B.C.–A.D. 33) was the daughter of Marcus Agrippa and Julia, the Emperor Augustus's daughter. With her husband, Germanicus, she had nine children, among whom was the future emperor Gaius (nicknamed Caligula). Although this portrait is similar to others that are known to depict Agrippina, it may actually commemorate someone not of the imperial family.

To judge from the ringlets in her hair and long braid in back, the work dates to the reign of Claudius and may have served as an image for a descendant. The bust is set in a round base from which springs an acanthus plant: Frequently, acanthus signifies that the subject has died and passed into the afterlife. But since acanthus supports occasionally appear in portraits executed during the subject's lifetime, they may often be purely decorative rather than symbolic.

If the subject is indeed Agrippina, we may suppose that this bust was made together with a portrait of Germanicus, like a comparable pair of Augustus and Livia in the Louvre, and that they were set on a shelf or mantel in a wealthy Claudian home.

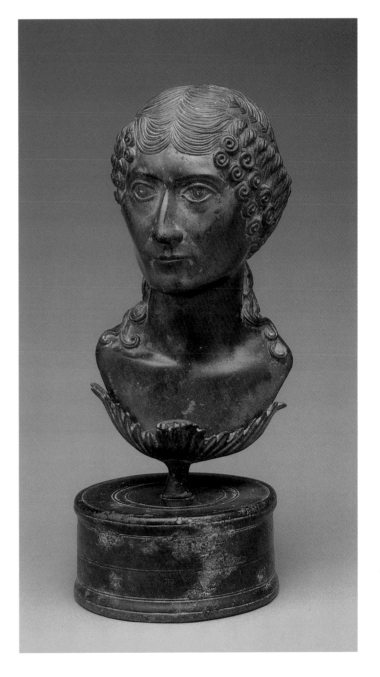

74 Portrait Bust, perhaps of Agrippina the Elder
Claudian, A.D. 41–54
Bronze; H. 9½ in. (24.1 cm.)
Edith Perry Chapman Fund, 1952 (52.11.6)

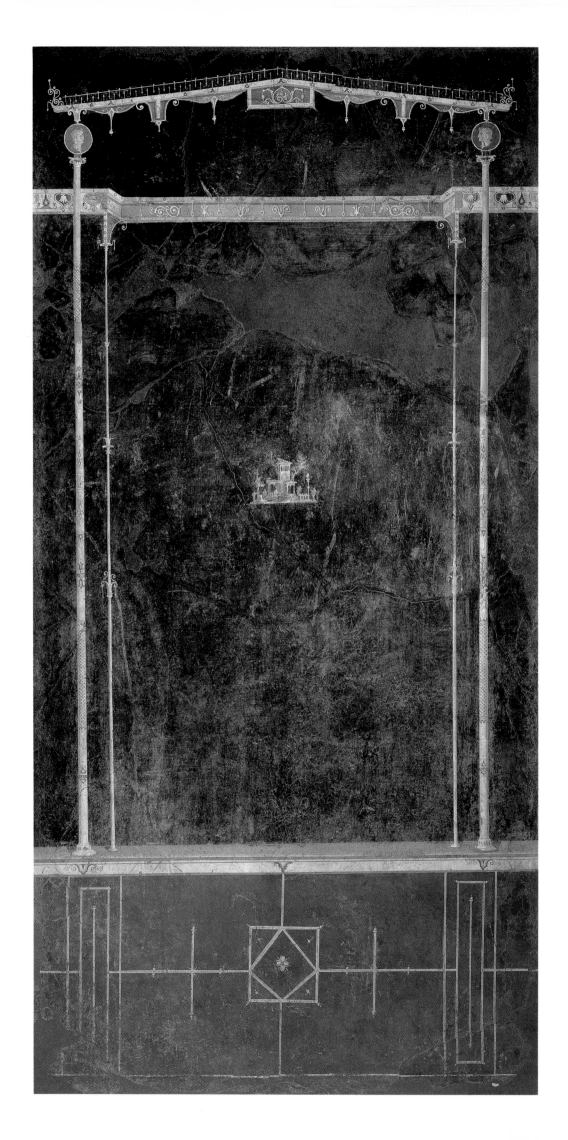

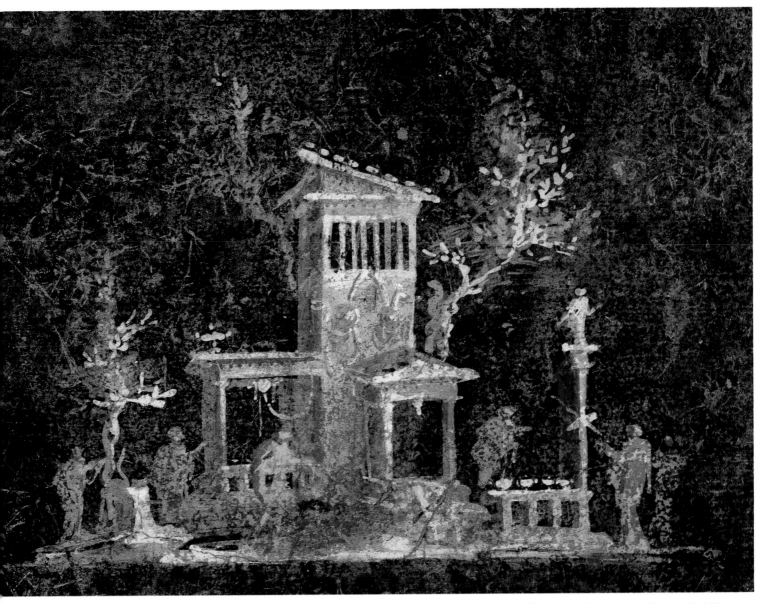

75 *Aedicula, Landscape, and Portrait Medallions*
Central panel of the north wall of Cubiculum
15 of the Imperial Villa at Boscotrecase
Mid-Augustan, ca. 11 B.C.
Wall painting; Painting: H. 91¾ in. (2.33 m.),
W. 45 in. (1.14 m.)
Rogers Fund, 1920 (20.192.1)

Above: detail

THE IMPERIAL VILLA AT BOSCOTRECASE

The third of the four Pompeian painting styles was developed around 15 B.C., when the taste for large figural painting and trompe-l'oeil landscapes began to seem old-fashioned. The paintings in the villa at Boscotrecase are among the earliest examples of the Third Style, dating to around 11 B.C. Whereas in the rear of the Boscoreale bedroom (Plate 65), large pediments open on a magnificent view of receding colonnades, in this bedroom from Boscotrecase, made a generation later, the sturdy architectural forms have been reduced to a spindly canopy resting on improbably thin columns that seem to be made of alternating vegetal and metal drums. Looking through the columns, we see no impressive panorama receding into the distance,

but instead an exquisite miniature landscape in inky blackness. The elements of the room thus seem to be a calculated play on the Second Style. This kind of visual witticism aroused the contemporary architect and critic Vitruvius to indignant attacks.

At the top of the panel are two portraits that appear to represent Livia, the wife of the emperor Augustus, and Julia, his daughter. From literary evidence we know that Julia owned this villa at Boscotrecase, and that Augustus may have visited it. The villa may have been completed, and this bedroom painted, in honor of Julia's wedding to Tiberius, the son of Livia (by a previous marriage) and Rome's second emperor.

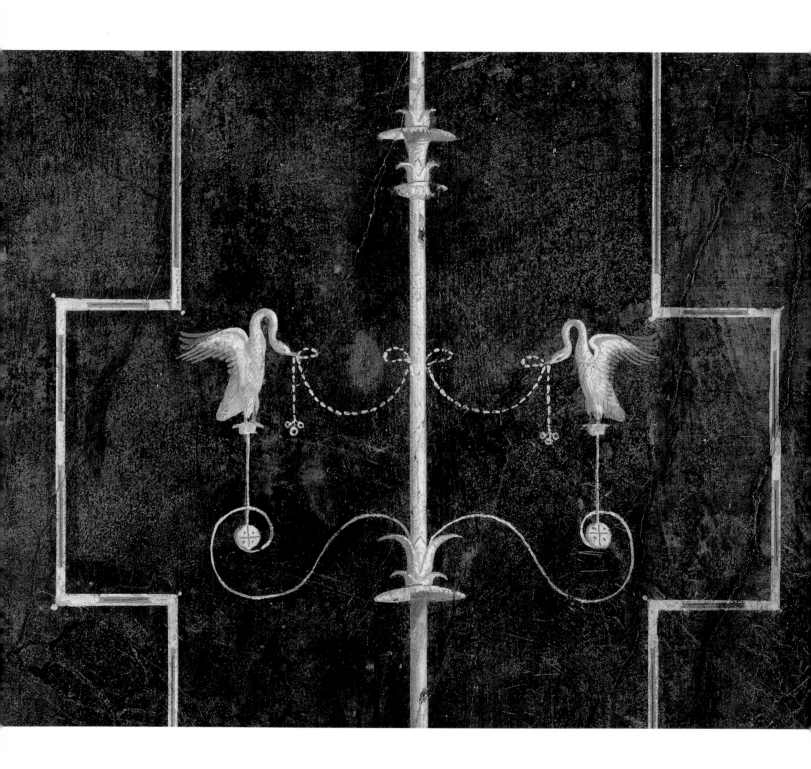

CANDELABRUM WITH SWANS

On either side of the main panel (Plate 75) on the bedroom's end wall were panels showing slim candelabra supporting yellow plaques with Egyptianizing scenes. Halfway up the candelabra two delicate swans hold a fillet in their beaks. The black wall behind the candelabra appears flat below, but turns into a semicircular niche above.

The swans are clearly related to the sculpted swans on the frieze of the contemporary *Ara Pacis* (Altar of Peace), a monument in the capital celebrating Augustus's pacification of the Roman world. Their inclusion in a bedroom containing portraits of the empress and the emperor's daughter further evinces a playful decorative program that incorporates imperial symbolism.

The figures in the yellow painted panel supported by the candelabrum have been identified as Apis, Sobek, and an Orans. The panel is an early Pompeian example of the "Egyptomania" that swept all of Italy in the late first century B.C. Augustus placed a special emphasis on Egypt in his iconographical program, constructing a sundial with an Egyptian obelisk in front of the *Ara Pacis* to symbolize his harnessing of Egyptian culture and science in Rome's service. The worship of Apollo, the sun god, is implicit in images of swans (birds sacred to Apollo) in an imperial setting, and dates from Augustus's victory over Antony and Cleopatra at the Battle of Actium in 31 B.C., which made him sole ruler of Rome.

76 Candelabrum with Swans and Egyptianizing Plaque
Panel from the north wall of Cubiculum 15
of the Imperial Villa at Boscotrecase
Mid-Augustan, ca. 11 B.C.
Wall painting; Painting: H. 91¾ in. (2.33 m.),
W. 20⅛ in. (51 cm.) Rogers Fund, 1920 (20.192.2)

Opposite: detail

Polyphemus and Galatea

Third-Style Roman bedrooms were often adorned with mythological paintings like this one from Boscotrecase. Such scenes apparently imitate the framed paintings that hung in Roman houses, and sometimes appear to have been arranged on the basis of their contents.

On the opposite wall of the bedroom from which this panel comes was a dramatic scene with a happy ending: the rescue of Andromeda by Perseus. By contrast, this painting shows the Cyclops Polyphemus as the unsuccessful suitor of the lovely sea nymph Galatea, who rides a dolphin at the lower left. Polyphemus is seated in the center of a rocky outcrop, which he shares with some of his goats; he professes his desire for Galatea with a melody on his panpipe, but to no avail. We know the outcome of this scene from Ovid (*Metamorphoses* 13.738–897), one of the greatest poets under Augustus. Galatea hid with her lover Acis, the son of Pan, while she listened to Polyphemus's song, but they were discovered, and Polyphemus rose in rage, throwing a boulder at Acis as he tried to escape.

At the top right of the painting is an episode from the return of Odysseus: Polyphemus, blinded by Odysseus and his companions, hurls a boulder at them. We are reminded here of the tragic end of the story of Galatea and Acis, since in Ovid's account, Polyphemus was happy when thinking tenderly of Galatea and permitted ships to come and go safely (*Metamorphoses* 13.769).

77 Polyphemus and Galatea
Panel from the west wall of Cubiculum 19 of the Imperial Villa at Boscotrecase
Mid-Augustan, ca. 11 B.C.
Wall painting; Painting: H. 73¾ in. (1.88 m.), W. 47 in. (1.19 m.)
Rogers Fund, 1920 (20.192.17)

79 *Plaque with a Satyr and Maenad*
Augustan, 31 B.C.–A.D. 14
Terracotta; H. 17½ in. (44.5 cm.),
W. 19⅞₁₆ in. (49.4 cm.)
Rogers Fund, 1912 (12.232.8b)

CAMILLUS

In the practice of Roman religion, it was an honor for young men to serve as *camilli*, or acolytes. Their function was to help in ceremonies, by carrying incense and performing related duties. The parent of the *camillus* was also an officiant in the ceremony; requirements for service were that both parents be alive, and that the *camillus* be freeborn and below the age of puberty. This bronze statue may not be a portrait, but rather a generalized likeness of a young practitioner in a Roman cult.

The *camillus* wears a tunic and sandals. His eyes are inlaid with silver, his lips with copper, and his tunic with strips of copper to suggest woven or embroidered bands of color. He holds a staff in his right hand and probably raised an incense box with his left hand.

78 Camillus
Claudian, A.D. 41–54
Bronze; H. 46⅛ in. (1.17 m.)
Gift of Henry G. Marquand, 1897
(97.22.25)

PLAQUE WITH A SATYR AND MAENAD

Terracotta reliefs like this one adorned Roman villas and showed figures and scenes largely derived from the repertoire of fifth- and fourth-century B.C. Greek relief sculpture. They date from the time of Augustus and reflect a widespread interest in Greek originals from the classical period. Here a satyr and maenad, followers of the god Dionysos, dance in ecstasy. The subject would have aroused controversy in Italy two centuries earlier when the wild celebrations of Bacchic rites led to a senate decree forbidding them. But by the time of Augustus, the cult had become so venerable that membership was again acceptable.

Too much emphasis on the subject of the plaque would miss its intended purpose. Bacchic iconography was popular in this period because of the huge assortment of active figural types inspired by drunken mania. This stylistic consideration, rather than a widespread devotion to Bacchus, explains the predominance of Bacchic themes in Roman decorative art.

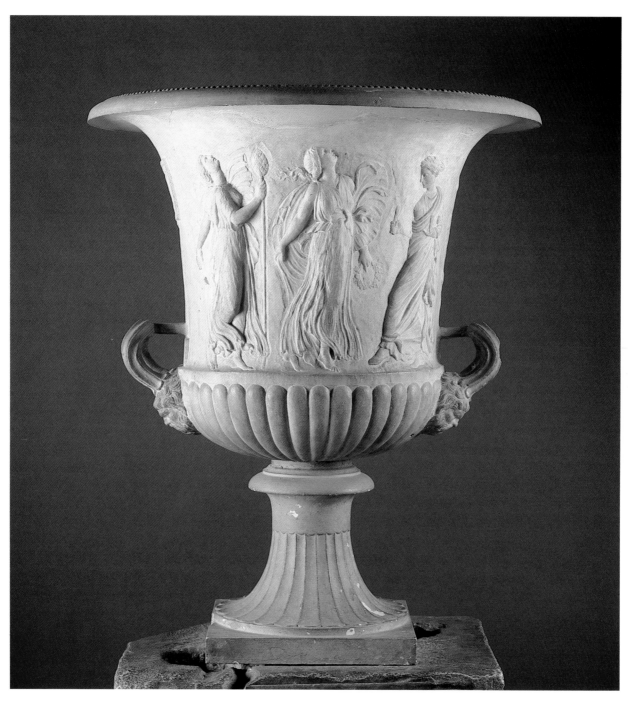

80 Crater with Dancing Maenads
Neo-Attic, lst c. A.D.
Marble; H. 31¾ in. (80.6 cm.)
Rogers Fund, 1923 (23.184)

NEO-ATTIC CRATER

Like the terracotta plaque with Bacchic figures in Plate 79, this work of Augustan date adorned a Roman villa. Although the vase was intended to be purely decorative, Bacchic subject matter is especially suited to its shape, since a crater was used for mixing wine and water.

The work is executed in the Neo-Attic style, so named because it was a revival of fifth-century B.C. traditions in Attica, the region around Athens. A brisk trade in the stock figures of Neo-Attic art sprang up in the late second century B.C. as Romans sought to fill their homes with echoes of Greek craftsmanship. Shipwrecks with analogous material have been found, perhaps destined for the Italian coast from Athens as well as from Alexandria in northern Egypt. Although of Athenian origin, examples of the Neo-Attic style are far-flung. Dancing maenads were copied as well in large marble reliefs, gems, glass, bronze, and virtually every other medium until the end of the first century A.D. The popularity of the school dwindled as Rome began to invent its own baroque style that, largely derived from historical reliefs, made the reliance on a Greek prototype seem dated.

Table Support from Campania

The luxuriant swirls of acanthus that fill the surface of this table support provide us with a precise date for the piece: shortly before the execution of the *Ara Pacis* in 13 to 9 B.C. The exuberance of the plant in this work was soon to be tamed in that official monument. Another factor contributing to its vivacity is that, unlike the Roman altar, this work is from the region around Naples and is thus more directly linked to Hellenistic decorative traditions and to older works of Asia Minor like the Pergamon Altar. It would have had a mate to support a long slab of marble, and might have stood in a villa garden.

81 *Trapezophoros (Table Support)*
Early Augustan, ca. 30–20 B.C.
Marble; H. 34⅝ in. (88 cm.),
W. 50¾ in. (128.9 cm.)
Rogers Fund, 1913 (13.115.1)

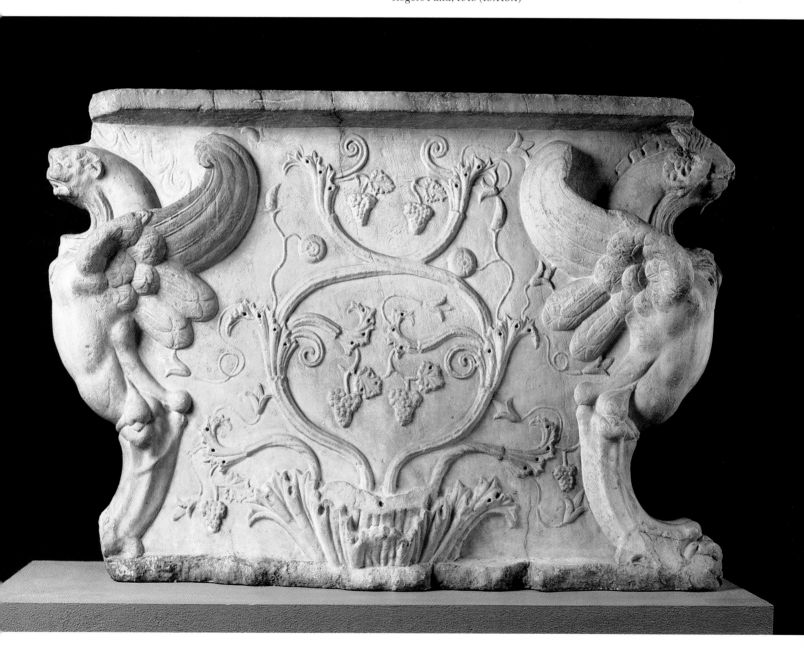

IVORY SANDALED FOOT

This tantalizing fragment of a large statuette is decorated with a personification of the Nile. Few comparable works in ivory on this scale survive, but ancient writers describe sculptures of this quality in ivory, gold, and silver in great numbers. Given the large size of the foot, it may have been part of a chryselephantine statue—in which the nude parts were made of ivory and the draped parts of gold—which would have served as a small cult figure in an Augustan temple.

Following Egypt's conquest by Rome under the emperor Augustus, interest in Egyptian art grew rapidly—as it did many centuries later during the reign of Napoleon, when hundreds of works were brought back to Paris. This is indicated also by the paintings of Boscotrecase shown earlier (Plate 76), one more example of how Rome's art, like that of Greece before it, profited from contacts with surrounding cultures.

82 Sandaled Foot from a Small Statue
Augustan, 31 B.C.–A.D. 14
Ivory; H. 2⅜ in. (6 cm.),
L. 5⅝ in. (14.3 cm.)
Fletcher Fund, 1925 (25.78.43)

83 Arretine Cup signed by Tigranes
Augustan, ca. 25 B.C.–A.D. 10
Terracotta; H. 7¼ in. (18.4 cm.),
D. 8⅝ in. (21.9 cm.)
Rogers Fund, 1910 (10.210.37)

ARRETINE CUP SIGNED BY TIGRANES

The most familiar type of Augustan pottery is known as Arretine ware, after the region in which it was produced (modern Arezzo). The glossy red glaze was cherished not only in antiquity, but it inspired artists of the Renaissance as well; Vasari had a large collection that he presented to Lorenzo de' Medici. Arretine ware shares many of the decorative elements of contemporary silver and cameo glass, especially in the popularity of Bacchic subjects and acanthus ornament. Many of the themes of Arretine ware belong to the Neo-Attic tradition, but this familiar repertoire is transformed and enlivened by potters who were proud enough to have stamped their names on the many vessels that survive.

The dancers and musician on this cup frolic in a field decorated with cymbals, panpipes, and tambourines (*tympana*), which are suspended from bows tied to garlands. Between the figures, flowers spring up to suggest that this celebration is taking place outdoors.

AMPHORISCUS BY ENNION

The makers of vases in antiquity often signed their works, as can be seen in late Archaic and early classical Greek pieces, in the Arretine cup (Plate 83), and here in this elaborate hexagonal glass amphoriscus (small amphora). It is signed in Greek by Ennion, an early master of mold-blown glass who made green, amber, and blue pieces and was a tireless innovator. Fewer than thirty examples of his oeuvre survive, but they are enough to establish him as one of the most able craftsmen in the medium. Ennion's vases were exported throughout the Roman world; they have been found in places as distant as Istanbul and Jerusalem, and in this case, Cyprus.

84 Amphoriscus signed by Ennion
Augustan, 31 B.C.–A.D. 14
Glass; H. 5⅜ in. (14.3 cm.)
Gift of Henry G. Marquand, 1881
(81.10.224)

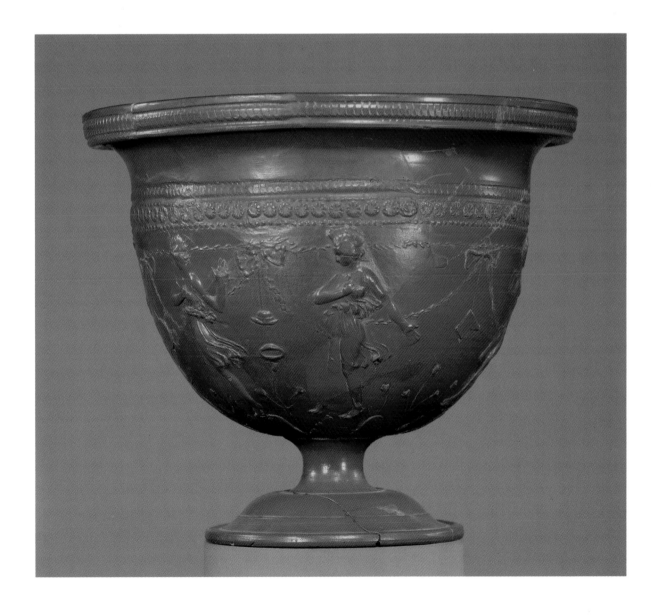

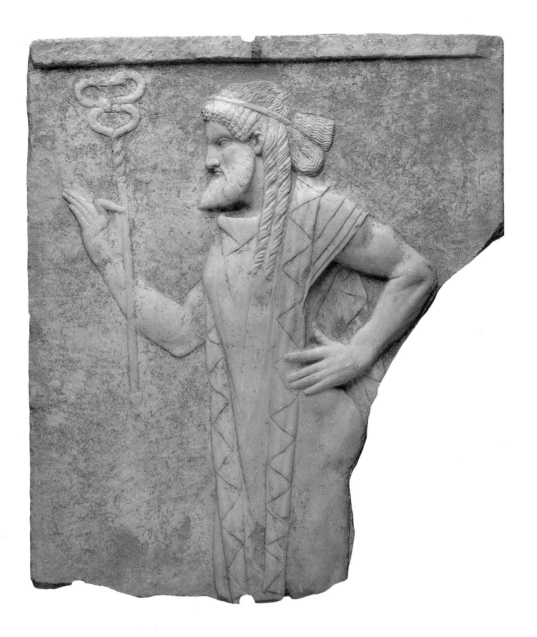

86 Cippus (Funerary Altar)
of Quintus Fabius Diogenes
Julio-Claudian, 1st half of 1st c. A.D.
Marble; H. 31¾ in. (80.6 cm.),
W. 16¾ in. (42.5 cm.)
Fletcher Fund, 1925 (25.78.29)

85 Relief with Archaistic Hermes
Roman, 1st c. A.D.
Marble; H. 26¾ in. (67.9 cm.)
Harris Brisbane Dick Fund, 1991 (1991.11.8)

RELIEF WITH ARCHAISTIC HERMES

Archaic is the term used to designate the style of Greek art that prevailed between about 600 and 480 B.C. It is characterized in part by great clarity of presentation, whether in the poses of figures or in details of accoutrement, such as garments, armor, and other attributes. From the late second century B.C. on, this style enjoyed a revival in Roman art. The figure of Hermes depicted here, and known in other examples, is an excerpt from a much-favored composition showing the gods Hermes, Athena, Apollo, and Artemis in procession.

CIPPUS OF QUINTUS FABIUS DIOGENES

Until the reign of Hadrian (r. A.D. 117–138), Romans were more often cremated than buried, and they were commemorated by elaborate tombstones, ash urns, or *cippi* (funerary altars) like this one. The inscription reads: "To Q. Fabius Diogenes and to Fabia Primigenia, who lived with him for 47 years, the freedmen and freedwomen and family of Q. Fabius Diogenes erected [this monument]."

The symbolism of the altar provides clues to Roman attitudes toward death and the afterlife. The rams' heads on the corners of the altar support garlands, which may allude to rebirth, as do the floral volutes at the top of the altar. An eagle sits protectively at the altar's center, and swans, perched on rocky outcrops, peck at the fruit in the garlands. Two smaller birds do the same just below the garland. This scene may imply some faith in the possibility of rebirth.

As on many grave monuments, the inscription is informative; the fact that Q. Fabius Diogenes was married for forty-seven years demonstrates that ancient lifespans were not uniformly brief. As was the custom in the early first century A.D., the slaves whom he freed contributed to the erection of this memorial.

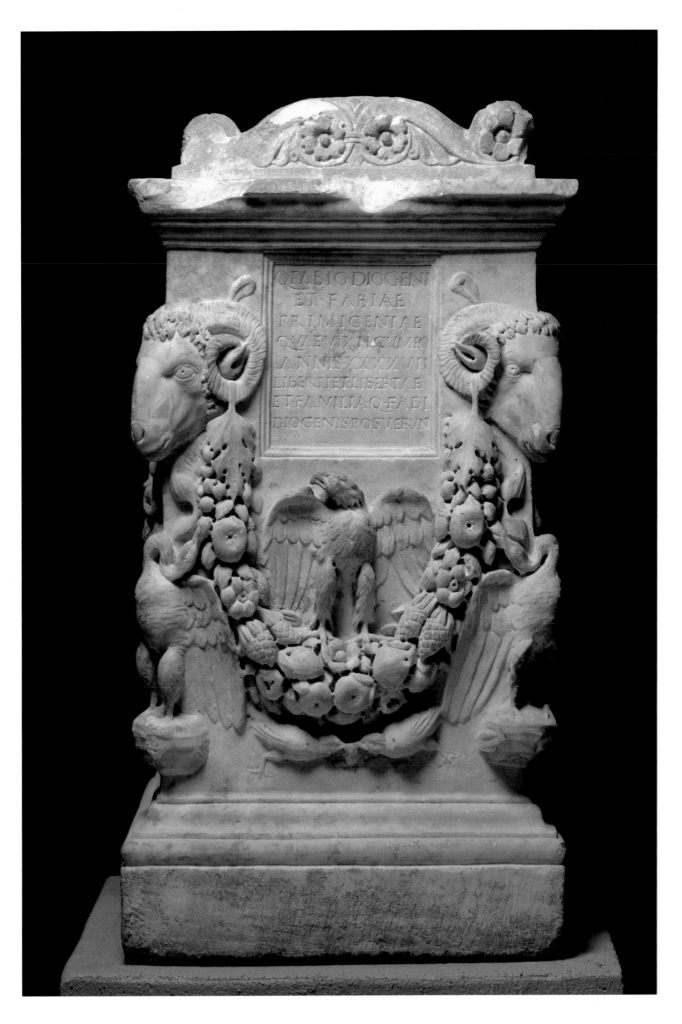

THE FLAVIANS

(A.D. 69–96)

The emperors of the Flavian period distinguished themselves from their sober predecessors of the Julio-Claudian age by exercising their preferences in the visual arts. Nero (r. A.D. 54–68) had earlier taken his authority so seriously that he tried to reshape the center of the capital into a private imperial residence, the Golden House, or *Domus Aurea*. The emperor Titus (r. A.D. 79–81) subsequently buried Nero's ambitions and erected the Colosseum over the remains of that palace, seeking to reduce the discomforts of the plebs, who lived in the increasingly crowded inner city. In addition, the Flavian age ushered in zoning laws and city planning, and five-story buildings began to relieve the crowded squalor of previously unregulated urban life.

The exuberance of Flavian architecture and decorative arts is reflected in the rich coiffures of Flavian women and the pompous portrait statues of men. Aspects of the late Republic seem to have been revived, as unabashed realism in portraiture coexisted with baroque Hellenistic style in painting and sculpture. This inspired artistic tumult came to a halt, however, with the death of the autocratic emperor Domitian (r. A.D. 81–96), whose demand that statues of him be made only of silver and gold typified the excesses of Flavian Rome.

DOMITIANIC MAN

This man's smirk sets him apart from the subjects we have examined thus far. His pleasure with his own appearance is also conveyed through fastidiously arranged hair. At one time the hair had added color, traces of which are visible today, and the whole effect must have been very lifelike. His disjointed nose may be a realistic rendering of an actual disfigurement rather than the result of poor workmanship.

The features of this portrait and its sculptural treatment, which includes a high polish, place it in the Flavian age, a time of artistic refinement and exuberance. The languor expressed in so many likenesses from this period, especially during the reign of Domitian (r. A.D. 81–96), reflects the tenor of official portraits, which have lost the matter-of-fact realism of the Claudian and early Flavian portraits and not yet attained the grand severity of the Trajanic period that followed.

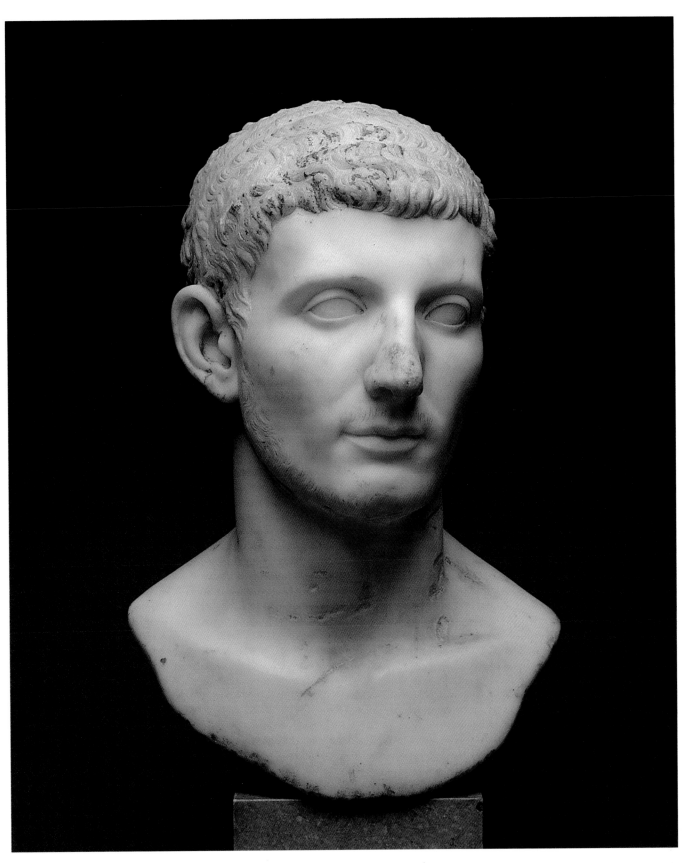

87 *Portrait of a Man*
Domitianic, A.D. 81–96
Marble with traces of pigment in the
hair and beard; H. 16½ in. (41.9 cm.)
Rogers Fund, 1909 (09.221.5)

ARCHITECTURAL SCULPTURE FROM THE PALACE OF DOMITIAN

High up on the Palatine Hill, overlooking the Roman Forum, the emperor Domitian (r. A.D. 81–96) decided to build a sumptuous imperial palace that would supersede Nero's ill-fated Golden House. The Palatine was the hill chosen by Romulus, the founder of Rome, for his first hut, and later by Augustus, Rome's first emperor, for the first imperial residence. The massive concrete complex—our word "palace" derives from its situation on the Palatine—was undertaken by the architect Rabirius and was richly decorated with statuary, colored marbles, frescoes, and mosaics. These two sections of cornice appear to have come from the imperial palace, and perhaps more specifically from the throne room, or *Aula Regia*. The *Aula Regia* was 138 feet long and 105 feet wide: wider than the central nave of St. Peter's in the Vatican.

Such elaborate fragments of architectural ornamentation from the imperial palace serve to give an impression of the extraordinary naturalism of late Flavian ornament, which almost bursts with the lively acanthus palmettes adorning the facade of the cornice; even the veins on the leaves are rendered. Domitian's palace was enlarged in the third century A.D. and continued to serve as the home of the emperors until the end of Roman rule in the West.

88 Sections of Cornice from the Aula Regia (Throne Room) of Domitian's Palace
Domitianic, ca. A.D. 90–92
Marble; left: H. 10 in. (25.4 cm.), L. 37½ in. (95.2 cm.); right: H. 19 in. (48.3 cm.), L. 29 in. (73.6 cm.)
Gift of J. Pierpont Morgan, 1906 (06.970d; 06.970b)

89 Mask of a Silenus from a Situla (Bucket)
1st c. a.d.
Bronze; H. 12 in. (30.5 cm.)
Gift of Mrs. Gerald van der Kemp,
1958 (58.140)

90 Cippus (Funerary Altar) of Cominia Tyche
Late Flavian or Early Trajanic, ca. a.d. 90–100
Marble; H. 40 in. (101.6 cm.)
Gift of Philip Hofer, 1938 (38.27)

Mask of a Silenus

This magnificent image of an elderly satyr is one of a pair originally attached to a large bronze *situla*, or bucket. His luxuriant beard radiates in corkscrew curls, and the ivy wreath and silver headband he wears are accoutrements of members of the cult of Bacchus. Half-closed eyes and a lax, open mouth convey his drowsiness from the wine within the vessel. Images of Bacchus and his followers were especially common on Roman drinking vessels, and the figures were often shown drunk as an inspiration to the host and his banqueting guests.

Masks of an old silenus and younger satyrs were also popular decorations on painted walls, as architectural sculpture, and on plaques, altars, furniture, mosaics, and gems. The progressive agnosticism of the Roman world until the mid-second century a.d. left Graeco-Roman gods without their original power, and artists often turned to religious subjects out of formal or decorative interest rather than devotion. Our silenus shows that Rome's secularization did not bring about a loss of artistic talent.

Cippus of Cominia Tyche

We know this lady's name from an inscription below the portrait, which reads: "To the Spirits of the Dead. To the most pious Cominia Tyche, his most chaste and loving wife, [from] Lucius Annius Festus. [She] died at the age of 27 years, 11 months, 28 days. Also for himself and his descendants."

This *cippus* or funerary altar, is known to have been in a house near the Roman Forum in the sixteenth century; it entered the collection of Cardinal Francesco Barberini during the seventeenth century. A jug and *patera* (libation dish) on the sides of the monument allude to the common practice in antiquity of pouring liquids as an act of commemoration, recalling the tradition of placing flowers at the graveside, which the Romans also observed.

The portrait is of a woman who lived at the end of the first century a.d. and follows contemporary fashion: She wears her hair in a high toupee of curls across the front. The regular alignment of the curls places this early in the reign of the emperor Trajan, though the elaborate hairstyle remained essentially unchanged since the late Flavian period.

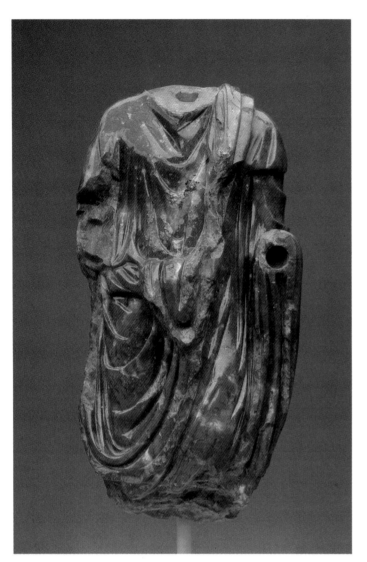

TOGATUS

Statues of Roman men wearing the toga help to chronicle the transition in fashion from Republican conservatism through Augustan experimentation to Flavian opulence, appropriately documented here in the expensive medium of jasper. These sculptures are of considerable use not only to the student of Roman costume, but to those interested in the transformation of Roman society's privileged class from one relying on Etrusco-Italic traditions to one concerned more with a dignified appearance.

This example from a number of *togati* in the Museum dates from the late first or second century A.D. Although the *togatus* lacks the head and arms and is broken at the knees, what remains is of the highest quality. To judge from the neat cylindrical holes in the neck and where the arms should be, these extremities were added in another material, perhaps marble or ivory.

91 Togatus
Late 1st c. A.D.
Jasper; H. 7⅜ in. (18.7 cm.)
Rogers Fund, 1917 (17.230.54)

92 Intaglio of a Gladiator Battling a Lion
1st c. A.D.
Carnelian; H. ⁹⁄₁₆ in. (15 mm.)
Bequest of W. Gedney Beatty, 1941
(41.160.710)

Right: impression

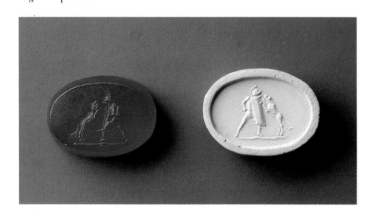

GLADIATOR BATTLING A LION

The Roman gladiator, so named for the *gladius*, or short sword, he sometimes used, has stimulated the imagination of postclassical writers up to the present and has generated more fiction than fact. Gladiators were for the most part prisoners of war, condemned criminals, and slaves, who were trained in schools of combat. The games in which they fought were held on a variety of occasions, often in celebration of a victory. For the most part, educated Romans, like Cicero, held the profession in contempt, but the gladiator image has nevertheless come to symbolize the violent predilections of Roman civilization. In point of fact, gladiatorial games in ancient Rome were no more common than well-attended public hangings in the seventeenth century.

The gladiator in this carnelian intaglio wears armor and a helmet with a fish for a crest, and carries an oblong shield, marking him as a *mirmillo*, one of the four classes of gladiator (the others are the Samnite, *retiarius*, and Thracian). His opponent is a lion, who rears up in front of him. Engraved rings and reliefs on lamps with this theme were common in the imperial period. For its defenders like Pliny the Younger, gladiatorial combat provided the means to prove bravery and scorn of death.

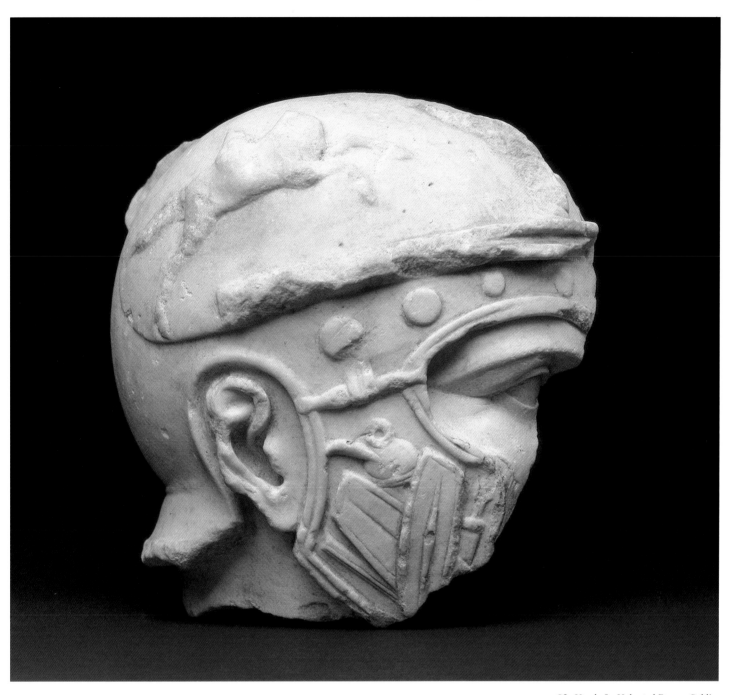

93 Head of a Helmeted Roman Soldier
Vespasianic, A.D. 69–79
Marble; 7 1/16 x 7 1/8 in. (18 x 18.1 cm.)
Fletcher Fund, 1925 (25.78.62)

HEAD OF A HELMETED ROMAN SOLDIER

Of the face of this soldier, only the right eye and part of the cheek have survived. The helmet is better preserved, but the relief is broken just below it, and of the cheek-piece only the upper half remains. A remnant of the crest rises toward the back of the helmet. In the front of the helmet the decorative right eyebrow is preserved; it tapers and curves up sharply in such a way as to resemble a horn. On the side, just above the level of the horizontal brow reinforcement, is what remains of a galloping horse and rider.

The helmet type may be dated to about A.D. 50–75. The sharp detailing of the eye and the fleshy fold above it combine to give the soldier a squint. The deep carving, the facial expression, and the fleshy brow indicate a Flavian date, perhaps around the time of the Emperor Vespasian.

It is difficult to determine in what kind of monument the soldier might have served. The head is close in scale to those on the roughly contemporary Arch of Titus, and it may have been part of a monument comparable in quality, if not in size. He could be listening to his emperor's orders or marching in a procession.

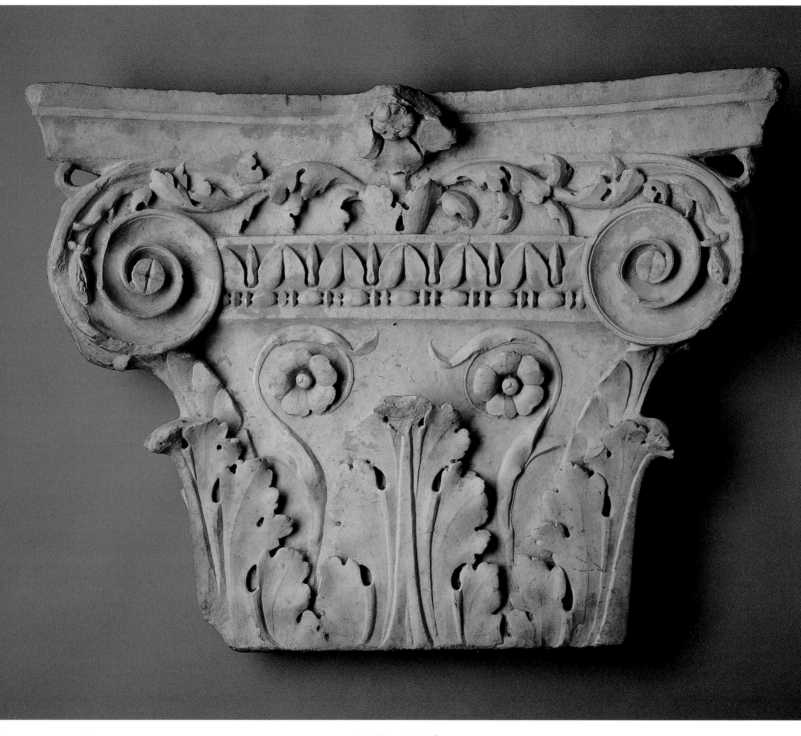

94 Pilaster Capital
Mid-1st c. A.D.
Marble; H..21 in. (53.3 cm.),
W. at top: 28 in. (71.1 cm.)
Fletcher Fund, 1926 (26.60.84)

PILASTER CAPITAL

This capital with acanthus leaves once crowned a marble pilaster. Like the fully preserved pilaster (Plate 96), it reveals a controlled approach to ornament, more restrained in feeling than the exuberant decoration of the sections from the Palace of Domitian (Plate 88). The acanthus leaves here are more subtly modeled, and the sculptor made use of a drill to emphasize various details. In addition to the Ionic volutes of the capital, we find an acanthus plant near the abacus at the top, a flower in the center of the abacus, and a cymatium of leaves, below which is a bead-and-reel pattern.

124

GLASS ALABASTRON

The technique of fusing glass rods of various colors and pressing them into molds produced extraordinary results. This alabastron, or perfume container—awash with color and delicate in shape—is an example of the technique. The green glass matrix has bands of various colors and shattered gold leaf. The top has a small hole for dispensing droplets of liquid, but it can be removed altogether in order to fill the alabastron.

95 Glass Alabastron
Early 1st c. A.D.
Glass and gold leaf;
H. 7⅛ in. (18 cm.) Gift
of J. Pierpont Morgan,
1917 (17.194.286)

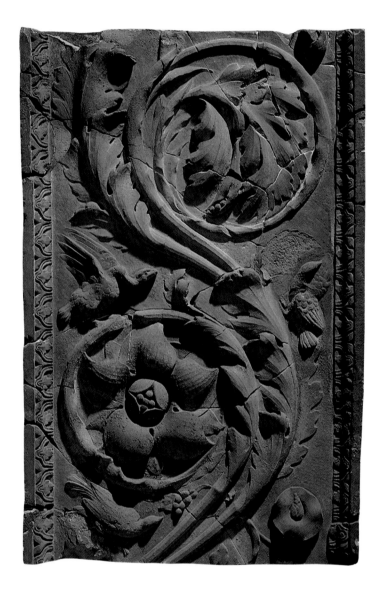

PILASTER OF ACANTHUS

Foliated scrolls rise from a cluster of acanthus leaves at the base of this towering pilaster, which reaches 11 feet 6 inches in height. Aside from the main scrolls, separate tendrils and flowers grow at various points, while birds, a lizard, and Eros appear in the field.

The Roman talent for carving foliate friezes was inherited from the Hellenistic world, in the art of Pergamon, but the Romans represented the acanthus plant in a more organized fashion than had late Greek craftsmen. This frieze dates from after the great tradition of the Augustan *Ara Pacis*, and is a baroque revival of Hellenistic taste.

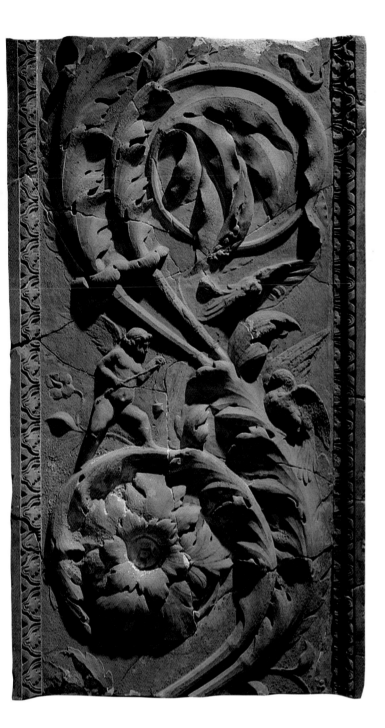

96 *Pilaster with a Foliate Acanthus Rinceau*
1st c. A.D.
Marble; 11 ft. 6 in. x 2 ft. 4⅜ in.
(3.5 m. x 72 cm.)
Rogers Fund, 1910 (10.210.28)

Assembled view: Page 4

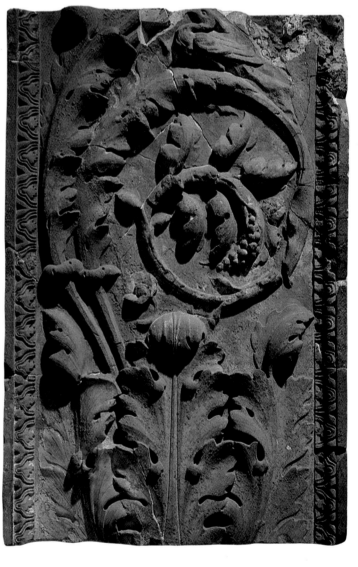

Bronze Silenus from a Couch

The lively countenance and torsion of this aging satyr set him apart from his sleepy relative discussed earlier (Plate 89). This silenus has a corkscrew beard and ivy wreath as well, but his animation suggests a different stage in Bacchic worship. Whereas the silenus from a wine bucket (Plate 89) has finished both his wine and his revelry, this wide-eyed silenus seems in the midst of animated celebration. His chest hair is indicated by silvery inlay, and the *nebris* (panther skin) he wears has the cat's spots indicated in niello. Silver is also used in the eyelids, and copper for the berries in his wreath, the edge of the panther skin, and the central line of the fillet.

This appliqué decorated the fulcrum or armrest of a couch, and may have glared at the reclining banqueter along with a similar celebrant in mirror reverse at the other end of the couch. It is said to come from Ephesus in Asia Minor and reflects the great tradition of works of art in that region made in the service of Bacchus. Ephesus was long the seat of the Asiatic branch of the Artists of Bacchus, a guild of craftsmen, musicians, and actors that constructed temples and produced festivals; their talents were employed in the minor arts as well. Our silenus's urgent mood recalls both the fierce devotion of Bacchus's followers to their god and their paradoxical alarm at his own inebriation.

97 Couch Attachment in the Form of a Silenus
1st c. A.D.
Bronze with copper, niello, and silver inlay;
H. 4¾ in. (12 cm.)
Gift of Estate of Dr. Jacob Hirsch, in memory
of Dr. and Mrs. Jacob Hirsch, 1955 (55.129.2)

A Hadrianic Man

The presence of a beard and the use of a drill to indicate the pupils are features suggesting that this portrait was made in the reign of the emperor Hadrian (r. A.D. 117–138). The shape of the eyes and of the beard may imply that the sitter came from the East.

The East was important in the reign of Hadrian since his personal preferences leaned heavily toward Greek culture and taste. Hadrian served in Athens under his predecessor Trajan and traveled for seven years around the provinces while emperor. His Greek pretensions led him to complete the Olympieum, or temple of Olympian Zeus, at Athens, and to accept the title Olympius.

Men's fashions changed less than women's, but this sitter's long hair sets him apart from the run of portraits executed under Trajan. The popularity of beards during the reign of Hadrian was in part due to the emperor's cultivation of one. Beards had previously been reserved for periods of mourning. The Republic, with its suspicion of all un-Roman traits and manners, seems quite remote when we look at this admiring commemoration of a bearded foreigner.

THE TRAJANIC AND HADRIANIC PERIODS

(A.D. 98–138)

The emperor Trajan (r. A.D. 98–117) extended the empire's borders to eastern Europe and the Persian Gulf, and he commissioned public buildings on a scale not seen since Augustus. The visual arts reflected the new purposefulness of this well-liked Spanish soldier-emperor and turned from the vivacity of the Flavians to a more sober style. Under Trajan, it became fashionable in men's portraiture to don an officer's cape, and foppish hairstyles disappeared in favor of more neatly trimmed bangs. Portraits of women retained elaborate hairstyles, but their expressions were more solemn, and decorative sculpture became a little more formal and less expressive.

The emperor Hadrian (r. A.D. 117–138) advanced Rome's claim to the provinces with his wall in the north of England, while his fascination with classical art revived a style popular under Augustus. Hadrianic classicism, coming as it did a century after the empire's founding, was a selective adaptation of classical Greek style. Romantic allusions to the classical world abounded in his private villa at Tivoli as well as in the lavish marble sarcophagi made popular during his reign.

98 Portrait of a Man
Hadrianic, A.D. 117–138
Marble; H. 9⅝ in. (24.5 cm.)
Rogers Fund, 1915 (15.145)

99 *Portrait of Marciana,*
Sister of the Emperor Trajan
Hadrianic, A.D. 117–138
Marble; H. 12¼ in. (31.1 cm.)
Rogers Fund, 1920 (20.200)

PORTRAIT OF MARCIANA

The emperor Trajan's older sister Marciana was deified by the Senate on August 29, A.D. 113. Several posthumous portraits were then sculpted of her, including this version, which distinguishes itself from the more reserved Trajanic sculptures by its high polish and drilled pupils. Other examples of the type are in Ostia, Florence, and the Vatican.

Trajanic and Hadrianic portraits often have a cool reserve, which reflects the neoclassical revival of the period. Impe-
rial likenesses in particular show this aloofness, but several private portraits also adopt the prevailing style of the emperor and his court.

The headdress of Marciana is as elaborate as the long coils of braided hair piled on top of her head. The elaborate coiffures of Roman ladies enable us to date portraits with some precision, since fashion in cosmopolitan Rome changed then as often as it does today.

Urn in the Form of a Marble Basket

Marble imitations of wicker baskets served as cinerary urns or as the *cistae mysticae* (mystical baskets) of Bacchic rites. An inscription on another monument tells us that a baker named Eurysaces placed his wife's ashes in a marble breadbasket.

The loving attention to detail in this work grows out of the persistent Roman fascination with trompe l'oeil, and this marble basket functions like a wicker one, since the cylindrical lid is removable. A comparable basket, out of which crawls a snake, may be seen carved on a Dionysiac sarcophagus from the third century A.D. (Plate 122).

100 Urn in the Form of a Cylindrical Basket
1st c. A.D.
Marble; H. 9¹¹⁄₁₆ in. (24.6 cm.), D. 12⁷⁄₁₆ in. (31.6 cm.)
Gift of Mrs. Frederick E. Guest, 1937 (37.129a-b)

SARCOPHAGUS WITH SCENES FROM THE STORY OF THESEUS AND ARIADNE

This late Hadrianic masterpiece of carving is the earliest Roman sarcophagus in the Museum's collection, and it is among the finest. Until the reign of Hadrian, sarcophagi (literally, flesh-eaters) as a means of burial were less popular in Rome than were ash urns.

On the front and sides of the coffin, eight Erotes shoulder heavy garlands made from various types of leaves. Three scenes of the story of Theseus and Ariadne are depicted above the swags. At the left, Ariadne presents Theseus with the clue that will enable him to find his way back out of the Labyrinth. In the center, Theseus does battle with the Minotaur, seeming to have the edge already. On the right, Ariadne is abandoned by Theseus on the island of Naxos to await the arrival of her future husband, Dionysos.

The three sequential scenes illustrate the Roman penchant for narrative, which attracted the literal-minded Romans more than it had the Greeks. It also suggests a less than totally resigned attitude toward death, since Ariadne's fate may imply hope for the middle-aged man whose skeleton was retrieved from this coffin almost a century ago. The lid of the sarcophagus shows a lively chariot race waged by more Erotes, who enlist the help of bears, lions, bulls, and boars to round the turning posts at each end and reach the palm tree of victory in the center. From seasonal attributes in the form of plants in the background, it may be deduced that the Erotes represent, from left to right, Spring, Summer, Fall, and Winter.

101 Sarcophagus with Scenes from the Story of Theseus and Ariadne
Late Hadrianic, ca. A.D. 125–138
Marble; H. 31 in. (79 cm.),
L. 85¾ in. (217.8 cm.)
Purchase by subscription, 1890 (90.12)

Opposite: detail

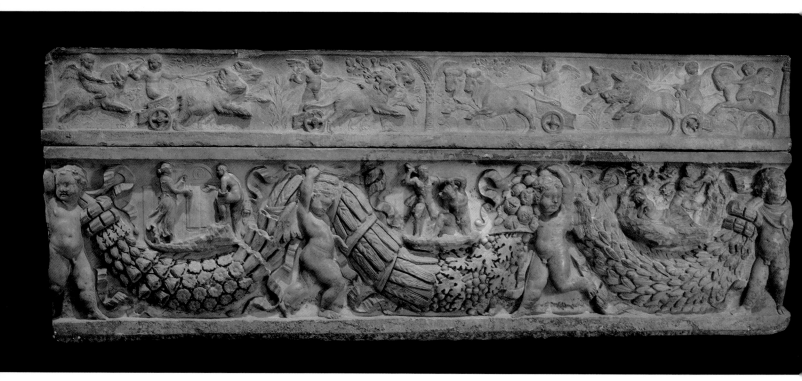

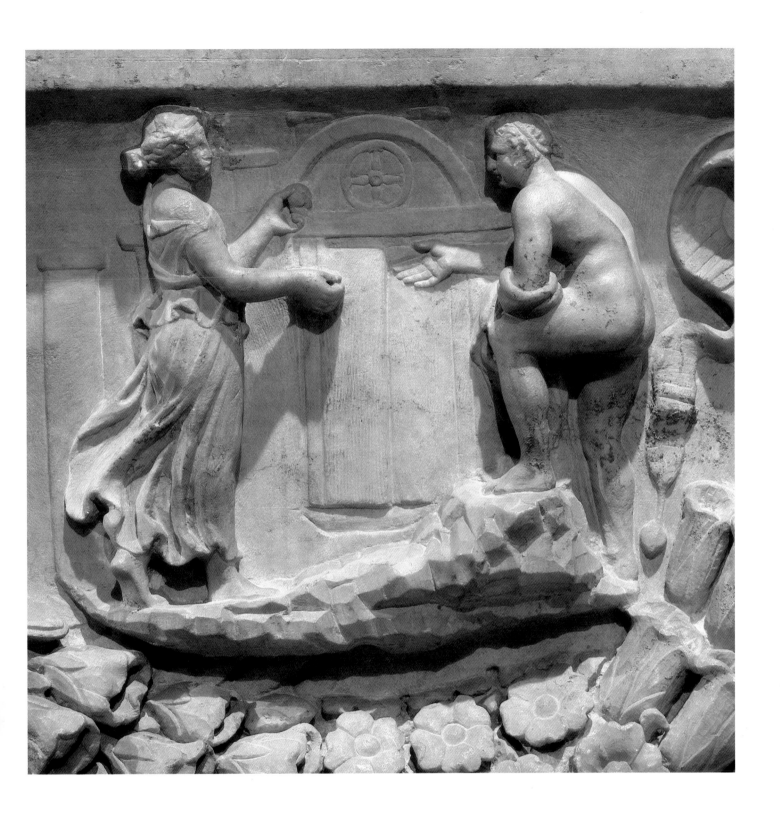

THE ANTONINE AGE

(A.D. 138–193)

Sculptors of the Antonine dynasty employed the drill with daring, achieving technically superb results never before realized in sculpture. At the same time, the philosophical dispositions of Antoninus Pius (r. A.D. 138–161) and his successor, Marcus Aurelius (r. A.D. 161–180), are reflected in the new meditative mood of male portraiture. Like the majestic column of Marcus Aurelius in Rome, marble sarcophagi present swarming battle scenes, alluding to actual campaigns against the Parthians. This bold, documentary approach to sculpture was anathema to classicism, and the late Antonine period reveals an impulse toward frontality and abstraction. The hard-won lessons of perspective were of little concern to late second-century sculptors. Sculptural friezes of the period are densely populated with figures in great commotion, often wearing anxious expressions that contrast with the calm bearing of contemporary portraiture.

102 Portrait of the Emperor Antoninus Pius
Early Antonine, A.D. 138–161
Marble; H. 15⅞ in. (40.4 cm.)
Fletcher Fund, 1933 (33.11.3)

PORTRAIT OF THE EMPEROR ANTONINUS PIUS

The classical revival under Hadrian had its roots in the Greek East, but the relative modesty of Antoninus Pius (r. A.D. 138–161), and the fact that he may never have left Italy during his reign, set him apart from his predecessor. His celebrations of Rome's 900th anniversary in A.D. 147 focused on the city and not her caretaker, and his respect for the Senate was no less impressive—it conferred on him the title *Pius* (devout). He presided over one of the most peaceful periods in Roman history, and he was commemorated after his death by a temple to himself and his wife, Faustina Maior, in the Roman Forum.

Antoninus's gentle spirit is conveyed in this masterful portrait, which is broken from a statue. He retains the neat beard made fashionable by Hadrian and makes no grandiose statements in official portraiture; his contributions to the empire were more subtle.

*103 Relief with the Emperor Antoninus
Pius and a Suppliant Barbarian*
Early Antonine, A.D. 138–161
Stucco; H. 8¼ in. (20.9 cm.)
Rogers Fund, 1909 (09.221.37)

THE EMPEROR RECEIVING A SUPPLIANT

While a benevolent leader, Antoninus recognized the need to cultivate a public image in keeping with his high office. This decorative fragment shows the emperor receiving a suppliant, identifiable as a barbarian because he kneels and wears trousers, which Romans did not wear. The emperor stands before a tent and seems disposed to his customary clemency, while the barbarian gestures imploringly. This image of the generous ruler reminds us of the commemorative column erected to him in the Campus Martius, which followed that built in Trajan's honor and preceded the column built in honor of his successor, Marcus Aurelius. The columns erected before and after Antoninus's displayed hundreds of such honorific scenes, including the emperor with his troops at the frontier, and this fragment doubtless alludes to this tradition. The scene may show one of the campaigns to quell revolts in Germany or Dacia.

Stucco ceilings and friezes were common in Roman homes and often show Bacchic scenes, but this subject is exceedingly rare. In general, Roman historical sculpture is found on architectural monuments like columns and triumphal arches, and we are fortunate that this glimpse of a reluctant military commander has been preserved.

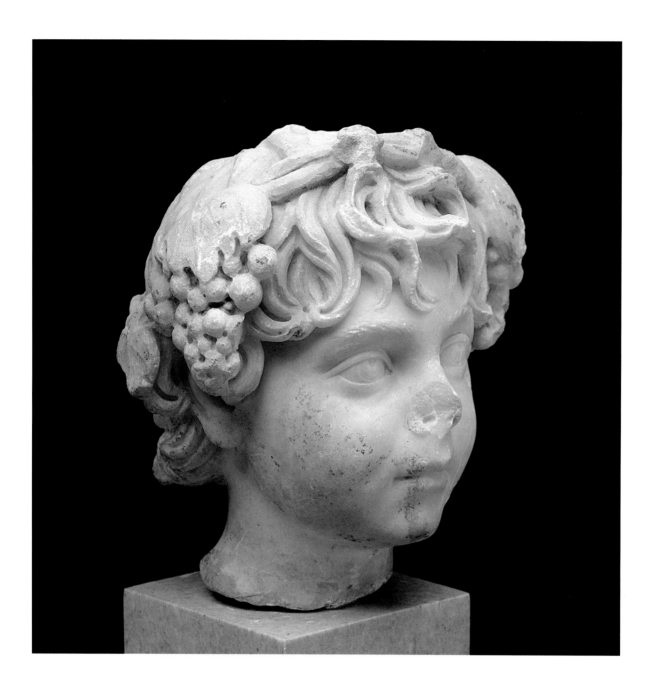

BOY IN THE GUISE OF BACCHUS

Unlike the bronze sileni who adorned vases and furniture
(see Plates 89 and 97), this wreathed Bacchic celebrant was
a young boy of good family. His parents wished him por-
trayed in the guise of Bacchus, which suggests that he may
have been an acolyte in the cult. His full, tousled hair, bulky
wreath, and faintly cherubic smile distinguish him from the
sober young girl on the facing page. Here the free use of
the drill complements the exuberant spiritual doctrine into
which he was apparently born.

104 Portrait of a Boy in the Guise of Bacchus
Early Antonine, ca. A.D. 140–150
Marble; H. 8¼ in. (21 cm.)
Rogers Fund, 1914 (14.105.1)

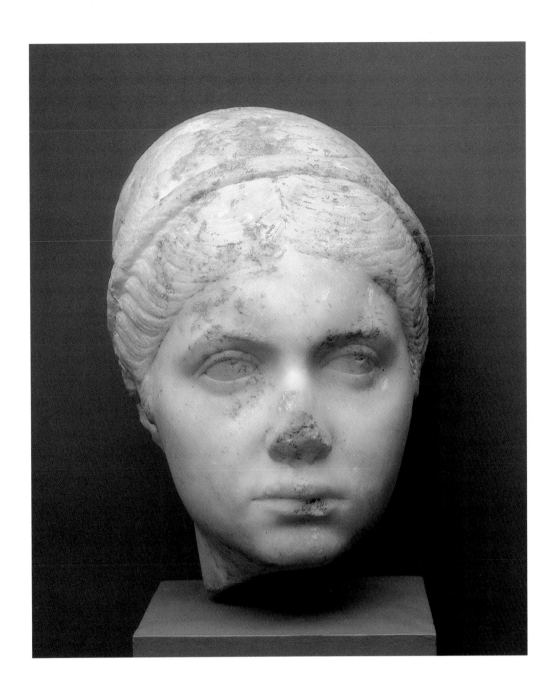

ANTONINE GIRL

A very similar portrait in Rome's Capitoline Museum has raised the question of this girl's identity, as it would seem that she was of sufficiently high stature in society to merit at least two portraits. If she died young, her parents may have commissioned more than one likeness of her as remembrances.

The solemnity of her expression is more a reflection of her character than of the period, since other Antonine portraits of women were often cheerful. Her hair is neatly parted and swept up into coils on top of her head, but she, like adult women of the time, has abandoned the elaborate hairpieces that predominated in the late Flavian and Hadrianic periods.

105 Portrait of a Girl
Early Antonine, ca. A.D. 138–150
Marble; H. 10⅛ in. (25.7 cm.)
Rogers Fund, 1910 (10.210.22)

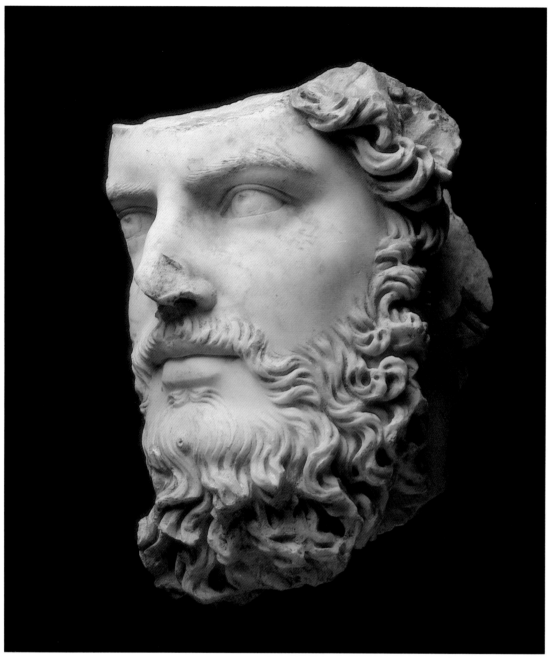

PORTRAIT OF THE EMPEROR LUCIUS VERUS

Marcus Aurelius (r. A.D. 161–180) and his coemperor Lucius Verus (r. A.D. 161–169) followed Antoninus Pius. This later phase of the Antonine period introduced rich sculptural detail through the use of the drill. The drill was well suited to the articulation of the longer beards that came into fashion under Marcus and Verus.

This portrait of Verus comes from a relief that may have been an ambitious historical monument. The irony of Verus's commemoration as a victor is his utter failure in that role; the task was ably but unenthusiastically taken up by his coruler Marcus. Verus was better known for his easy life at Antioch. His more thoughtful and accomplished coregent was the author of letters and the Stoic *Meditations*, which reveal a capable philosophical mind. The prevailing current of Stoicism in this period addressed ethical issues, rather than questions of pure theory, and it exercised a profound influence not only on the Antonine emperors—informing their respect for the Senate—but on later beliefs, most notably Neoplatonism and Christianity.

The reflective mood of this likeness and that of many other portraits of the period, often shown with upraised eyes, testifies to the growth of religious conviction in the Roman world and sets the stage for Rome's eventual undoing through foreign creeds.

NEREID RIDING A HIPPOCAMP

Antonine mosaics are every bit as lively as the elaborate works in sculptural relief of the time, and the subject of this mosaic, a Nereid riding the waves on a monster that is half-horse, half-sea creature, is a common subject on marble sarcophagi of the time. Antonine mosaics depart from the Hadrianic preference for small, fine tesserae; instead, they employ a larger tessera, which results in fewer gradations and a more powerful, expressionistic form. Here the figures are enclosed in an octagonal frame, and they are rendered in slightly smaller tesserae than the surrounding patterns of chevrons, triangles, and guilloches. The mosaic was apparently part of a large floor that may have included a variety of mythological and allegorical scenes.

107 Nereid Riding a Hippocamp (Sea-Horse)
Antonine, ca. A.D. 138–180
Mosaic; 50 x 50½ in. (127.0 x 128.3 cm.)
Gift of Susan Dwight Bliss, 1945 (45.16.3)

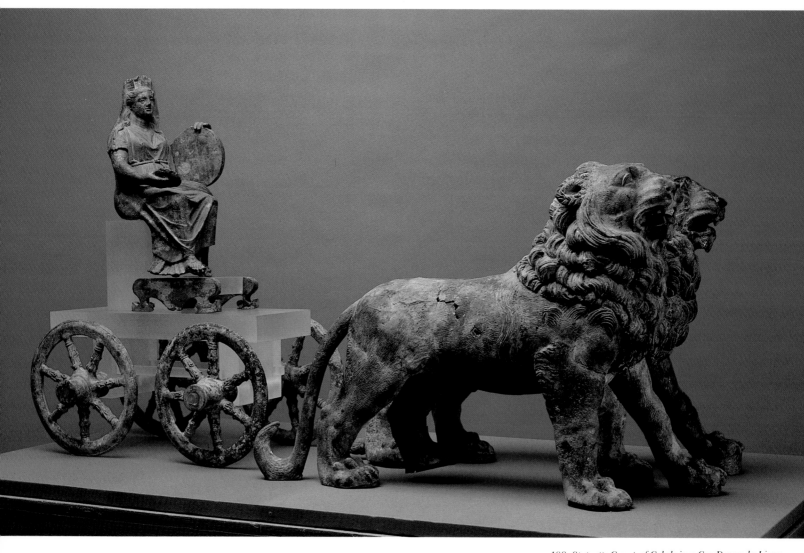

108 *Statuette Group of Cybele in a Car Drawn by Lions*
2nd half of 2nd c. A.D.
Bronze; L. 54¾ in. (139.1 cm.), W. 12 in. (30.5 cm.)
Gift of Henry G. Marquand, 1897 (97.22.24)

CYBELE IN HER CHARIOT

The Asiatic mother goddess, Cybele, was one of the foreign divinities who joined the Roman pantheon. Her appearance in Rome dates to 205 B.C., when the Senate sought refuge from plebeian criticism by shrouding their decisions in the mysterious instructions of the Sibylline books. A convenient prophecy that an alien invader would be forced out of Italy if the Great Mother were received in the capital—Hannibal was losing his Italian campaign—prompted Cybele's arrival. Her first Italian temple was built on the Palatine in 191 B.C., but the cult was slow to spread, since allegiance initially required castration. Roman citizens accordingly ceded the honor of priesthood to Phrygians. By the time of Claudius,

however, membership had become less exclusive.

This elaborate bronze group from a fountain shows Cybele in a wagon being drawn by lions. Here the lions do double duty as waterspouts. Each year on March 27, the festival of Cybele and the young Attis ended with the procession of a silver cult image of the goddess carried in a car to a river, where it was ceremoniously bathed. That rite symbolized the earth's fertilization by rain. The cult lived on in Rome until the early fifth century A.D., when it was effectively adapted to the purposes of a younger religion: Throughout Italy today, sculptures of the Virgin Mary are washed in much the way Cybele is said to have been.

THE SEVERAN DYNASTY

(A.D. 193–235)

Septimius Severus, the first African-born emperor (r. A.D. 193–211), managed to quell disorder stemming from the empire's unchecked growth in the century following Trajan's reign and from the battle for succession following the assassination in A.D. 193 of Commodus (r. A.D. 180–193), the last Antonine emperor. Septimius's portrait types develop from that of a soldier to one resembling Marcus Aurelius, and eventually to one exchanging long, deeply drilled locks for curly, close-cropped hair. The sudden difference in how the drill was used—from elaborate Antonine channels and undercutting to the staccato rhythm of holes and lozenge shapes—signals a larger shift in artistic direction, toward a more limited concern with naturalism, and a preference for simplified forms. Caracalla (r. A.D. 211–217), the son of Septimius, cut his hair and beard shorter than had ever been the Roman fashion, and he adopted a brutish portrait type that effectively severed all ties with the artistic traditions established by Augustus two centuries earlier.

109 Portrait of the Emperor Marcus
Aurelius Antoninus (called Caracalla)
Late Severan, ca. A.D. 217–230
Marble; H. 14¼ in. (36.2 cm.)
Samuel D. Lee Fund, 1940 (40.11.1a)

Page 142: text

PORTRAIT OF THE EMPEROR CARACALLA *(Page 141)*

Marcus Aurelius Antoninus (r. A.D. 211–217) won the nickname "Caracalla" because of his invention of a long, hooded tunic of that Celtic name. His adoption of a foreign costume perhaps came naturally to the elder son of the emperor Septimius Severus (r. A.D. 193–211). Although thoroughly assimilated to Roman ways, his father had been the first foreign-born emperor, and one who welcomed an internationalism in politics and art that completely changed the Roman Empire. He died in York, England, in A.D. 211. Septimius's other son, Geta, was assassinated by Caracalla, and the ruthless young emperor waged brutal campaigns to consolidate Roman authority and to ensure his popularity with the army. In A.D. 212 he issued an edict granting citizenship to everyone within the empire's borders, thereby gaining more imperial revenue through inheritance taxes. But at the same time this expansion of citizenship unbalanced a class system that had endured since the days of the early Republic.

Roman historians such as Dio Cassius note that Caracalla frequently wore an angry expression. Portraits of him made after his murder in A.D. 217, like this one, retain the scowl but exhibit a changed hairstyle. Full hair and beards, still popular at the beginning of the third century, have given way to the simpler fashions favored under the "soldier emperors," who ruled at a time when succession was more often assured by assassination than by ancestry.

110 Intaglio with Portrait of the Empress Julia Domna
Early Severan, ca. A.D. 205–210
Beryl; L. ¹⁵⁄₁₆ in. (24 mm.)
Rogers Fund, 1925 (25.78.90)

Left: impression

PORTRAIT OF THE EMPRESS JULIA DOMNA

Syrian-born Julia Domna was the second wife of Septimius Severus. Julia was an educated woman who assembled a circle of leading philosophers at the court in Antioch. She is shown here in a bust-length portrait that incorporates a large bun at the back of her head. This likeness of Julia is unique in its combination of the spiral locks descending over her cheeks with features of an early hairstyle; it is thought to be a backward-looking work from the end of her husband's reign. She is believed to have taken her own life in A.D. 217, upon learning of the death of her son Caracalla.

111 Portrait of a Young Woman
Early Severan, ca. A.D. 193–200
Marble; H. 10³⁄₁₆ in. (25.9 cm.)
Rogers Fund, 1923 (23.160.6)

YOUNG WOMAN FROM THE TIME OF SEPTIMIUS SEVERUS

In one of the earliest portraits of the Severan period, this young woman wears her hair in a simple coil at the back of her head. The likeness dates from the beginning of the Severan dynasty but retains much of the fleshiness of late Antonine portraits, closely resembling images of Crispina, the wife of the emperor Commodus (r. A.D. 180–193). The somnolent gaze is often found in works before the Severan period, but her distinctive, modest hairstyle marks this as a work of the end of the second century A.D.

112 Portrait Bust of a Veiled Woman
Early Severan, ca. A.D. 200–210
Marble; H. 26 in. (66 cm.)
Fletcher Fund, 1930 (30.11.11)

VEILED YOUNG WOMAN

The alert, if somewhat shy expression of this young woman, together with the long hair that loops down below her jaw and is gathered at the back of the head, places her slightly later than the woman described above, as late as the first decade of the third century A.D. She is as highly polished as the earlier piece, but the evident smoothing-out of features has been replaced by a more calligraphic treatment of the area around the eyes. The face is visibly flattened out, and she seems altogether more immediate, as if caught in motion.

The literal-mindedness of this portrait is a convention of the Severan period, and Antonine modeling is exchanged for greater linearity, as may also be seen in the flatness of the veiled mantle she wears. Despite these formal changes, the portrait is a careful and harmonious character study.

144

113 Portrait Bust of a Woman
Middle Severan, A.D. 210–222
Marble; H. 25⅝ in. (65 cm.)
Rogers Fund, 1918 (18.145.39)

PORTRAIT BUST OF A WOMAN

The coiffure, with the hair drawn behind the ears and gathered in back into a modest plait, dates this portrait to the Middle Severan period (ca. A.D. 208–222), perhaps during the reign of Caracalla or soon thereafter. The subtle psychology of the previous portrait has been left behind, and the sitter is presented forthrightly in a way reminiscent of Republican portraits. During the third century A.D., the refinements of Augustan portraiture are often put aside in favor of frankness for women and fiercely knit brows for men. This is an important change in the nature of portraiture, which had remained, with few exceptions, flattering and naturalistic since the end of the first century B.C.

Sarcophagus with Endymion and Selene

This refined example of Middle Severan sculpture tells the story of the shepherd boy Endymion and his lover, the moon goddess Selene. Endymion, who was a gift of the gods to Selene, reclines at the lower right of the sarcophagus front. A personification of night pours a sleeping potion over him, as Selene descends from her chariot to awaken her lover Endymion.

This coffin was found in a funeral chamber in Ostia in 1825 and was brought to England in the following year. In shape it evokes an ancient wine trough, for which lions' heads were often used as spouts—just as they were in Cybele's bronze chariot group (Plate 108). The sarcophagus once contained the body of Arria, the mother of Aninia Hilara, who died at the age of fifty and whose name and portrait are on panels in the center of the lid. Nine panels on either side show mythological subjects in relief.

On the front of the sarcophagus is a sea of lithe figures, none of whom maintains a common ground line. This abstract manipulation of the sculptural field is reminiscent of sculpted panels on the Arch of Septimius Severus in the Roman Forum. The Severan impulse toward abstraction in portraiture is paralleled in relief sculpture, and the swirling forms of this sarcophagus reveal how sophisticated that style could be.

114 Sarcophagus with the Myth of Endymion and Selene
Severan, ca. A.D. 210–225
Marble; H. 28½ in. (73 cm.), L. 74¼ in. (1.89 m.)
Rogers Fund, 1947 (47.100.4)

Opposite: detail

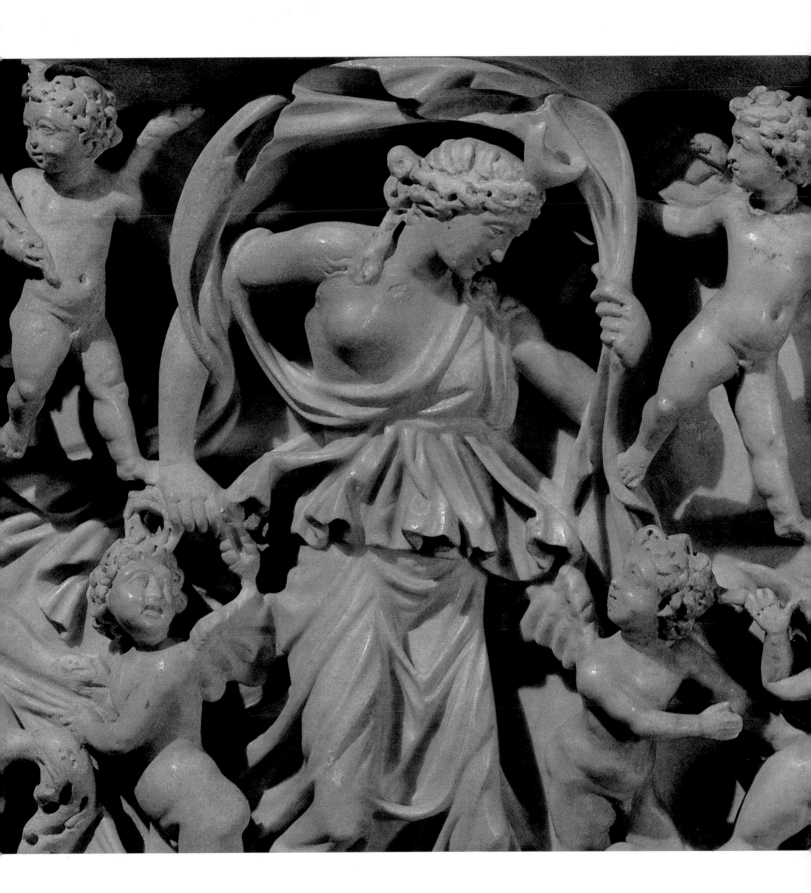

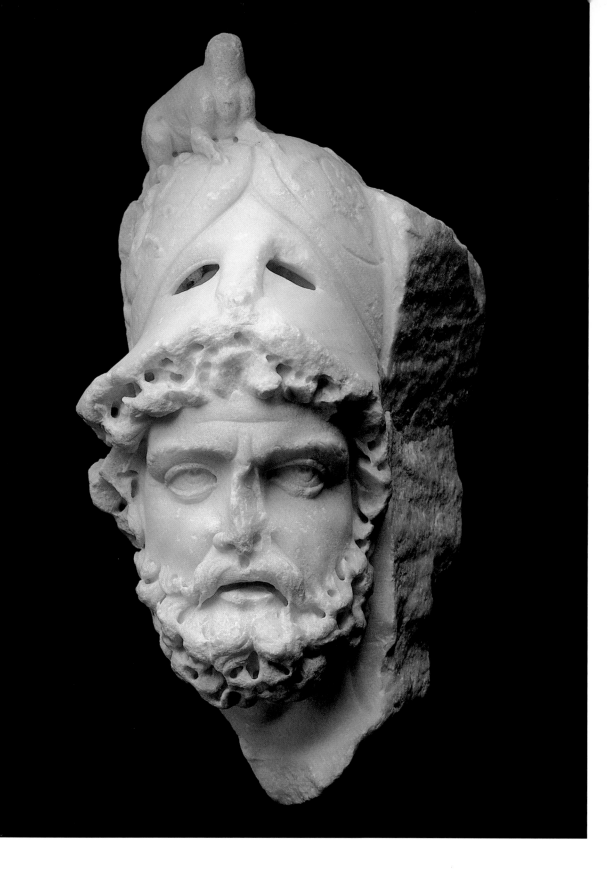

115 Head of Mars,
Broken from an Historical Relief
Early Severan, ca. A.D. 193–211
Marble; H. 14⅞ in. (37.8 cm.)
Rogers Fund, 1918 (18.145.49)

HEAD OF MARS FROM AN HISTORICAL RELIEF

Among the Roman gods, Mars was second only to Jupiter in importance. He was worshiped in almost a dozen temples in Italy and festivals in his honor were held in March and October. Although his mythology depends largely on that of the Greek god Ares, he assumed renewed importance under Augustus as Mars Ultor (the Avenger), a title acknowledging his help in bringing to justice the murderers of Augustus's great-uncle, Gaius Julius Caesar. In 2 B.C. Augustus consecrated a temple in his forum containing a colossal statue of Mars Ultor; it was frequently copied in various media thereafter and became a necessary feature of public monuments celebrating an emperor's triumphs.

The basic sculptural type of Mars Ultor—a bearded, older figure wearing a Corinthian helmet tipped back on his head—occurs in the Antonine panel showing the emperor's return, which is built into the Arch of Constantine. Mars also appears (lacking his head) on the attic of the Arch of Septimius Severus at Leptis Magna in Libya (A.D. 205–6); here, his

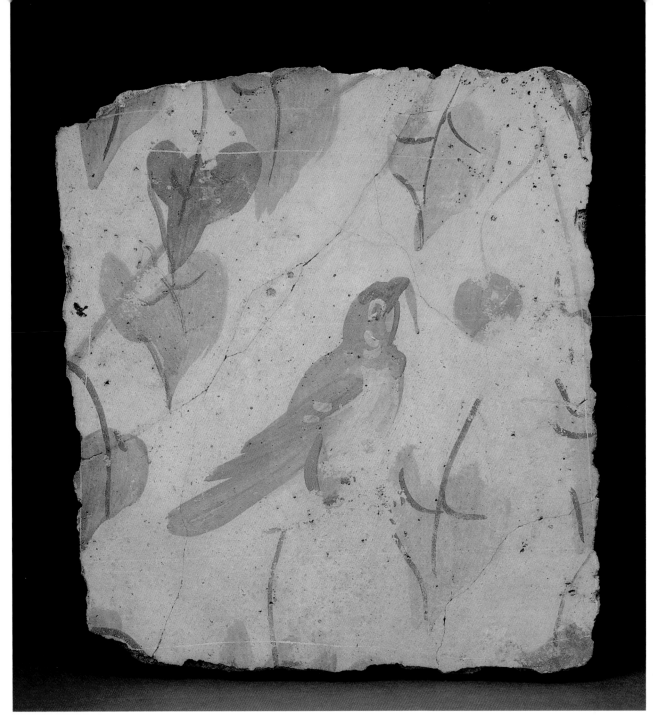

116 Bird in Foliage
2nd–3rd c. A.D.
Fresco; 12½ x 11⅜ in. (31.8 x 28.9 cm.)
Gift of Henry G. Marquand, 1892 (92.11.10)

Fresco with a Bird in Foliage

Although we have fewer preserved examples from the second and third centuries A.D., Roman wall painting continued unabated after the formulation of its renowned four styles. This charming fragment shows a house sparrow perched on an ivy branch, and the loose, fresh brushstrokes tell us we are long past the careful, mannered works of the Augustan period. Technical sophistication declined because clients were less willing to employ painters for long periods. White ground is favored for its simplicity, and for the impact it lends highly colored decorative elements like plants and birds.

pose seems borrowed from that of the Antonine panel. The reliefs at Leptis were probably carved by sculptors from Aphrodisias in Asia Minor, as evidence of the new internationalism of Severan art. The missing head of the Leptis Mars would have very likely provided a parallel quite close to the Museum's Mars, and it is possible that this majestic example comes from a triumphal dedication of the early third century, such as Septimius Severus's portico in Rome, now known to us only from literary sources.

FROM THE SOLDIER–EMPERORS TO CONSTANTINE

(A.D. 235–325)

The tormented expressions common in portraiture after the Severan dynasty speak of a society in which nothing could be taken for granted, during which succession to the throne was a military, no longer a dynastic, prerogative. The development of marble sarcophagi is no less informative about the artistic turmoil of the third century A.D. After the huge, ambitious scenes on coffins of the Antonine period, sarcophagi from the third century A.D. on show a profusion of styles, from intricate, interlocking forms (see Plate 114), to large, free-standing figures (see Plate 122).

Art of the third century cannot be categorized because frequent changes in leadership prevented a settled artistic climate. Although Gallienus (r. A.D. 253–268) and Diocletian (r. A.D. 284–305) restored a measure of order and harmony, it was only with the emperor Constantine (r. A.D. 306–337) and his new religion, Christianity, that the frowns and turmoil of late imperial art were replaced by the outward calm of an all-encompassing world order, and Western art took the spiritual direction it would follow for centuries.

PORTRAIT OF A MAN

The anguish of an age is reflected in this man's knit brow and concentrated expression. Unlike the Republican of two-and-a-half centuries earlier, who was wrinkled but calm (Plate 66), the tension of this sitter is an evocation of the troubled period of the mid-third century A.D.

The delicate equilibrium of the Severan period was upset by Caracalla, who ultimately undid all that had been accomplished by Augustus and that had been maintained for two centuries. The time of unrest has some peaceful interludes—notably under Gallienus and Diocletian—but in general it was an epoch without lasting order, and without guiding principles.

The prevailing style in portraiture was to show sitters with worried expressions, abrupt turns of the head, and short hair and beards more suited to helmets and battle than expressive of a philosophical, philhellene orientation. The Greek example meant little to most of the emperors who followed the Severan dynasty; physical survival was a sufficient credo. Rough tool marks suffice to describe this man's short hair and beard, and the running drill of the Antonine and Severan periods has been put aside. The vigorous realism that makes works from this era resemble Republican portraiture is only superficial, since the faces reveal not statesmanlike sobriety, but military preparedness.

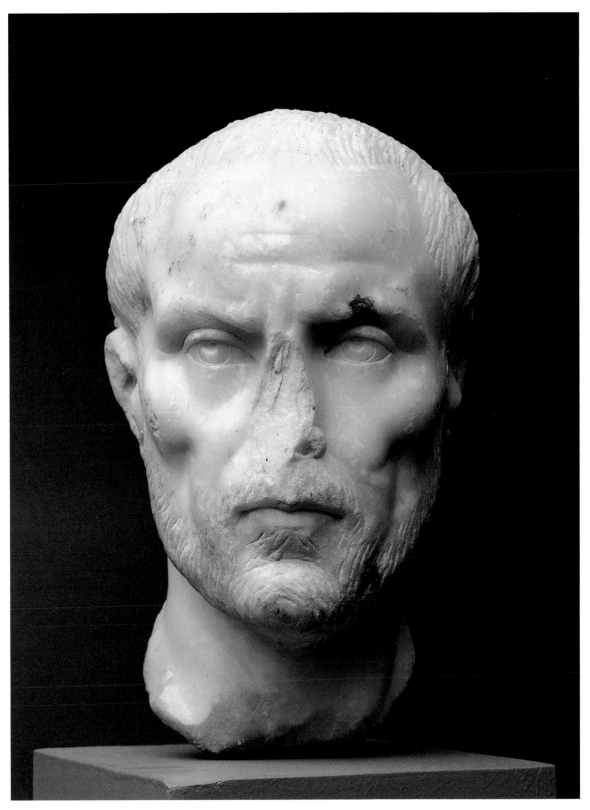

117 Portrait of a Man
ca. A.D. 245–255
Marble; H. 9 in. (23 cm.)
Rogers Fund, 1907 (07.286.112)

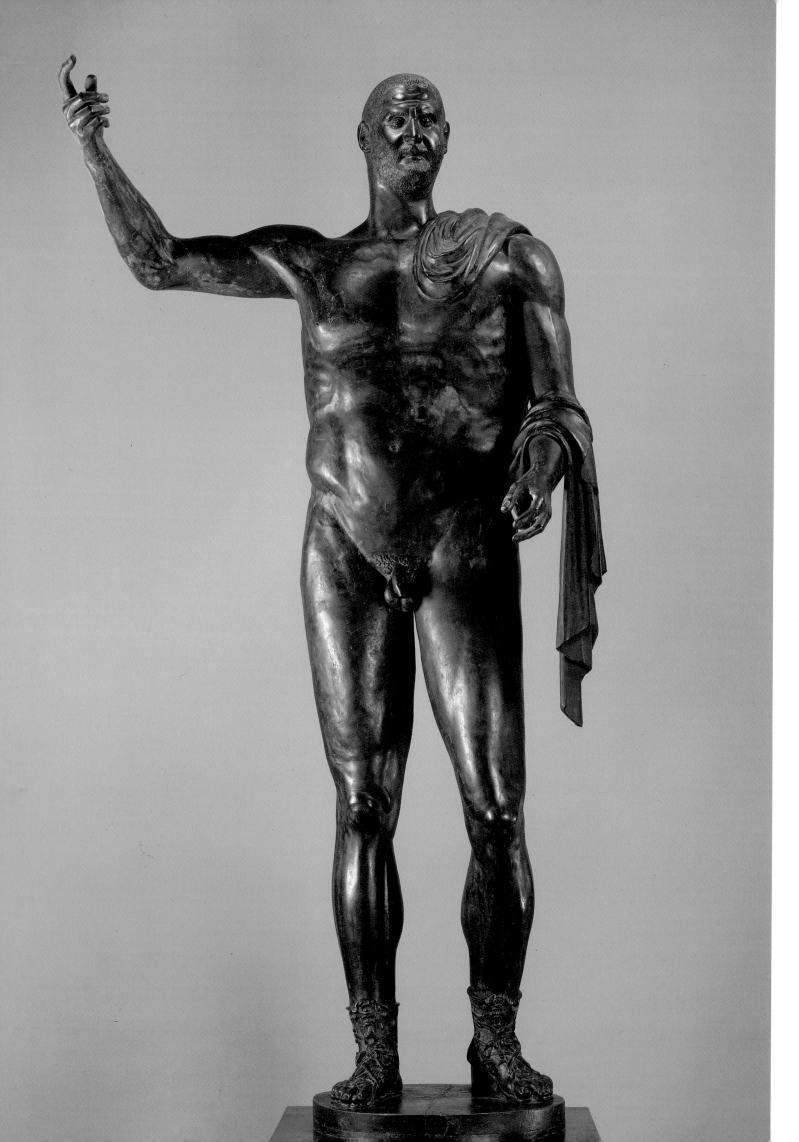

PORTRAIT STATUE OF THE EMPEROR TREBONIANUS GALLUS

A noble Etruscan by birth, Gallus (r. A.D. 251–253) was reputedly proud not of his ancestry but of his wrestling ability, which he confirms by wearing boots appropriate for the palaestra. His massive frame and improbably small head point up the intent of this nearly eight-foot-tall bronze: to impress or intimidate the populace through his sheer strength. He would have cradled a *parazonium*, or short sword, in his left arm, and may have held a spear or staff in his upraised right hand. Although his pose is one routinely adopted by Roman emperors—recalling Greek heroic and athletic statues—the statue's disproportion, wrestling gear, and brutish crew cut and stubbly beard, no longer evoke the ideals of classical Greece in the days of Augustus.

Gallus killed his predecessor, and met the same fate at his successor's hands only two years after becoming emperor. His brief rule—unlike the nineteen-year reign of Marcus Aurelius or the fourteen years of Septimius Severus—was typical of most of the third century A.D., when there were more emperors than during the empire's first two hundred years. The increasing threat of tribes hostile to Rome's original mission—the imposition of a civilized order throughout the world—and Rome's own dwindling devotion to that aim, eroded the confidence of the Senate. The expansion of the empire's citizenry, following Caracalla's edict of A.D. 212, diminished the capital's importance, and the ensuing chaos was difficult to quell.

118 Portrait Statue of the Emperor Trebonianus Gallus
A.D. 251–253
Bronze; H. 95 in. (2.4 m.)
Rogers Fund, 1905 (05.30)

119 Sarcophagus with the Contest of the Muses and Sirens
Gallienic, 3rd quarter of 3rd c. A.D.
Marble; H. 21 in. (53 cm.), L. 77 in. (1.96 m.)
Rogers Fund, 1910 (10.104)

SARCOPHAGUS WITH THE CONTEST OF THE MUSES AND SIRENS

While the portraits that survive from the third century A.D. reflect the troubles of the age, marble sarcophagi often continued a tradition begun under Hadrian, recounting myths involving rebirth and immortality. Although myths had long been considered make-believe by most educated Romans, superstition was built into Roman life, and old sepulchral traditions persisted. While mythological battles between Greeks and Amazons were still popular, battles between Roman legions and barbarians very much alive were common themes as well. In the twilight of the Roman world in the second half of the third century A.D., mythology born millennia before retained its place.

The contest of the Muses and Sirens illustrated here was a contest between the forces of art and letters and those of nature. The bird-legged Sirens and graceful Muses seem equally matched in this quiltlike array, as though the struggle no longer held the importance it once had. Nature and disorder were, in fact, gaining steadily on art and culture, and this refined but emotionless display lacks the energy of the story of Theseus and Ariadne on the sarcophagus made over a century earlier (Plate 101). The sculptor is more fascinated by the formal possibilities of his figures than by the implications of the contest, and we sense that the stage is being set for a less emotional style that we associate with late antiquity.

120 Jug with a Chain Handle
Gallienic, ca. A.D. 260–268
Glass; H. 7 3/16 in. (18.3 cm.)
Gift of Henry G. Marquand,
1881 (81.10.169)

GLASS JUG

Achievements in glass during the third century A.D. were no less impressive than those of preceding centuries; this delicate vessel combines a sturdy shape with the startling conceit of chains of glass serving as the handle. One of a pair, the jug comes from Beauvais in southern France, where it was found in a tomb in 1863. The shape is wholly unclassical in profile—a Roman innovation, and practical, since it cannot be tipped over. The chain handle celebrates an important practical convenience, and the ensemble was surely as diverting a shape in antiquity as it is today.

Gaul had been a Roman possession since the time of Caesar, whose account of his campaign there stands as one of the great historical narratives of all time. The Roman conquest of Gaul, like that of Britain, Germany, Spain, and other territories, left a lasting impression on each, with the result that towns like Londinium (London) owe their present organization to Roman city planning, itself derived from the architecture of military camps. The provinces provided natural resources for Rome's economy, but it was, ironically, Rome's belief in manifest destiny that was her undoing, since northern tribes eventually dismantled Rome's complex network of provincial government. By A.D. 476 the situation was so critical that Rome—the *urbs aeterna* or eternal city —was itself overrun and sacked.

121 Fibula
Tetrarchic or Constantinian,
A.D. 305–310
Gold; L. 2⅛ in. (5.4 cm.)
Purchase, 1895 (95.15.113)

GOLD FIBULA

The safety pin is today a useful but ordinary convenience;
in antiquity it spurred the imagination of artists, and mir-
rored the tastes of the day. A fibula was not simply a decora-
tive brooch but had always served the very practical purpose
of fastening a garment. The leech-shaped Etruscan fibulae
of the seventh century B.C. were organic forms, while this
arching profile resembles nothing so much as a crossbow.
By the time of the barbarian invasions of the fifth century
A.D., such baubles had become portable status symbols. The
upheaval of the late empire compelled art collectors to in-
vest in jewelry, since the increasingly unsettled nature of life
forced frequent moves. Status was no less important in times
of difficulty, and by adorning himself with personal effects
as refined as this, the owner ensured that his collection would
not be lost to the next raid, fire, or devastation of his home.
The inscription on the fibula translates: "Hercules Augus-
tus, may you always conquer." The epithet "Hercules" al-
ludes to an emperor from the tetrarchy (A.D. 293–305) or to
the emperor Constantine (r. A.D. 306–337) himself. The
bearer of this pin thus encourages his leader to victory.

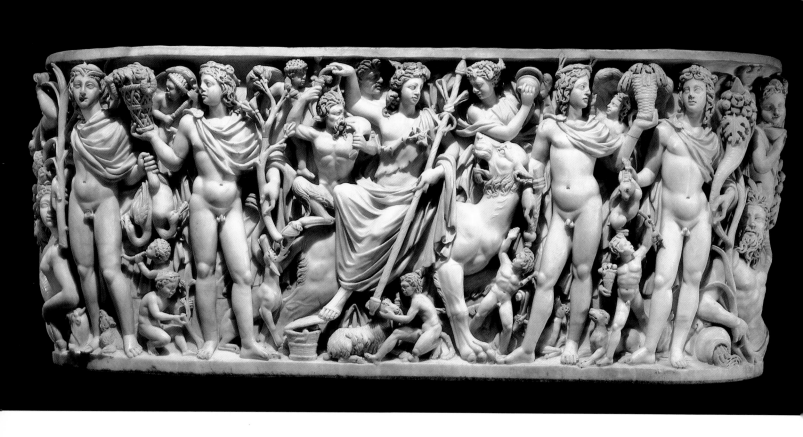

SEASONS SARCOPHAGUS WITH THE
INDIAN TRIUMPH OF BACCHUS

The changing seasons have always been important to mythology and religion; here the lissome four Seasons are depicted standing and displaying their attributes. The god Bacchus rides triumphantly on a panther, while his attendant satyrs and maenads cavort and celebrate the fruits of the vine. The period of the coffin is that of the emperor Gallienus (r. A.D. 253–268) who has been credited with a flowering of interest in classical culture. Portraits from his reign have longer hair and beards, in a literal efflorescence of philhellene sentiment. His noteworthy fifteen-year reign does appear to have provided a respite in which creativity thrived, at least in the capital, but it may be facile to attribute to him the brief revival of classical style from which this magnificent work evidently draws.

The figures of the Seasons, although fleshy, have little of the character of fifth-century-B.C. forms. Instead they reveal the stamp of their time, assuming poses, bearing improbably large heads, like those of children, and limbs as boneless as sausage. This transformation of classical form should not be taken as a waning of sculptural talent, but as an expression of third-century-A.D. vision. The Gallienic period produced several sarcophagi of this scale and luxury, and it was the last age in antiquity in which the classical style prevailed.

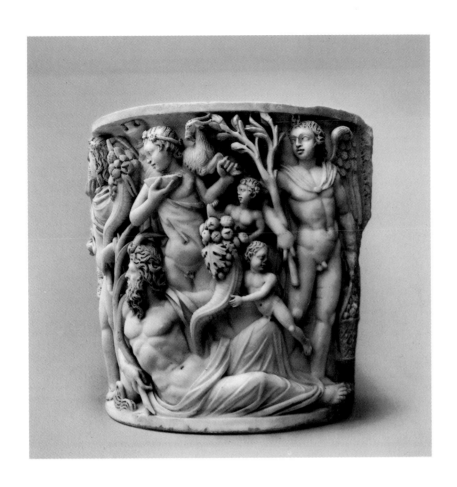

122 Seasons Sarcophagus with the Indian Triumph of Bacchus
Gallienic, ca. A.D. 260–270
Marble; H. 34 in. (86 cm.), L. 85 in. (2.16 m.) Ex coll.:
Duke of Beaufort; Cardinal Alberoni Purchase,
Joseph Pulitzer Bequest, 1955 (55.11.5)

This page: details

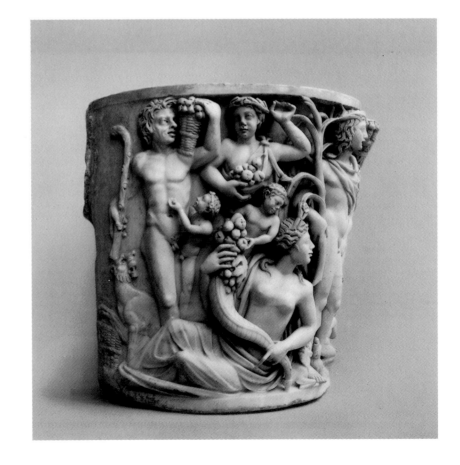

PORTRAIT OF THE EMPEROR CONSTANTINE I

In the year A.D. 312 Constantine was battling his rival Maxentius on the Milvian bridge, which still stands in Rome, when he purportedly saw in the sky a cross, and the legend "by this sign you shall conquer," and thus Rome's last pagan emperor was also her first Christian one. A lack of interest in recent fashions began early in his reign. Shorn of a beard, with full locks across his forehead, this portrait of Constantine recalls the example of the emperor Trajan, and may in fact be recut from an earlier portrait of that ruler. Constantine's contribution was not the expansion of the empire, but its transformation under the guise of a new world order, making the mortal emperor a subordinate to his savior.

Constantine's upraised eyes express a spiritual orientation that would have been anathema to Trajan's essentially secular image. The colossal head surmounted an enormous statue of the seated emperor, who may have sat impassively with globe in one hand and scepter in the other, as he did in a statue in the basilica bearing his name. That basilica effectively became a Christian structure, an ironic appropriation of Roman engineering triumphs on behalf of the religion that outlawed emperor worship. Constantine's appropriation of the portrait type of Trajan echoed in all forms of art: Erotes were eventually transformed into angels, sarcophagi with philosophers bearing ancient texts into sarcophagi with Christ and the scriptures, and a myriad of other changes. The adaptation of classical forms to Christian purposes is a story that begins to unfold in the early fourth century A.D. and lasts until the Italian Renaissance, when the forms themselves were rediscovered without the spiritual message that had imbued them for a millennium after Constantine's conversion.

123 Portrait of the Emperor Constantine I
Constantinian, ca. A.D. 325
Marble; H. 37½ in. (95.2 cm.)
Ex coll.: Giustiniani
Bequest of Mary Clark Thompson, 1923 (26.229)

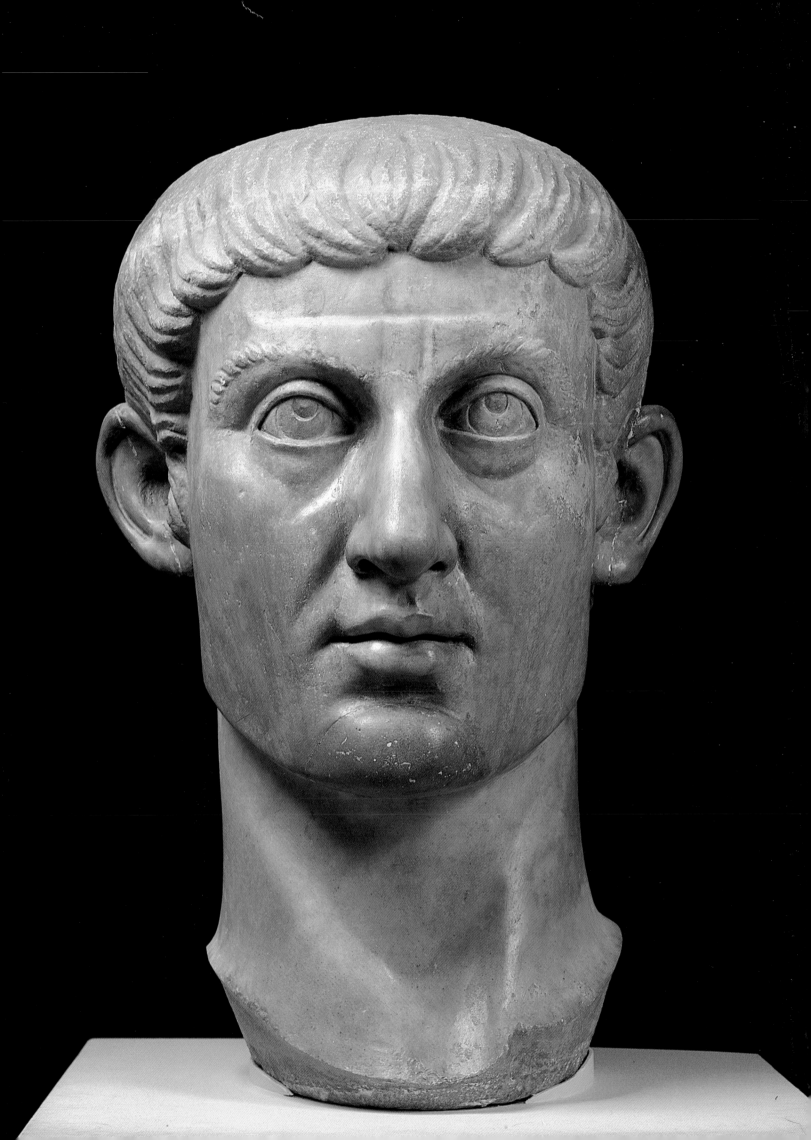